VOICES OF THE CHINCOTEAGUE

Voices of the Chincoteague

Memories of Greenbackville and Franklin City

Martha A. Burns and Linda S. Hartsock

Copyright © 2007 by HartBurn Productions LLC
ISBN 978-0-7385-2498-6

Published by Arcadia Publishing,
Charleston SC, Chicago IL, Portsmouth NH, San Francisco CA

Printed in the United States

Library of Congress control number: 2007922156

For all general information contact Arcadia Publishing at:
Telephone 843-853-2070
Fax 843-853-0044
E-mail sales@arcadiapublishing.com
For customer service and orders:
Toll-Free 1-888-313-2665

Visit us on the Internet at www.arcadiapublishing.com

Contents

PREFACE		viii
THOSE WHO HELPED		xii
	LAY OF THE LAND	17
	Welcome to Greenbackville	17
	Seasons of the Chincoteague	20
1.	COMMUNITY ANCHORS	28
	The Right Arm of Community	28
	Iron Horse of the Eastern Shore	31
	Fired Up Community	35
	Raising the Roof	38
	Law and Disorder	43
	On My Honor	45
	Common Touchstone	47
	Off to School	50
2.	SALTWATER CHANTEYS	54
	Working the Water	54
	Keep What You Catch	57
	Raftin' in the Winter	59
	Boys on the Bay	61
	Tools of the Trade	63
	Harbor From a Gut	68
	Catching Crabs the Hard Way	71
	Heavy Lifting	72
	Protecting Your Turf	75
	The Secret of Clamming	77
	Poling the Boat	79
	A Survival Skill	80
	Nobody Picked More Crabs	82
	Workboat Adventure	83
	The Handwriting on the Wall	84

3.	**NO SUCH THING AS 9 TO 5**	90
	Making a Buck	90
	Shave and a Haircut	96
	Filling the Cans	97
	Kid's Work	102
	Working the Land	104
	Working Women	107
	Saltwater Lumber Jacks	111
	Making Hay and Drum Fishing	112
4.	**LIFE GOES ON**	115
	We Take Care of our Own	115
	Making Ends Meet	119
	Woman Tied Down	121
	Bring 'ere Wives	123
	Don't Go Runnin' Off to the Doctor	125
	Go Anywhere, Do Almost Anything	128
	When Houses Were Homes	129
	Going Visiting	132
	Before Refrigeration	134
	Newfangled Inventions	139
	Ways Out	142
	Stoked and Smoked	145
5.	**CHARACTERS IN THEIR OWN RIGHT**	149
	Airplane in a Crate	149
	Driving on Home	152
	Better Make it Two	154
	Finding God in the Marsh	155
	Beauty is in the Eye of the Beholder	157
	Pinky the Horse	158
	The Girl with the Impala	159
	Those who were Different	161
	She Was Somethin' Else	164
	Shore is Purdy	166
6.	**HAPPENINGS**	168
	Life with Wind and Water	168
	Ole Time Religion	175

	If It Weren't for those Pigeons	176
	The War Remembered	177
	Hard Candy Christmas	181
	Cold Case Files	183
	Not Little League	186
	Sled Train Disaster	188
	Vanilla, Chocolate, Pineapple?	189
	My Lucky Break	191
	Riding the Train, By Gum!	192
7.	HERE ABOUTS	197
	Red Hills	197
	Pope's Island	201
	Captain's Cove	203
	A Tale of Two Towns	209
AFTERWORD		212
APPENDIX 1. Local Lingo		214
APPENDIX 2. Early History		218

Preface

Although you know where you plan to end, seldom when you begin a journey do you know what will happen along the way. In the case of this project, we envisioned preserving the wonderful stories told by those who have always lived in the area. Further, based on our past training and experience, we believed it would take the form of a book. Like any journey worth remembering, this one had its interruptions, twists and turns, anomalies, unique characters, travelers along similar but different paths, dead ends, and flat-out road blocks. If you are reading this, you will know we did reach the destination—a book.

We determined early on that a straightforward history would not capture the humanity, character, humor, and depth of the people. So, like any sensible traveler, we looked for a road map. Much to our surprise, there was none! Consequently, we began to look around for similar projects and products. The closest we came was a 624-page nonfiction work by William Least Heat-Moon, *PrairyErth*, about a county in Kansas. Already being fans of his books *Blue Highways* and *River-Horse*, we wrote to him asking a host of questions about where and how to begin. Within a few weeks a wonderful handwritten letter arrived. With his permission, we share his responses to our questions.

> When do you know you have enough material to begin writing? And, equally important, when do you stop gathering information for a project that could go on forever?
> **Answer:** *You begin and end when the calendar tells you to, otherwise the gathering of material will be endless!*
>
> How do you avoid the product being "dated" or, more to the point, outdated?
> **Answer:** *You want your history to be dated. Don't worry about this one.*

Preface

How do we begin the actual writing?
Answer: *Sit down and start <u>someplace</u>—most any point will serve to start you; structure should come along as you write.*

Should we organize by person, event, walking tour of the town, or some other system?
Answer: *You could use <u>all</u> approaches or <u>any</u> of them or <u>several</u> in combination. The point is to decide and JUST BEGIN.*

Is it better to write as you go or collect and research and then write?
Answer: *Work as you go, once you have some material. Proceed and the way will open—as I say in River-Horse. Write and you will slowly find your way. Above all BEGIN!*

With that counsel and encouragement, we BEGAN. As nearly four years passed, his words and advice were, as they say in these parts, "spot on." This effort is not completed, even though this book represents four years of interviews, library and internet research, travel on and off Virginia's Eastern Shore, and hours writing at computers and simply living among and listening to the people of these communities. In fact this journey has, as they say, only just begun. There are many more tales and yarns that should have been included, characters who have not been identified, conclusions that may be amiss, and interpretations that might have missed the mark. We welcome reactions, corrections, and other input which may, or may not, appear in a later book. If there is another book, it will depend on our stamina, community support, and interest in going through this process again. Importantly, we invite the next generation of authors to step up to the plate.

At the time this book was published we had owned property or lived in the area for over 16 years, but as "come 'eres," were not natives. Non-natives anywhere on the Eastern Shore were, and are today, commonly known as come 'eres, the implication being that they have inserted themselves without invitation into an existing community. From professional training and personal interest in our surroundings, we tried to listen more and talk less. It didn't take long before we began hearing wonderful stories of years gone by. First at the post office and later at the Bay Witch, then a local bait and gasoline place and later a restaurant of local acclaim. Some tales

surfaced over and over again and as time went on, it became clear they were part of the collective memories of these people. Then valued members of the community began to move to other areas or to nursing homes, or die. The stories and tales that we heard were too unique and wonderful to be lost forever. One person said, *every time one of them goes, it's like you may as well have burned up a whole book.*

In 2001, at our urging, the postmistress and a native son put together an ad hoc committee to organize an Old Tyme Days / Community Reunion. There were some who decided in advance to have no part of the event. The day of the first Old Tyme Days it rained buckets, as it did the following two years on the day of the event. In spite of it all, that first year over 60 people showed up. With that success the event has become a mini-tradition and is repeated annually, with 2006 attendance over 300. And, those who early on criticized the effort are now full participants.

The community event was a big step forward but the stories only lived for the moment when they were told to those present. After the second year, it was clear that someone needed to do the hard work of preserving these memories and stories. We set about interviewing those who agreed to talk with us and recording their stories of old times. As time went on, those interviewed suggested others who should be included; some who attended the Old Tyme Days expressed interest; a couple of local newspaper stories brought interest from outside the community that resulted in some self-nominated contacts; and friends and neighbors made suggestions. Not everyone we contacted agreed to talk with us. After all, we were come 'eres and might be up to no good. But as time went on, as Heat-Moon promised, the way did open!

Still having little idea where this project would lead, but also having been trained in the discipline of descriptive research, we knew certain things. To begin with, we knew it was important to ask everyone the same thing in the same way. We identified an outline of questions that would be covered in all interviews. As the pages that follow will attest, these questions elicited no small amount of input. Once we began, stories, legends, characters, facts (as they were remembered), and a host of memories came forth.

> When did you move here? Ever live anywhere else but here?
> Did you live in Greenbackville or Franklin City?
> Born here? Brought here? Come here?
> The first thing you remember?
> Describe family, home, work, income, weather

What did people do in spare time? Hobbies? Recreation? Fun?
Most exciting thing that happened? Hardest time? Funniest story?
What do you miss most?
What didn't we ask that you thought we should or would?

In the beginning, we thought we could convey the interview information simply as it was told. Whenever possible, that has been done with italics to indicate words that came directly from a person we interviewed. Often however, when we put ourselves in the shoes of a person not from this area we found terms and concepts that might be unclear to the uninitiated. In those cases, we have added our take on the situation. Additionally, we have used our observations of the area over the past 16 years to provide insight and descriptions of places and things that may not be abundantly clear from a narrative or to a person who does not live in this area. Our interpretations come from observation, personal experience, and what we have been told. Those who have lived in the area all their lives seem to be surprised when we identify unique features of the area that they have taken for granted and judged not very special. In all cases, serious effort has been made to retain the language, flavor, emotion, and meanings described by our sources.

There are certain passages in this book that we feel require an explanation. It is important for the reader to understand that this book was written about a time when certain words, concepts, and behaviors were commonplace but which are totally unacceptable in 21st century America. Although described by those interviewed, neither they, the authors, nor the publisher intend to offend or insult any group or person described herein. The only goal was to portray life as it was remembered.

This process has kept us busy for four years and brought an even greater appreciation of these communities. We can only hope that this book—the only one ever written exclusively about Greenbackville and Franklin City—will help keep the memories of those wonderful places alive for future generations. Sentiments about these towns are best expressed in the words of a long-gone pillar of the community who wrote at the time of Greenbackville's centennial celebration in 1967: *We cannot know what the future has in store and when I reach my end, though destiny may take me to far distant lands, while memory lasts the dearest spot on earth is to me and will always be Greenbackville, Virginia.*

Those Who Helped

The following outlines those who, working with the authors, made this book possible. Without them, there would be no book.

Contributors
People who shared their stories, memories, and the legends passed down from prior generations are the heroes and heroines of this book. Each of them spent at least an hour and many times much longer describing how life used to be. Without their willingness to think back and talk about the good times as well as the bad, this book would not be able to portray lives well-lived in a place and time that is now past. Almost to a person, when asked to talk with us, they agreed somewhat reluctantly echoing the phrase, "I'll help if I can but I really don't know anything." The authors soon learned that this was never true. These members of the community contributed relevant, sometimes funny, sometimes sad, but always memorable insights of life in these communities and all of rural America in the 1900s. Some blushed with good humor as they told embarrassing stories of themselves. Some had a tear in their eye and a lump in their throat as they described the most difficult times. Contributors fell into four categories. They are people who were:

> Born, raised, and continued to live in the community
> "Bring 'eres" who married and lived in the community, but were not truly natives
> Natives who lived away from the community for a substantial part of their lives
> Relatives of residents from usually nearby places who visited frequently and shared experiences

Contributors as well as many others helped locate artifacts and evidence of times gone by. They went to attics on hot days, shared from their own antique collections, and many made one-of-a-kind photographs

available. Without their gifts of time, insights, and interest, there would be no book.

In respect for their privacy and to honor the promise made to them by the authors, no individual names of those interviewed or others who contributed in other ways are listed here or used elsewhere in this book. Consequently, the only source notations are when a professional photographer's work has been used. We owe a huge debt of gratitude to our contributors.

Counselors

No endeavor of this scope would ever see the light of day without careful, insightful guidance from those with expertise, experience, and information. Listed below in the chronological order that their support was offered and accepted are colleagues who helped. All contributed with no hope of any remuneration more than a big thank you both then and now.

> **Brice Stump**—Photographer and feature writer for the *Salisbury Daily Times* who wrote several major feature articles about this project and Greenbackville. His articles brought folks to us who would otherwise not have been identified. He also took a number of professional photographs for the book and served as head cheerleader and counselor. He was pivotal in helping us find the right publisher.
>
> **Dr. Kara Rogers Thomas**—Folklorist/lecturer in interdisciplinary studies at Frostburg State University. The first outside professional reader who gave encouragement and initial ideas for organization of the text.
>
> **Lora Bottinelli**—Deputy director and folklore specialist at Ward Museum of Wildfowl Art, validated the content and enthusiastically encouraged the completion of the work. She also ranked the quality of each story and suggested ways to improve the presentation.
>
> **Ann Ford**—Proofreader par excellence! Not only does she tell you what page and line has a problem, in a red font she shows how it should be corrected and then refers you to another page where her comments, rationale, and documentation for the recommendation are provided.

Joan Selby—Proofreader of parts of very early versions making it possible for us to have "sample chapters" available.

Freddy and Charlotte Holland, Martha and Cecil Schrock, and Joyce and Lester Benson—our farming friends reviewed and offered suggestions to improve the section on farming.

Dot Pinto—shared her husband's old railroad books with maps and timetables.

Kirk Mariner—Offered advice and insights on the many details of publishing based on long experience. Also reviewed and critiqued the part on early history based largely on his work.

Patricia A. Sullivan—Professor and program chair in the medical school at George Washington University, spearheaded and facilitated activities that prove the Old Girl's Network is alive and well.

Caroline Burch—a friend of a friend and an insider in the publishing world who was pivotal in helping us meet publishers and understand the way the game is played.

Jim Kempert, Arcadia Publishing—editor who every author hopes they will find. He was invaluable to us as our advocate and our sounding board throughout the publication process. He smoothed the rough edges of our writing, transformed family snapshots into book-quality photographs, and crowned his efforts by giving this volume a title that captures the essence of its contents and a cover with the look and feel of the people of these towns and the Chincoteague Bay.

Friends

It is said, "friends are the family you give yourself." That has certainly been the case for the authors both long before discovering the Eastern Shore and later while living there full time. Without the encouragement, understanding, and prodding of our family of friends, this book would never have been started, let alone finished. You know who you are! Thank you!

VOICES OF THE CHINCOTEAGUE

LAY OF THE LAND

This section is the foundation for the rest of this book. Most of the content is designed to help the reader get a feel for the area and the "lay of the land." It would be difficult to have a full picture of what happened and how without some acquaintance with where it happened.

The geography of the area and the unique characteristics of the four seasons are integral factors in the way lives were, and are, lived by residents of these two towns. Getting a grasp on the lay of the land will allow the reader to more clearly envision the setting of this book.

WELCOME TO GREENBACKVILLE
Ahead are work boats, boat slips, crab pots, and the Bay. You are at the Harbor—life blood of this community both in the past and today.

Looking at a Virginia map, go to the farthest northeast corner of Virginia and you will find Greenbackville and what once was Franklin City. As you travel north on the old seaside road, now Virginia State Route 679, or south on Maryland Route 12, you come to an intersection. Depending on the time of year, you see fields of corn, soybeans, or potatoes on all sides. There is a street sign with different parts pointing in most any direction depending on the last time it was knocked down by a delivery truck or someone unfamiliar with the intersection misjudging the angle of the turn. One sign on the post reads Fleming Road. Another is Swan's Cut Road—named for a nearby creek (or gut) that empties into the Chincoteague Bay. In recent years, those who were put off by naming a road "Gut" changed it to Swan's "Cut." That same road crosses the old seaside road (Fleming Road) and is simply called State Line Road.

Today, this road truly is the state line between Maryland and Virginia. It goes straight until it reaches Greenbackville. There was a time when there was no state line and this land was part of the original grant to Lord Calvert, whose major holdings became the state of Maryland. As might be expected, there were border disputes when it came time to

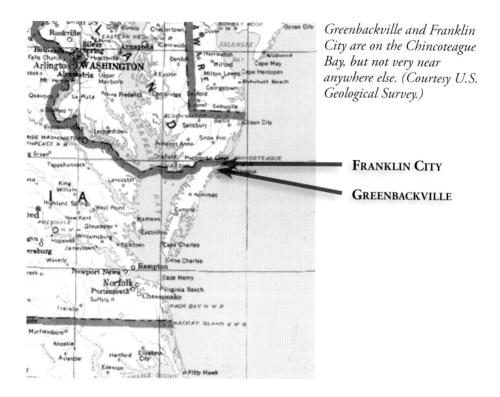

Greenbackville and Franklin City are on the Chincoteague Bay, but not very near anywhere else. (Courtesy U.S. Geological Survey.)

declare what land was in which state. A commission was established to map it out. Were it not for Edward Scarborough, a Virginian who served on the commission and held his state's interest high, the territory of Franklin City and Greenbackville would probably be in Maryland. Scarborough, in addition to his commitment to serving Virginia, had a peg leg. Regional folklore attributes the area's Virginia status to Scarborough's peg leg; it is said that when he stepped off the line from west to east he listed to the left, which resulted in many more acres being in Virginia than Maryland. Take a look at any accurate map of the lower Eastern Shore that shows the state line between Maryland and Virginia; then, remember that the line was stepped off from the Chesapeake to the Atlantic and you'll see just how peculiar that angle is.

Shortly after turning onto State Line Road, you pass the main entrance to Captain's Cove. This planned community was laid out in the 1960s, but not seriously developed for 40-some years. For hundreds of years when it was farm land and still today, when it is beginning to look like every other suburban community in the country, the official post office address of this land is Greenbackville. However, it is not located in the town, but nearby.

Moving on down the road, you come to the back entrance to Captain's Cove. This area was once known as Chapman Town and consisted of several smaller farms adjoining a larger farm, which later became Captain's Cove. Adjoining Chapman Town and the larger farm is a third one that raised cattle, hogs, chickens, corn, and hay. The latter farm was still functioning in the early 2000s. The only sign left of Chapman Town was the family home, which was still occupied though surrounded by new homes and a growing community. Owners of both farms were recognized as the oldest men in the community at the first Olde Tyme Days in Greenbackville in 2001.

Next, on the left, is the Greenbackville Cemetery. It is legally in the state of Maryland as it lies on that side of Stateline Road. Franklin City's cemetery is on the other side of town on Greenbackville Road and is also in Maryland. Both are managed by a group of local volunteers under the same organizational structure. According to a member of that group, it is impossible to tell how many occupied graves there are because once a lot is sold, *there's no way of knowing whether it is used.*

Past the Captain's Cove entrances, State Line Road was pretty much as it had been for the last 80 to 100 years, at least until 2006. The view is mostly of corn, soy bean, potato fields, and a few single family houses including a trailer or two and one complex of a very run down house, shacks, and old cars. Most houses are bolstered by huge wood piles in the back—evidence of the use of wood burning stoves for heat. Further, evidence of the residents' energy and enterprising spirit is proclaimed on the sign attached to a mail box that announces "Wood For Sell."

On the left, as you approach Greenbackville, there is another typical Eastern Shore sight. This home site consists of a large house trailer, an old commercial chicken house, a boat trailer with a boat on it in the winter (the boat is in the Bay in the summer), a pickup truck, a stack of crab pots, and a dog house. The scene is notable because it is repeated throughout the Delmarva Peninsula.

Finally, you know you have arrived when a sign announces "Welcome to Greenbackville Established in 1867." This sign is relatively new, donated by a local retired businessman who was born in Franklin City. Having no incorporation, no town council, no mayor, and importantly, no budget, there are few ways of getting public works done. Generally, when something happens for the good of the community it is because of individual initiative and largess.

By now, you get the feeling you are someplace. Exactly where is not clear at first. There are some large older Victorian houses, a few 1940s-style

bungalows, and several aging house trailers. In addition to State Line Road, there are two streets (six to eight city blocks long) that end in a T with Front Street, which borders the Harbor. The two long streets are intersected by a few shorter streets; in fact, one of them is one block long and is called Short Street. The country that surrounds the town is mostly salt marsh and water and a little farmland to the west. State Line Road continues until it makes a sharp turn—possibly because of the encroachment of the marsh. Shortly after that turn, State Line Road ends. Ahead are work boats, boat slips, crab pots, and the Bay. You are at the Harbor—life blood of this community both in the past and today.

As you begin to explore the rest of the town you discover many old homes—some in excellent condition, others in various states of disrepair begging for attention. A restaurant at the Harbor's end, a post office on the main street, an impressive firehouse for such a small community, a home builder's office and storage area, and a beauty shop in the front room of the owner's home (for many years it operated out of a converted utility shed) constitute the commerce of the town. The old fire house has been renamed the Community Center and there is a Methodist church. Those are the facts.

The balance of this book is about the people of this community—its heart and soul. It's about their memories of the way things were in earlier times, their relationships with their families and neighbors, the tragic and humorous events that gave color and texture to their lives, and most of all their connections to their beloved Chincoteague Bay.

SEASONS OF THE CHINCOTEAGUE
Watermen and farmers know what is ahead of them.

When Native Americans lived in this area and the first European settlers arrived, both the water and its surrounding land were known as "Gingoteague," which was subsequently anglicized to Chincoteague. Only later did names such as Chincoteague Bay and Chincoteague Island arrive. It is difficult to know with complete accuracy the parameters of the area known as Chincoteague, but it is clear that it spans some miles inland. The Chincoteague Church, for example, is located seven to eight miles inland near Route 13. The following seasonal descriptions address the entire area known as Chincoteague—not just the Bay and not just the Island.

Those who earn their living from the water measure time by *getting ready for the season and workin' it*. As soon as a new year arrives, work begins

on makin' new crab pots, fixin' old ones, and doin' the work on the boat an' motor. I put it off all summer prayin' it wouldn't go up on me before the season was over. Farmers' work lives are also driven by the seasons whether it be planting, harvesting, or getting ready to do one or the other. Watermen and farmers know what is ahead of them and work hard to make the specific preparations for whatever happens in the coming season.

These days, water cops (technically Virginia Marine Resources officers) attempt to enforce laws that are supposed to reflect the seasons when specific catches are most plentiful, healthiest, and edible. Generally these legal seasons work, but specifically they fail miserably. Only watermen know when it is time to go after a specific catch. How can they know?

It takes a lot of common sense as well as trial and error. One reported, *When we start pickin' up toads in the pots then it's time to put out the toad pots and so on with everything we go after.* (Toad is the local term for a species of blowfish that is very popular among those who have tasted its sweet tail meat.) Similarly, they will put out test nets and do a few *licks* with a dredge to see what comes up. As any good fisherman knows, the only way to see what fish are biting on is to clean the first fish caught and see what's in its stomach.

In the old days, watermen and hunters did not need to rely on government regulations to know what to harvest and when. The reason they fished and hunted was to make a living or to put food on their own family's table. There was no doing it for fun or sport. It was unthinkable to hunt deer in the spring or harvest oysters in the summer. There was also a commonly understood and respected principle that *if you take more than you need, it won't be there for the future.* Unfortunately, that principle seems to elude many sport fishermen and hunters today.

Game wardens, laws, and licenses are now required to control and enforce what a smaller group of people, who felt responsible for the land and nearby waters, knew instinctively. For example, even landlubbers know that you should not eat oysters in months that don't have the letter R in them. That is not because the oysters, or the rocks they live on, disappear in the summer, it is because during the warm months they are *poor—not as fat and milky* and they are prone to diseases. There is also the belief that the advice to not eat oysters in months without the letter R was because, when harvested, they require a cool environment. Alongside the Chincoteague Bay in the summer you can find plenty of heat and humidity but virtually no coolness. In the days before electricity and refrigeration, it was difficult if not impossible to provide a cool environment powered solely by natural elements—temperature, winds, shade, natural ice, and the like. In the old

days, you didn't kill deer in the spring or summer because it would have been difficult to handle the large amount of butchered meat without refrigeration, and also, that is when they are raising their young.

In other parts of the country the weather is often the number one topic of conversation, but in gathering places around Greenbackville the focus always was and still is on the catch—as in: *How'd you do yesterday?* Sometimes the weather is mentioned but only as it relates to whether or not it affected the fishing, hunting, or crops. More often than not, the answer to that question also foretold the coming of another season just around the corner. Some of the signs and symbols of the seasons of the Chincoteague follow.

Spring

There are many conventions for determining when spring actually arrives. In Washington, D.C., it is when the cherry trees around the Tidal Basin bloom; in Capistrano, California, it's when the swallows return; in ancient mythology, it is after the Ides of March; and for every community that has changes between seasons there are very definite harbingers of spring. To non-natives, early spring on the Eastern Shore doesn't look a whole lot different than winter—rain, cold, sometimes sleet, brown vegetation, dreary dark days, and the like. A few blooming white Bradford pears, daffodils, and camellias announce the arrival of spring to the less observant.

To the natives, there are signs of change everywhere.

- Boat bottoms are being painted.
- Crab pots are stacked by the hundreds in the Harbor waiting for the first day of the legal season.
- *Frogs are hollerin' on warm evenings.*
- Purple martins and hummingbirds return.
- Tree swallows and bluebirds argue about who gets the nesting place this year.
- Yellow finches who were dull gray all winter begin to sport their new yellow feathers.
- Your nose tells you fields are being fertilized with chicken manure.
- The purple-blossomed weed that covers fields before planting is in full bloom, often as far as the eye can see.
- Black and red drum—big fish ranging up to 70 pounds or more begin to appear in the water and on the dinner table.
- In May, you begin to see very sleepy watermen who catch and manage the transition from hard crabs to soft crabs. The

watermen are up all night at this time of year because they must rescue the soft crabs that have shed their shells before they are eaten by those already finished with the molt.
- Soft crab sandwiches begin to appear on menus.
- Even though the tops of marsh grasses are still brown, the salt marsh begins to green from down deep in the mud.
- In fields owned by commercial growers, piles of tomato stakes begin to appear alongside fields, and miles of black plastic cover seedlings to protect them from the chill.

Summer

To come' eres, summer in the area means beach, sand, vacations, and the never ending debate about what will keep the mosquitoes off: commercial repellents, a dryer sheet in your pocket, taking vitamin B, not eating bananas, and so on. Once they exhaust that subject they begin on remedies to stop the itching: rubbing alcohol, rubbing the skin around the bite, antihistamines, meat tenderizer, toothpaste, etc. To locals, summer means so much more.

- The temperature near the Bay is cooler than inland because of the ocean and its breezes.
- The salt marsh has peaked and is shades of green from top to bottom.
- Folks are wearing boat shoes, not boots.
- The come 'eres have arrived—around weekends they are everywhere.
- T-shirt shops, food stands, and restaurants that were closed all winter are open and full of customers, especially on Chincoteague Island.
- Folks who may not have worked for pay all winter suddenly have jobs. This is especially true of women and teenagers.
- The temperature soars but there is usually a breeze and often an afternoon thunderstorm.
- Mosquitoes—the area's signature insect—reappear with a vengeance. Many a heated argument is overheard debating the value or harm of aerial spraying. Natives generally are not bothered by mosquitoes or simply accept them as a fact of life.

Fall

For locals, the coming of fall is nearly as exciting as spring. Most come 'eres go back home and those who stay often miss the subtle changes around them. Today, this means to residents of Greenbackville and environs that school starts, the tourists go back to where they came from, vacation—if you were lucky enough to have one—is over, and it's back to work for a long stretch. Consequently, life begins to follow a more normal routine that is busy but less frenetic than summer when all the playing and extra jobs are added to the normal workload.

For residents of Franklin City and Greenbackville in the old days as well as those who still work the water or farm the land, fall is a time of harvest, gathering, and processing what nature has provided. Because of the warm ocean nearby, fall is one of the most beautiful times of the year and lasts much later than in other parts of the country. In fact, signs of the seasonal change are not usually blatantly obvious until sometime in November.

- Some work boats that ran crab pots all summer are being refitted to dredge clams.
- Gradually you notice there are more crab pots stacked at the Harbor and in backyards than there are floats on the water marking their presence in the bottom of the Bay.
- Most pleasure boats and many work boats rest on trailers or cinderblocks. Some are being scraped, painted, or having mechanical work done.
- Extra effort is made to tie up boats and tie down loose things just in case a hurricane visits.

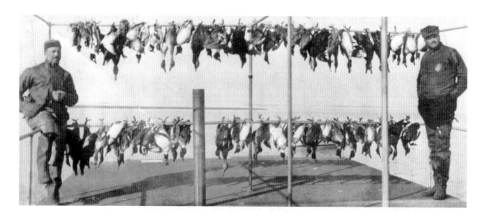

Back then, waterfowl was plentiful and hunting limits nonexistent.

- Households are paying more attention to their water supply, batteries, canned food, gas tanks and the like in case of a hurricane.
- The talk of the early morning coffee drinkers turns from who is catching what to whether the oysters will ever come back, those who stopped working on the water because they just couldn't make it, what developers might do next, and how lucky or unlucky we were during the last hurricane season.
- Pleasure boaters disappear from the Bay and only serious fishermen and watermen are on it.
- The local boat repair business is swamped with pleasure boats lined up and down the road waiting to be winterized.
- At dawn and dusk you begin to hear the boom of guns in the distance announcing the arrival of deer and duck hunting seasons.
- Traffic signs announce, "Deer rutting season, drive carefully."
- All but the largest roadside vegetable stands have closed.
- Small open-air buildings that house crab floats (shallow containers where water runs continuously and crabs are allowed to shed for the soft shell market) are emptied and boarded up for the winter.
- Corn and cotton fields turn from green to brown, announcing it is time to harvest. The soybean fields join in the fun but go one better by starting out green, going to a golden yellow, then a light brown, and finally to a blue gray.
- Giant machines—combines—cut and separate the crops from their stems and leaves. Often you're late because they are in the roads trying to get to the next field before the fall rains begin.
- When you drive back roads from one town to the next, you can see great distances across fields that were earlier hidden by high stalks of corn.
- By the middle of September there are fewer and fewer hummingbirds at your feeders and by the end of the month they have all left.
- Tree swallows, purple martins, grackles, and other songbirds that visit for the summer and are quite independent begin to hang around together and even practice flying as a flock. Then one day, they too are all gone.
- You begin to see more monarch butterflies than you have all summer. If you are lucky, you'll see a whole tree or bush that from a distance looks like it has turned gray overnight,

but when the wind blows it turns bright orange from the butterflies roosting there resting up for their migration to Mexico.
- One early morning in late November, you hear a new sound in the sky, the first of the 40,000-plus snow geese that will winter in the area. Their formations, different from the well known Canada goose's V, look more like the letter C.

Winter

It is hard to tell when winter actually begins. The calendar says December 21, but that means little or nothing around Chincoteague. Some Decembers and Januarys have temperatures in the 50s and 60s, boats are still *over*, and sport fishermen are complaining that the rock fish migration is late. Other years, it snows by Thanksgiving. Predicting when winter will come, how long it will stay, and how severe it will be is folly. But locals have sure ways to tell when it has arrived.

- The most beautiful and vivid sunsets of the year happen in the far southwest sky between 4 and 5 p.m.
- To many the landscape is dull, dark, and drab, but to the careful observer there are rich and multiple shades of green, brown, and blue never seen at other times of the year.
- Sometimes, the northern lights can be seen on a dark night.
- Except for winter waterfowl, the salt marsh is brown and seemingly dormant.
- Buffleheads, mergansers, and black, green, and blue-winged teal ducks all begin to inhabit the sloughs, guts, and canals.
- Hurricane season is over but nor'easters will blow up and cause as much or more damage.
- TV and radio weather reports of temperature mean little because the nearby ocean's warming effect works its magic. The stations are all inland where it is always colder.
- Community, school, church, and fire company regular meetings that were suspended for the summer resume.
- From the week after Thanksgiving on to Christmas, town parades occur usually at night since school and work occupy participants and observers in the daytime.
- Once about every five to ten miles of highway, nature's refuse removers—turkey vultures—are at work on a deer carcass that had an unfortunate encounter with an automobile.

- Bushes in the Bay—duck blinds—begin to be repaired and spruced up with new branches, reeds, and paraphernalia. Some even have heat, cots, and well stocked bars to help take off a chill.
- Small motor boats with weeds, branches, and phragmites attached are seen moving about on trailers. These are mobile duck blinds.
- On a warm winter day, you leave to go to town and the air is clear but as you progress inland you find thick fog.
- Muskrat begins to appear on the menu of truly local eateries.
- Part-time residents (summer people), tourists, and migrant workers are significantly fewer.
- Locals consider going to the Wal-Mart on Saturdays and Sundays.
- A host of fundraising suppers are held offering up all-you-can-eat ham, chicken, beef, or oysters along with sides of applesauce, pickled beets, greens, mashed potatoes, dumplings, and the like. Almost always, clam or oyster fritters accompany the main offering and if you are lucky, you might get a local delicacy—wet cornbread.
- From November on, competitive shooting matches are held for prizes of turkeys, hams, oysters, clams, or cash.
- Occasionally you see a house or business burned nearly to the ground. Fires are a fact of life when many still use kerosene space heaters and volunteer fire departments are miles away.
- If you are really lucky, you'll see an otter or two playing in the Harbor.

Reactions of some locals to these signs of the seasons brought some smiles, with one commenting, *Ya know, it takes an outsider to see it through different eyes an' remind us of how special this place is.*

1. Community Anchors

The fierce independence of these people, their deep felt need to be self sufficient, and their isolation from more populous areas where some forms of social order were mandated, led them to reject formal governmental structures. That said, there are still some things that require collective action and cooperation.

Like other unincorporated small towns with no official government, life is structured by the organizations within those towns. The few social institutions and organizations that were and are tolerated by residents of these communities are remembered and described in this section.

THE RIGHT ARM OF COMMUNITY
An important link to the outside world, it also was, and still is, information central for the community.

A post office has continuously operated in Greenbackville since 1887. In addition to being an important link to the outside world, it also was, and still is, information central for the community. Since the early days, information about the community, its people, events, and the like has always been available at the post office.

Some of the activity there is the official business of providing addresses, selling postage, and delivering mail to boxes. Other activity is not directly postal business, but still fairly formal in nature—posting dates for events and contact persons, collecting clothes and food for the needy, and raising funds for a variety of causes.

Equally central to the functioning of a small community's post office is its role as the center for information and gossip about the health of residents, who is mad at whom about what, what kid is in trouble and why, when the new widow went to bed and with whom, whose dog died, where the rescue squad went last night, and so on.

Community Anchors

The post office came into being as a result of many folks' needs and interests; but, the prime mover was the first young schoolteacher sent by the state in the 1870s. He recognized the need for a post office but also had the motivation and know-how to file an application and lobby officials in Washington, D.C. A village had already begun to grow and "Greenback" caught on as its name. Lore has it that at the beginning of the oyster boom, a jealous inland land owner commented that the marshland that was being sold for $100 an acre was *worth about as much as a greenback* (the then-new unpopular paper currency issued after the Civil War). When the young schoolteacher completed the application and went to lobby for his post office, he tacked *ville* onto the town's name because it somehow seemed more respectable to him.

Once the federal government decided to establish a post office in Greenbackville, the question of where it would be located began. In those days, not only on Virginia's Eastern Shore but throughout the country, post office jobs were part of the patronage system (this was true until 1970). In other words, if the Democrats were in office, you could be pretty sure the postmaster would be a Democrat. Likewise, when the political tide turned, the mantel was handed over to the other party and on it went for years. One additional characteristic of the patronage system was that the post office was always located within an existing business, usually a store owned by a prominent Republican or Democrat.

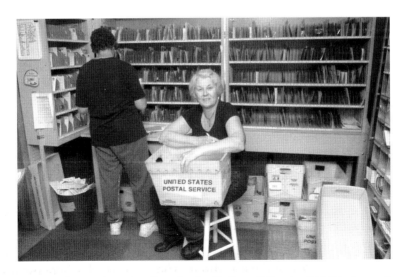

Sorting the mail in the Greenbackville Post Office in 2006 isn't much different than it was 50 or 100 years earlier. (Courtesy Brice Stump.)

Not only did this patronage system provide income for the postmaster, it also provided an additional perk—rent. Back then, the federal government could ill afford to build a post office in every little town, so the astute local politician who snared the appointed job also had a subsidy for their business because the post office would be located there and the government would pay rent.

In Greenbackville, the address of the post office moved up and down Stockton Road depending on which political party was in power. During the Roosevelt New Deal years, it was located in the Selby Store where today's post office is. During the preceding Hoover years, it was down the street at the Bevins Store across from the Union Church.

In 1969–1970 with the passage of the Postal Reorganization Act, the patronage system in the post office ended. In reality that simply meant that the postmaster/mistress was no longer chosen by the political powers-that-be. But it also meant that the Post Office Department became an independent agency of the federal government and as such could establish employment criteria, which it did. Passing a rigorous test was one requirement for a postmaster/mistress after 1970. The demise of the patronage system also led to more job security and higher salaries for postal employees. The postmaster/mistress had always been a person known to everybody in town, but now that person was in place long enough for everyone to count on them to know everyone and everything. In Greenbackville, it is the only government job and is a position of prestige.

Before and after the reorganization of the post office system, Greenbackville's mail is first delivered to New Church and then transported to Greenbackville. One of the men who carried the mail from New Church always noticed when free samples were a part of the mail being transferred to Greenbackville. If those samples were of something he liked, he sometimes failed to deliver all of them and kept some for himself. One day he was particularly taken with some samples of chocolate that were a part of the mail and consumed a great deal of it on his travels from New Church to Greenbackville. It was only later that he discovered that those *chocolate samples were really Ex-Lax.*

One postmistress longed for the old days when, she said, *The post office is there but it's not in the store like it used to be. It's not really ours anymore. Even though it's the Greenbackville Post Office it's run by Washington, Richmond, or whatever.*

COMMUNITY ANCHORS

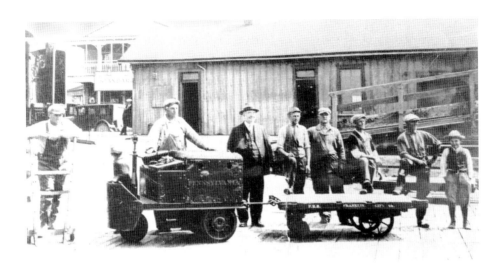

Railroad workers at the Franklin City Station waiting to unload ice and other essentials from an incoming train before reloading it with seafood and produce.

IRON HORSE OF THE EASTERN SHORE
Small villages where the rail depot was the only link with the outside world...

With any situation, to be accurate, one must go back to the beginning. And often when the investigator arrives at the beginning, it is unclear what the impetus really was for what followed. Which came first: the chicken or the egg? The tree or the forest? The horse or the carriage? In this instance, the question at hand is, what was responsible for the boomtowns of Greenbackville and Franklin City—the railroad or the oysters? Clearly, the oysters were there before the railroad; however, they were of little value until the railroad could take them to the cities where merchants and their customers were willing and able to pay top dollar for them. This is a story of the railroad that took the oysters to market, helped build two towns, enriched the lives of people who lived in the towns, and linked small and insular communities with the outside world.

The large, fat oysters were discovered by early settlers and later by a schooner captain laying over off Cockle Point. Landowners, namely Lindsay and Franklin, recognized the discovery and began to launch schemes to get rich quick—Lindsay laid out his marshland in lots that became Greenbackville. Meanwhile, Franklin convinced his fellow board members of the Worcester Railroad that there was money to be made by running a line from Snow

Hill to the Chincoteague Bay. And by the way, as the decision to extend the railroad was being made, Franklin had already laid out his town that bordered the route the rail line would take. Cronyism? Luck? Or just a cunning businessman using the system?

Origins

The main railroad on the Eastern Shore in the 1860s was the Junction & Breakwater, a subdivision of the Philadelphia, Wilmington & Baltimore Railroad. It began in Delaware around what is now Harrington and Georgetown with the main goal of reaching Rehoboth. As that railroad grew, it began to establish branches and spurs and later joined forces with the Worcester Railroad that ran from Selbyville, Delaware to the Maryland towns of Berlin and Snow Hill and on to Franklin City. This joint effort reached Franklin City where there were ferries to Chincoteague Island by April 1876—less than ten years after Greenbackville was founded. A year later the Delaware, Maryland & Virginia lines merged and were managed under the Philadelphia, Wilmington & Baltimore Railroad—later to become the Pennsylvania Railroad. At that time, the D.M.V. Railroad was the only independent rail spanning those three states with 98 miles of track. In 1882, Poor's Manual (an uncopyrighted publication compiled by H. V. Poor and H. W. Poor that was printed annually in New York from 1868 to 1924) reported that the Worcester Railroad had 3 locomotives, 3 passenger cars, 2 baggage cars, 17 box cars, 1 stock car, 20 platform cars, and 5 service cars—at that time, a very respectable inventory. These trains were the link to the outside world in terms of commerce, news, and mail.

The Section Gang

Trains came and went but it would never have been possible without the dedicated men who made sure the tracks and roadbed were sound. They not only had to patrol and fix problems, they did it regardless of the weather and before the next scheduled train arrived. *The section gang were the ones who kept the trains goin'. I remember two white men and one black one—there may have been more, but these are the ones I remember. They started out of a morning early, I don't know the time. They'd leave Franklin City with a hand car and a small trailer type car behind it. If you ever saw one of them, you'd know. It was a hand car with wheels that fit right on the railroad tracks and was moved by the ones on it pullin' back an' forth like sawin' wood to move it over the tracks. Trouble was, they had to move not only themselves and the car they was on, but also the one behind with all their supplies an' tools. The trailer car carried the replacement*

spikes, pieces of rail, ties, tools, and the like that they'd need to repair any track that was broken or loose. You go figure how much a railroad tie would weigh. An' I know that the rails themselves weighed 80 pounds per foot an' that's not countin' the tools and spikes and everything else. They were strong men! And, didn't matter what the weather . . . they went . . . no cab . . . no heat . . . sometimes, they'd stop an' take shelter at a station till the weather'd clear. An' if a train came along, they'd pick up the hand car and the trailer and put both off the tracks so the train could pass an' then they'd have to put it back on and continue their work. Even when they got to the end of their section, they still had to work the car and trailer all the way back home. They'd work from here to up to Snow Hill or Newark/Queponceco Station, probably 15 or 20 miles. Many years later, they put motors on these little cars but it was still hard work by very strong men in all kinds of weather.

The Conductor
The little girl who lived this story is now a woman in her mid-80s: *Early on, we lived with my grandparents in Greenbackville and many in my family worked on the water, but not my father. He was a conductor on the train. I remember when I was just a little kid how he'd go off to work. He'd walk to Franklin City to get on the train. He'd get everyone on and settled and then, he'd be sure he was on the south side of the train as it pulled out of the station. That way, he could always return the wave from his mother, my grandmother, who was waitin' to see him go from her back porch. He's the one that would yell 'All 'board . . . Hursley [now Stockton], Girdletree, Scarboro, Snow Hill, Wesley, Queponco, Ironshire, Berlin, Friendship, Showell, Bishop, Selbyville, Frankford, Dagsboro, Millsboro, Stockley, Georgetown—ALL ABOARD!'*

He'd be gone overnight and then back home the next day an' then he'd go again. He was gone every other night and home on Sunday. I guess I'd have to say, my mother was really the one who raised me.

Because my father worked for the railroad, he had a steady income and as far as I can remember, we always had a car. When the Depression came, there were fewer trains and his hours got cut back. He couldn't any longer go from Franklin City. He'd come to Franklin City, stay home for a day an' then, he'd have to go back to Harrington on another train to get on the one that'd bring him back to Franklin City. He taught me to drive the car when I was twelve. You know back then you were always havin' flat tires. So, there was a man in town who didn't have a car or know how to drive but my father would have him come with us in case there was a flat, and I would drive my father to Pocomoke City where the other train would come to take him to Harrington. So, I drove him to work every other day at the age of twelve.

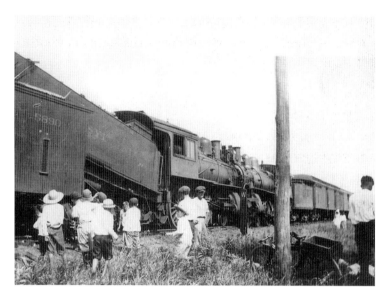

Head on collision of two locomotives in Franklin City was a sight to see—everyone turned out.

Turning The Train Around

The turning point for the train was on the Maryland-Virginia state line as the train was coming into Franklin City from Stockton (Hursley station). The turn was accomplished by the use of a "wye."

Turning on a wye, according to Steve Okonski at trainweb.org, is the technique used to turn a train around when there is no faster way. It requires a track arrangement generally shaped like the letter Y. Imagine the train coming from the bottom of the Y. The track switches are set so that the train is pulled up the left branch. Next the switches are reset so that the train can back up onto the right branch of the Y. Finally, the switches are set so the train can be pulled down to the bottom again. It is now headed in the opposite direction from when it started the process.

This process for turning the train around worked flawlessly in Franklin City except for one time. No one seems to know how it could have happened but two locomotives collided right at the Y. The northbound engine left the Franklin City Station and the southbound locomotive had not yet cleared the cutoff from the main track. The result was a head on collision.

As the oyster business fell into decline and the automobile took over, the last of the trains also brought the end of an era. Many old railroads are long

gone and forgotten but the legacy of this railroad remains. There would have been no town of Franklin City or Greenbackville or its Harbor had it not been for the railroad.

FIRED UP COMMUNITY
Seeing the need and wanting to meet that need is almost always easier than actually accomplishing what is desired.

Before the 1950s the only means of fighting fires consisted of a bucket brigade summoned by a fire whistle, plus all able-bodied men and boys in the community. This worked well for marsh fires and other small ones, but it was not effective for larger challenges.

If a large structure was involved requiring more equipment than a bucket brigade, a call was placed to nearby towns' fire companies. They were a valuable resource but often the fire was beyond control by the time they could muster the volunteers and get to the site. The neighboring responders were Stockton, Maryland—5 miles away; New Church, Virginia—15 miles away; and Atlantic, Virginia—11 miles away.

Nearly every town in rural America with a volunteer fire company has a story to tell about THE big fire. Usually that fire was the impetus for the creation of their fire company. Franklin City residents remembered the day their church burned, but that only resulted in a merger with the Greenbackville church, not a fire company. To the best of anyone's knowledge, there never was a fire company in Franklin City even though it had far more buildings and commercial establishments than Greenbackville. On the other hand, everyone in Greenbackville remembers when and why its fire company was organized.

It was New Years Day 1956 and amazingly there had been no major fires that a bucket brigade couldn't handle. Soon this was no longer true. That day there was an attic fire. Some say it was started by kids playing with candles but officially inspectors ruled it to have been started by faulty electrical wiring. Fortunately, this fire was just across the street from the canal and those in the bucket brigade were successful in extinguishing it.

The people who lived in the house that burned could no longer live there so they moved into a vacant apartment over a store on the main street until their home was repaired. That would have been the end of it.

On the last day of that same month, January 1956, an eyewitness reported, *We were in the bar that sat right where the street in front of the Post Office*

dead ends. We were in there having hamburgers—he made the best damned hamburgers I've ever had, don't know what he put in them. A local man was in there, it was sort of a hangout place. His wife comes in and wants him to come home real quick. She was kinda flustered and we hear her mention fire. They lived in that house where the service station was next to the post office. So we go there and in the kitchen, I guess she had a frying pan on the stove and, the wall behind the stove is burning. Somebody went out to call the Stockton Fire Company. We're standing there kind of looking at it an' somebody gets a bucket of water and throws on it. That's not doing anything and it's starting to get up into the ceiling. And so, I think I suggested, but I don't want to take the credit for it, we'd better get this stuff out of the kitchen because when the fire company gets here it'll make a mess of things. We took all the kitchen table and stuff out. I guess they had that room and a bedroom. The rest of the house was full of furniture that was stored there. After the kitchen, we went to the next room and the next room and upstairs and just stayed ahead of the fire. We got everything out except for a couple things right around the stove there. There was a vacant building down where the parsonage sits now that used to be a store. Once the fire was out, we put all that furniture in the attic of that store.

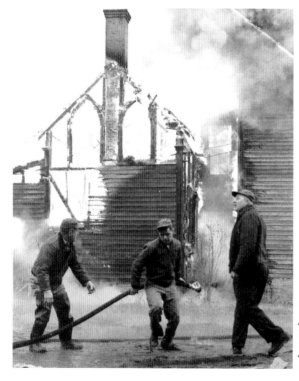

Before protective clothing, fancy trucks, and modern equipment volunteer firemen fought the blazes in work clothes and with hoses.

The vacant store where they put the furniture from the second fire was next to another store where the people from the first fire were living. The following day, smoke was seen coming from the vacant store where the furniture from the second fire had been moved. Men and boys were summoned again to put out the third fire. By the time they got there, it was too late and the building burned to the ground. It was assumed that some of the furniture from the previous day's fire had smoldering embers embedded in it and those embers emerged as a full blown fire the next day. The man and his family that had already been burned out of their home in the first fire parked their relatively new car in front of the vacant store. That night not only was the store and furniture destroyed but that almost new car also went up in flames.

After three fires in a month, residents of Greenbackville decided that relying on distant fire companies was not good enough. Soon, a group of community leaders decided that it was imperative that Greenbackville have its own fire company. It is important to remember that Greenbackville was incorporated for a few years in the late 1920s but soon gave up that notion due to the citizens' unwillingness to pay additional taxes and to one of the town's officials supposedly *dipping in the till*. Had that incorporation succeeded, it is possible that services such as firefighting would have been in place when these three fires happened in the same month. At least there would have been a mechanism to tax and fund the effort to establish a fire company. That not being the case, it was up to the informal leadership of the town to figure out how to fund and organize their fire department.

Seeing the need and wanting to meet that need is almost always easier than actually accomplishing what is desired. Until the fire company was established they *made do*. Eventually, one man donated land in the middle of town and everyone else pitched in to generate enough funds to begin buying equipment and building a firehouse. A windfall occurred when the New Church Fire Company sold the community their old pumper truck. It was in pretty bad shape but it was better than nothing. One man rebuilt the engine and others worked on getting the rust off and repainting it so it looked and ran almost as good as new. Early on, before there was a firehouse, another man made his garage available for the pumper truck when it was not in use. One person said *I always think of that garage as the very first firehouse.*

It was clear that the next major problem was to create a building to house the truck. Also, now that they were going to be real firefighters, they needed oxygen tanks, fire retardant clothing, and a host of other equipment. To the

amazement of some, members of the community put aside their differences and banded together to raise money to build their firehouse and buy equipment. Remembering those days, one of the main movers described it as follows: *We never went into debt with the bank to build the firehouse. We asked people to give what they could. We told them every quarter would buy another cinderblock or a two-by-four. When we'd get donations, we'd buy some more materials and build a little more ourselves. None of us knew anything about building that big a project. There was one man that was an engineer or something. On the weekends, he'd build the first piece and then he'd go back to his work somewhere else and we'd copy whatever he laid out. It took us a couple of years but we finally got it all done AND we did it ourselves!*

One of the first fire calls answered was a marsh fire. The adrenalin always flows when any fire whistle blows but on that day it was especially exciting. The new firemen with their recycled truck, helmets, coats, boots, and oxygen tanks ran to the firehouse, put on their gear, and headed out. They could see the smoke and flames and ran toward the marsh. The truck arrived and they charged into the marsh pulling hoses and other equipment with them. With little or no training prior to that, they did not realize the weight of all their gear or how tiring it could be to run with it. They promptly sank into the marsh mud waist deep! Quickly, the new gear was abandoned and they reverted to putting out the fire the old way. Later, they retrieved and cleaned up the equipment. Nevertheless, the new fire company was on its way—it had its first call and rose to the occasion.

RAISING THE ROOF
I love it when we go in debt. That's when everybody gets pullin' together and things begin to happen.

As with any new acquisition, the day it arrives is the final step in a long process. There is much celebration, lots of congratulation, and excitement. After the newness wears off, the never-ending, serious business of maintaining, protecting, and caring for the new enterprise gets underway. Such was the case for the Greenbackville Volunteer Fire Company and its first firehouse.

Once the firehouse was finally completed and some equipment was acquired, the need for resources had just begun. Fire trucks, hoses, axes, tires, ladders, radios, fireproof clothing, first aid equipment, tires, a rescue boat, gasoline, training, and a host of other expensive and necessary items would continue to be ongoing expenses to the fire company—and in turn to the

community. Additionally, as more trucks were purchased, it was necessary to remodel the firehouse and ultimately build a new one.

The first fire truck was a used one purchased from the New Church Volunteer Fire Company. Other needed items, often used, had to be bought as well. This meant that even though the whole community had given not only money but sweat equity to build the firehouse, and more funds were needed. At first, community members were *drained dry* and simply had no more money to give. Asking them to give more simply was not an option. So, other sources of funds had to be found.

I love it when we go in debt. That's when everybody gets pullin' together and things begin to happen—a phrase often repeated by the first president of the fire company as he described their solution. The new firemen and the Ladies Auxiliary rolled up their sleeves and began a number of fundraising activities. Petty differences of opinion, personality conflicts, and all the things that divide a community were put aside. They had a mission and everyone pulled together to accomplish it. Some of the ways they found to generate funds follow.

Trash Truck

In the early days of the fire company, someone donated a dump truck. The men fixed it up, repainted it, and went around every Saturday morning collecting trash for 25¢ per customer. Prior to that everyone kept their trash in the backyard until there was enough to burn it—not only a hazard for the environment but also a potential fire call.

The dump truck was also used at least on one occasion as a float in a local parade. It was decorated and loaded with a piano, a player, and some auxiliary members who sang. They brought home a trophy for most unique entry in that parade.

Public Dinners

Greenbackville women have many talents. One of the best known is their fine Eastern Shore cooking. The Ladies Auxiliary decided they could harness their talent as well as take advantage of the foods grown in the area. They had family style dinners, open to the public, twice a year. In March the main fare would be chicken and clam fritters and in November it would be turkey and oysters. Of course, the dinners also included several vegetables, potatoes, rolls, coffee, and a table full of desserts.

No more than was absolutely necessary was purchased for these dinners. *The more you had to buy, the less profit you'd make. So we tried to get farmers*

to give us as much as they could. We'd go to the fields and pick turnip greens and after the potato harvest was over, we'd gather up what the machines missed. It was weekend recreation to go clammin' and then we'd take them to ____ [the local seafood broker] *who'd sell them but keep a book of how many we brought in—then when it was time for a dinner, he'd give us an equal amount of fresh clams.*

When a farmer gave us chickens, they were alive. We had to kill, scald, pick the feathers, gut, and clean them. That always took a day or so before the dinner to get them ready to cook. One time, we got them on a Saturday and it was too late to fix them so we put them in an empty house across from the church. We figured they'd be OK for a day and we'd work on them all day on Monday. No one knows what happened but the next day, when we came to church, all dressed up in our Sunday best, there were chickens all over town! If we didn't catch them, they'd be gone. Church was a little late but we got every one of them and went to church too!

Watermen would bring oysters into the Harbor and they would have to be culled—broken apart, sorted by size, and put in barrels for shipping to city markets. It was a well known fact that all the oysters didn't make it to market and the rejects would be left in a pile. Several folks made extra money by recovering these overlooked oysters, shucking them, and selling them at the going rate of $1 per quart. This was also the source of many oysters that ended up in oyster fritters for the public dinners.

In the days before the firehouse was completed, these dinners were held in the old school on the second floor where there was an auditorium. The space was adequate, but the cooking facilities were wanting. Fritter mixing, potato peeling, and all the food preparation was done at the old school and then carried to individual kitchens for cooking. Once cooked, it all had to be taken back to the second floor of the old school to be served. Cooking facilities were bad but the plumbing was worse. There was no water on the second floor so to wash dishes they had to pump the water by hand at a well outside and carry it up the steps.

When the firehouse was finally finished, complete with *commercial restaurant stoves, plumbing, refrigerators, ice machine, and all* it made the public dinners a lot easier to conduct. The Ladies Auxiliary got very good at this production. The auxiliary was known for the fresh ingredients and quality of their cooking and because of that they began to *put on* or cater dinners for others such as the Ruritans and some business organizations. As one fireman said, *the women weren't interested in the actual building of the firehouse but they worked just as hard, maybe harder than we did on those public dinners that made a lot of money for us.*

Cookbooks

Compiling cookbooks and selling them was also tried. Those who have them from the Greenbackville Volunteer Fire Company have rare books. It was soon learned that cookbook production is a very complicated, time consuming, and expensive job. Also, every other group around tries it sooner or later and the market is saturated.

Womanless Beauty Pageant

A beauty pageant was publicized and folks from all around the area would pay admission to attend. Once the show started, it was clear that the beauties were the firemen dressed as women, or in today's term, drag. For the most part, the men found their own outfits, wigs, and accessories and even did their own makeup. No one saw them until the actual show and the identity of a couple of the "beauties" was never certain.

Word got around to other local fire companies and invitations began to roll in for the pageant to be conducted in other communities. They took their show on the road. How much money was raised is still unclear but they certainly made a reputation for themselves and had a good time.

Raffles

A sure sign that you are on the Eastern Shore is when someone tries to sell you a raffle or "50-50" ticket. More often than not when entering a public

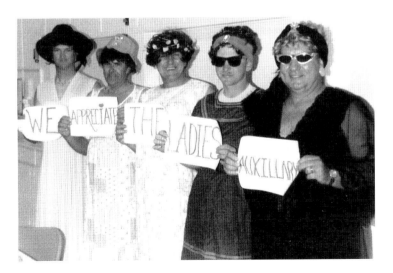

Firemen dressed for the womanless beauty pagent. They would do anything to raise money for the new fire company.

event, you will be approached to buy a 50-50 ticket. This usually means you are making a donation for every ticket you buy. Before the event is over, a drawing is held. If you win, you get half (50 percent) of all the dollars collected and the other half goes to the sponsor of the event.

Other raffles are more traditional. An item or items are usually donated to the fire company by a local business or individual. Or, sometimes, desirable items will be purchased especially for the auction. In either case, raffle tickets are printed and sold, followed by a drawing to select the winners. The fire company has done quite well with these fundraisers and has raffled Longaberger (handcrafted) picnic baskets, barbeque grills, used cars, and once even the "Community Quilt" that was made by members of the Ladies Auxiliary.

Bingo

Until recently, the first Friday night of winter months meant that firemen could be found conducting bingo games with auxiliary members staffing the kitchen. The popularity of this event waxes and wanes depending on promotion, scheduling, and competition from other activities. Another factor working against bingo is that some in the community believe that good "God fearing Methodist people" should not be engaging in what they define as gambling.

Bingo aside, everyone knows you can count on the kitchen to produce clam (and sometimes oyster) fritters at these events. Some say bingo is just an excuse for going to the firehouse for fritters.

Donations and Memorials

The fire company's most generous supporter is a businessman/farmer who lives nearby. In 1983 that man's arm got caught in a manure spreader and the arm was nearly ripped off. *I told my boys to go get my wife and then thought again and said, 'Hell tell her to call 911.' She did and they came down to the barn, where she liked to piss a squid worm at all the blood and the sight. Those boys from the fire company came in less than 15 minutes and got me to the hospital. I owe my life to them!*

The farmer has since made many generous donations in his wife's name to the Greenbackville Volunteer Fire Company. He also makes incidental contributions of both livestock and money for fundraising activities such as scrapple sales, pig pickin' dinners, bake sales, and the like. In his own words, *I've given away more than lots of folks ever made. But it's my money, I earned it so I can do what I damned well please with it. If you can't help people out when they need it, what kind of a person would you be?*

As the cost of fire equipment rapidly escalates and laws keep being passed requiring updated equipment even for volunteer fire companies, the ongoing problem of ways and means is likely to grow, not diminish. As the fire company celebrated its 50th anniversary, it is in a far different condition than it was when it was started. Though many grateful people in the community appreciate the work of the fire company and the auxiliary, only time will tell if they will support it monetarily to the extent that will be required to keep the equipment maintained and the volunteers trained and ready for action.

LAW AND DISORDER
They took care of the law themselves. Nobody went to Accomac. Accomac was far away. Didn't have no way to get there. Didn't have no telephone. So you just handled whatever came up the best way you could.

Over time, neither Franklin City nor Greenbackville residents have been big fans of laws, government, or for that matter, anyone telling them how they should lead their lives. Consequently, laws and law enforcement were often given short shrift by the residents of these communities. Anyway, enforcement sources are too far removed to have much clout. The county seat, Accomac, is more than 40 miles to the south and the state capital is nearly 200 miles away. Therefore, justice in this part of the Eastern Shore is clear and swift but for the most part administered by citizens themselves.

Greenbackville had a policeman and a jail for a few years in the 1920s when the town was briefly incorporated. In less than a decade, the town became unincorporated. One reason the incorporation ceased was because of the unwillingness of residents to pay the extra state tax to be incorporated. Another reason given was that a member of the town council absconded with the town's funds. Either way, there has been no formal law enforcement since then other than a very occasional visit from the Accomack County Sheriff's Office based far away in the county seat of Accomac.

On the water it is a different story. The Harbor is managed by a committee and a local harbormaster who enforces the necessary rules and laws to maintain order and access. A previous harbormaster was known for many things, including the .44 pistol that she was licensed to carry. The idea of its use and her announced willingness to do so were reported as deterrent enough. The Coast Guard and state Division of Natural Resources (DNR)

patrols the Chincoteague Bay and nearby ocean waters and also serves as the law enforcement authority on land. Today, the DNR water cop lives in Greenbackville and is well know and respected by all.

Local Justice

The ways of this world were explained as such: *When I was comin' up, people didn't say much to outsiders—police and such. The law then was, if you had problems, there wasn't any complainin' to anybody. See, like if you had your boat down here, what they would do, is each man had a certain place for his boat. Everybody did and you knew where it was. If you came in and maybe you were drinkin' or you had a fuss with me and thought 'I just want to spite him' you'd park your boat in my place. And I'd come in and your boat'd be in my spot, an' I'd go to you and say 'Hey you got your boat in my place. Now move it.' If you said 'I'm not goin to move it,' a lot of times if this happened, they would run right into your boat and sink it.*

They took care of the law themselves. Nobody went to Accomac. Accomac was far away. Didn't have no way to get there. Didn't have no telephone. So you just handled whatever came up the best way you could.

The Jail

During the short time that Greenbackville was incorporated it had a law enforcement officer and a jail—the storage room in the back of a store. *That little room at the back of the store had some bars on it and was a real small room. It had a door that locked up and that was about all that was there for a jail.*

All the officer needed to do was apprehend the perpetrator, put him in the storeroom, and lock the door from the outside. Seldom was the jail used for anything other than a drunk-and-disorderly offense. The offender was released the next morning, usually with a large hangover as enough punishment for his errant ways the previous night.

The jail, seldom used, stayed in existence until *one night the boys were a drinkin' and the owner of that building—well he just sold off the jail right there at the bar. An' after that we didn't have no jail!*

The Town Cop

There was only one cop and for a short while at that: *I knew the town cop. He was my grandfather. He was a soft spoken man. He didn't talk much and was easy going. His years as a paid cop weren't many but he was always called Cop _____. He was a very tall, big, strong man. He wore regular clothes like everybody else but he had a policeman's hat, badge, and nightstick. I once asked*

him *'did you ever have to use that nightstick on anybody?'* The answer was *'No, son, I never did. I'd just take 'em by the arm and lead 'em back to that storeroom and lock 'em up overnight, then I'd let 'em loose the next day. Most of those fellas were from Chincoteague who came over by boat and got a little drunk on a Saturday night.'*

ON MY HONOR
It communicated to these small town boys that there is a world beyond the Eastern Shore.

The local Boy Scout troop had a dedicated adult leader who gave the boys lots of support and introduced them to new experiences. From tales told, a real understanding of the value of setting goals and achieving them was an important lesson he taught over and over again through scouting projects. By all reports, he seemed to understand that, as a war veteran, he was a role model for the boys.

Boys who were rough and tumble got awards for their strength and toughness. Boys who were good with less physical activities won awards for the neatness of campsites and the quality of campfire cooking. Every scout

Girl Scouts with uniforms got to stand in front even if hand-me-down uniforms didn't fit too well. Those square knots never did turn out the same!

seemed to be recognized for what he did best. Adults who worked with the troop managed to give credit to each scout for his contribution. They seemed to have made it clear that skill in building a fire and keeping the camping area tidy was valued no less than hunting and fishing.

As with most organized children's activities, this one required a lot of adult input. The leaders of this troop worked with the pastor of the local church and, through their work with the scouts, one year the whole troop—*every boy, got a God and Country scouting award at the same time.* This is an award viewed as second only to an Eagle Scout award. It was a big deal to these boys and still is something they are proud of even as adults.

The boys went to scout activities away from home. Some got to go to Camp Rodney, between Easton, Maryland and Seaford, Delaware. One boy even went to a scout program in Arizona. Exposure to other boys from other places was important because it communicated to these small town boys that there is a world beyond the Eastern Shore.

Those who brought up the topic of scouting, some more vehemently than others, believe they learned important life lessons as boy scouts. One even said, *It gave me role models other than the waterman, hunter, or rough and tumble outdoorsman. It showed me that I could be a compassionate, artistic adult with strong values and that it was all right to choose a life of service to others.*

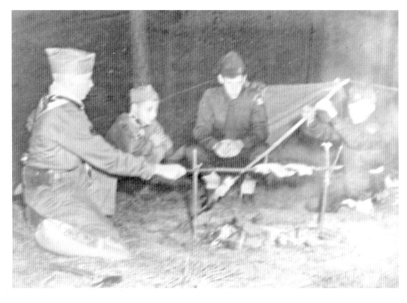

What's for dinner? Could be fish or game that the Boy Scouts caught themselves.

Only one person interviewed mentioned Girl Scouts. She fondly remembered scouting activities including trips, earning badges, and even going on campouts at nearby Cockle Point.

COMMON TOUCHSTONE
To those who joined the church and believed in its teachings, religion dictated lots of things beyond church activities.

The Eastern Shore of Virginia historically has deep Methodist roots. There were circuit preachers who had responsibility for three or more congregations and would ride between them to conduct services each Sunday and also to service the faithful during the rest of the week. Circuit riders disappeared once a town had enough population to support a full-time preacher. Preachers with multiple congregations reappeared as the population dwindled in these and other nearby communities. At the time this book was written, the minister of the Greenbackville United Methodist Church also had responsibility for the Signpost United Methodist Church about six miles away.

In the heyday of these two towns, there was greater diversity in the population; consequently, the interests, businesses, places for leisure pursuits, and churches were more numerous and varied. There are records of at least three churches that served residents of Franklin City and Greenbackville—a Methodist church in Greenbackville and another in Franklin City and a Baptist church in Franklin City. Today there is only one. Today's church membership mirrors the population but only 25 percent of the nearly 200 residents of Greenbackville are active in the church. Nevertheless, the church constitutes one of only two organized social institutions in Greenbackville, the other being the fire company.

The church activities at various times included Sunday services, bible study classes, Sunday night prayer meeting, Methodist Youth Fellowship, and vacation bible school in the summers.

In earlier days, and perhaps even now when they happen, the Sunday night prayer meeting was run by the lay leaders of the church. During these meetings, the organist was present sitting at the organ, with his back toward the assembled group. When the final prayer ended, the organist would play a hymn and the prayer meeting ended on that note. The organist's cue to begin the final hymn was the "amen" of the person offering the prayer. One man who was a lay leader really liked to pray for the group and was notoriously long winded in his prayers. One night he was especially long winded and

his prayer seemed to go on forever. The organist kept waiting and waiting for the amen so he could start the final hymn. Finally he heard it. As he put his hands out to play, he heard the lay leader say *Oops, I forgot something.* That would result in another seemingly interminable prayer tacked on to the previous one plus some degree of repetition. Finally at the conclusion of the second prayer, the lay leader said *And we thank you Lord for the million dollar hands of our organist. AMEN!*

There are several memories of preachers. One was of a man of the cloth who sought to increase his flock by frequenting the beer hall. One person interviewed said: *He would go down to the beer hall. He never asked a soul to come to church. He'd order up a co-cola an' he'd sit there where they were drinkin' their beer an' playin' pool an' he'd drink his co-cola. An' he would say 'Nice bein' with you guys, if you ever decide you'd like to meet me at church, come see me." And a lot of 'em started leaving the beer hall an' goin' to church.*

Another long-time preacher in Greenbackville was a very *strict and staid man.* He was an old-time preacher in a more modern era, but is credited for *practicing what he preached.* He preached against the sins of alcohol and tobacco. When television was so new that people of the town congregated to watch television in the few homes that had them, the preacher would often join the group but when an advertisement for beer or cigarettes came on he would always turn his head away from the screen so that he would not see it. He knew that he had a reputation for being very strict but he didn't let that stop him from coining the word *satanized* eggs. With a small smile he would explain that he was not about to give the devil credit for those delicious eggs that showed up on almost every table from time to time. Another of his coined words was *carn-evil* which he used in the place of carnival. He was especially opposed to such pleasure seeking events, especially Chincoteague's Pony Penning Carnival held across the Bay every year. In spite of his strictness, he is reported to have worked closely with his flock, especially the children.

The preacher during the 1962 flood is remembered for his actions at the height of the crisis. When the town was covered with water and everyone had been evacuated, he really wanted to see how much damage had been done and was also just plain curious. He didn't own a boat because such a possession was way too extravagant for a preacher to own. (When and if he got paid, it was often in seafood or other items for his table rather than cash.) Being a problem solver, the preacher simply commandeered a come 'ere's boat and set out to tour the town by floodwater. In other circumstances it might be called stealing but it was all in the name of the Lord.

To those who belonged to the church, religion was used by them as the rationale for condoning or disallowing behaviors across the board. Sometimes it was a bit of a stretch. For example, there was a young girl who loved paper dolls: *On Saturdays we'd go to town and my favorite thing in all the world was to go to Newberry's and get a hot fudge sundae for a quarter. Every time I'd get any money for a birthday or something, I'd cherish that money till I could spend it. So I would always buy paper dolls if I had enough money after the hot fudge sundae. It would be late on Saturday night when we'd get home, so Sunday I'd want to cut my paper dolls out. If I was at my Grandfather's house, my aunt, who kept house for him after his wife died, would get after me for using those scissors on Sunday. Scissors were for work and you didn't work on the Lord's day.*

Interestingly, the rules about what could be done on Sunday varied depending on who was the preacher. During the reign of one pastor, the playing of baseball on Sunday was forbidden. When he left and was replaced by another, baseball on Sunday was deemed a fine use of the Lord's day. Some say the real story is that the pastor who forbid Sunday baseball had no children while the one who allowed it did have children; whatever the reason, there was a long stretch of time when there was no Sunday baseball in Greenbackville.

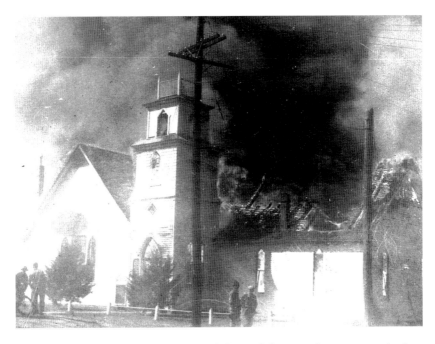

The Franklin City Methodist Church burned down and was never rebuilt.

Several people have suggested that it was the women and children who were most actively and willingly involved in the church. One man said: *It was seen as kind of unmanly to go to church. So to show their manliness, many of the men who were made to attend by their wives didn't stand or sing during the services.* This observation rings true on some counts but is contradicted by the mention that the men's bible class that met in the back of the church was pretty well filled every Sunday. The person who observed that also noted that *the Young Ladies Bible class that met in the choir loft included his grandmother who was well over 60.*

The Greenbackville church (now call Union Methodist because it merged with the Franklin City Methodist Church that burned to the ground) is an institution that has endured. It is a fixture in the geography of the community as evidenced by the way directions are given *(from the church you turn right or left or whatever)*. However, possibly most important is that the church is the common touchstone of most long time residents—even if they weren't churchgoers they went to weddings, funerals, dinners, or bazaars.

OFF TO SCHOOL
Most of those interviewed had little to say about school other than they were happy to have any reason at all to not be there.

The Greenbackville School closed in the early 1900s. From then until around 1940, children went to elementary school in New Church. Then, sometime around 1941 children started going to elementary school in Atlantic and that lasted until around 1962. Next, the children were bused to the North Accomack Elementary School which later was renamed Kegotank Elementary. All of this is by way of saying, though there hasn't been a school in Greenbackville in a very long time, there was always a school that children were expected to attend. After the early grades, the only high school that anyone remembered was Arcadia High School south of Oak Hall and approximately 20 miles from Greenbackville.

The School Bus
If you asked a person who grew up in rural America what they remember about school, most will come up with at least one story having to do with school buses. In fact, many remember more about the bus and what happened on it than they do about school. One man remembered getting on

Greenbackville School early in the 1900s with a surprisingly large number of students.

the bus as it came into Greenbackville. Actually, he lived on the Maryland side of Stateline Road and therefore should have gone to Maryland schools. But his family believed Virginia schools were better than Maryland's. His parents were always known to be very private people in the first place; but, this skirting of the law caused them to be somewhat more clandestine with any public records that would identify their address. Consequently, they had no phone because the phone book would have listed an address. His parents enrolled him in Virginia schools by simply saying he lived just outside Greenbackville, which was true. Back then, there were no official names for roads or 911 addresses. He, along with a few other students from Chapmantown and nearby houses on the other side of State Line Road in Virginia, got on the bus as it went down the Virginia side of the road toward Greenbackville. As the loaded bus left town on the Maryland side of the road, they passed his house in Maryland.

Because he was already on the bus as it passed through Greenbackville and Franklin City, he could tell you every stop and every student who boarded the bus in Greenbackville or Franklin City. *What happened on the bus was that everybody claimed a seat and it was a proprietary issue. You made sure you*

sat in your seat and didn't trespass. I remember a girl, who had that quality of not belonging, getting on the bus toward the end of the run. I remember her going up and down the aisle of the bus asking for permission to sit down and no one allowed her to. When she came to my seat, I gave her permission to sit down. It was a memory that stuck with me and I sometimes wondered what had become of that girl. I was really happy recently to meet her again. She was this nice and happy lady but I remember when she didn't have an easy way to go with the other kids.

Playing Hooky

The first person interviewed for this book remembered an incident of truancy. *When my two girl friends and I left home that morning, we really planned to go to school but somewhere on the bus ride from Greenback to New Church, we decided we'd just go visit one of the girl's aunts who lived in Marion Station instead. We rode the school bus to New Church but then we hopped off the bus and went away from school as fast as we could. We took the train to Marion Station and had lunch at my friend's aunt's house. It was a lot of fun. Then, we went by the train back to New Church and got there just in time to catch the school bus home. We thought we had gotten away with skipping school. What we didn't know was that the bus driver saw us go away from school in the*

Teachers of Greenbackville students at the school in Atlantic, Virginia were a dedicated, if sometimes unappreciated, lot.

morning and reported us to the principal. We were in big trouble—or at least we thought we were! The next day, the principal called all three of us in. He suspended each of us for two days and insisted that each of us tell our families what we had done and what punishment we had been given. I remember how scared I was about telling my family but I knew I had to do it. I was surprised that telling them wasn't so bad. I told them exactly what we did and promised never to do it again. They weren't happy but they weren't real mad either. I'd do it all again—the adventure and the memories it gave me were worth those couple of days away from school and the embarrassment of my friends and family knowing what I had done.

Skipping school was not an uncommon activity. One woman said: *I don't know how it got started but me and my girl friends skipped school every Tuesday. As I think back, I really don't know how we decided that but we did it. Parents didn't much care if you went to school or not. Some boys'd say they got one day off from school every week to work on the water; the school didn't give them that day off—they really just skipped school and nobody cared. One kid in Greenbackville skipped school for a whole solid year before he got caught.*

Schoolin' was not a priority. You didn't need book learnin' to be a waterman; you needed to be out there on the Bay learnin' from your Dad. School didn't have anything to do with what was goin' for us.

Schooling was not a high priority for most residents of the area. A very few were able to get enough schooling to go on to college and other ventures. Most of those interviewed had little to say about school other than they were happy to have any reason at all to not be there. Memories of a favorite teacher, a special lesson, homework, projects, programs, or even school-based extracurricular activities such as band, sports, and the like simply were not important enough in the lives of those interviewed to be among the first things they remembered.

2. SALTWATER CHANTEYS

Without Chincoteague Bay, there would have been no oysters. Without oysters there would have been no watermen. Without watermen and their families there would have been no train, no houses, no commerce, or anything else. There would have been no boats, no docks, no trot lines, and no Greenbackville or Franklin City.

For those who lived in these communities the Bay was, and to some extent still is, a source of income, a catalyst for business, a place to meet friends, a playground for kids, a courting destination for teens, and even a quiet spot where older folks can enjoy a sunrise.

As such, tales of life and work on the Bay are plentiful.

WORKING THE WATER
No waterman could afford to be exclusively an oysterman, a clammer, or a crabber. They all fished all three of the major catches depending on the season.

The real heyday for Chincoteague oysters was during the late 1800s and very early 1900s. During this time, the boomtowns of Greenbackville and Franklin City thrived thanks to bivalve gold. Even though native Chincoteague Bay oysters were gone by the 1940s due to overfishing and disease, there was a second period of economic viability into the 1950s and 1960s that resulted from planting seed oysters.

During this mini-boom, adult oysters and spat (baby oysters, also known as seed oysters) were transplanted by owners of the oyster/clam houses who rented their oyster beds or *rocks* from the state—all oyster beds in Virginia are owned by the state. Some transplants came from small bays near the ocean to the south, known as *down the Bay*. Others were transported nearly 100 miles from the James River, by *a run boat pullin' two monitors* (wooden barge-like boats) *all the way up the inland waterway from down by Norfolk*. The stay of these itinerant oysters in the Bay allowed them to be marketed as Chincoteague oysters and also gave them a saltier taste than oysters from

other areas. *Good* (fat, salty, and large) *seaside, or salt oysters*, as they were called, would rest and fatten in the Chincoteague Bay for two to three years before being harvested. Of course, this business like any other had those who would cut corners and harvest them as soon as they had been in the water a few hours or days. Nevertheless, when a menu or sign in Baltimore, Philadelphia, or New York read "Chincoteague Oysters," these transplants brought top dollar.

In order to bring this high priced commodity to market, it had to be harvested. This was done by several fleets of work boats harbored in Greenbackville, Franklin City, and Chincoteague as well as other smaller places around the Bay. Some of them went out daily while others would stay out for several days. Either way, they brought their catch back to sell to one of the shucking houses or to a broker who would in turn sort, put them in barrels, ice them down, and send them to the cities by the Delaware, Maryland, & Virginia Railroad that came to Franklin City.

No waterman could afford to be exclusively an oysterman, a clammer, or a crabber. They all fished all three of the major catches depending on the season. One waterman reported that he *oystered* in the mornings for the oyster houses and clammed in the afternoon for himself. He would then sell his afternoon catch directly to buyers from the northern markets. In the summer, when oysters were not harvested, many watermen were crabbers. Until the middle of the 20th century, crabbing involved a mile or more of trot line with bait of bacon rind, tripe, or *hog chock* (cheek) every 18 inches. The boat maneuvered along the line with a waterman armed with a hand net to scoop up crabs hanging on the bait.

In the early days, the quickest way for a waterman to get paid was to sell to a shucking house or a broker. The houses' employees (mostly women) shucked the fresh catch into the gallon oyster cans that are collector's items today. The cans were then iced down and shipped to market. In those days, there were said to be 14 such businesses in Greenbackville and Franklin City.

Another way to get immediate cash was to sell the catch to a local broker. The broker was then responsible for getting the seafood to market either by rail or highway. Until 2000, there was a local business performing this function at the end of the Greenbackville Harbor. In the early days of this business the owner and his wife would truck seafood to Crisfield where it was picked up by boat and shipped to northern ports. Later, trucks came directly to the Greenbackville Harbor to pick up seafood from the broker there. Both these methods brought immediate cash to the waterman but because there was a middleman, it was always less than if you sold directly.

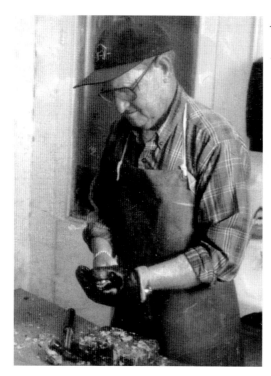

A native shucks oysters with his "holding hand" protected by a very thick rubber glove.

A risky method of getting paid for a hard day's work on the water was to ship the catch to market yourself. When a boat arrived back at the railhead, the sorted catch was off-loaded to the Delaware, Maryland & Virginia Railroad and sent on its way to Baltimore and Philadelphia as well as to such places as New York's Fulton Market. At this point the work was done, but no payment for it had been made. If the merchants in the markets were honorable, in a couple of weeks a check would arrive by mail to pay for the seafood shipped. Often, the check received was far less than it should have been because the merchant claimed the barrels weren't full or a number of oysters had died by the time they were delivered. Being hundreds of miles away from the markets, there was little a waterman could do to investigate the problem or get the money he had earned. Revenge and boycotts were the only answer. If checks for less than expected arrived consistently from the same market owner, the waterman could simply choose to no longer supply that merchant. If it was bad enough, his fellow watermen would join in for an old fashioned supply-side boycott of all the merchants in a particular market. Merchants can't sell what they don't have, so a new agreement would be reached; soon, the checks would arrive in the correct

amount and in turn fresh seafood was delivered. That is the way the system is supposed to work, but sometimes the watermen simply gave up out of despair. For example, one ex-waterman explained: *They told me I was a legend in my own time. I could get out and get a boat load of crabs in less than a half hour. That's nice but it doesn't pay for raisin' my kids or put food on my table. Now, you can't get crabs till April 1 but we didn't used to have certain dates when you could start workin' on the water—if you could get the crabs you could sell 'em. In the spring, when the frogs are hollerin' for three nights in a row, the crabs'll be crawlin'. Back in 1970, I had 240 pots in and even tho' it was late March the frogs were hollerin'. I was pullin' out about 80 bushels a day and it was still cool enough to hold 'em over a few days. By the end of the week, I had 465 bushels of crabs to sell. The boys in Crisfield were still doin' oysters and said 'Don't bring 'em over here, we can't handle 'em.' So I hired Tidewater Express, a trucking firm out of Chincoteague, and they carried those crabs all the way to Fulton Market in New York City. Two weeks later, I got a check in the mail for $93—$22 of it went for gas and gloves, $37 for bait, and that didn't even count what it cost to hire the truck. The next day my 36 foot boat, the drudge, and all my equipment was for sale and I went to work as a security guard at Captain's Cove.*

As in many other industries, those who put into motion a whole chain of economic events, in this case watermen who catch the seafood, end up earning only a small fraction of the price paid by the final consumer. Continued operation of this principle over time, along with other factors, eventually contributes to the downfall of a business.

They were watermen because they loved the independence, the pride of the catch, and their ability to find the seafood and run the boat. Their lives were centered on the water.

KEEP WHAT YOU CATCH
If you put the gas in the boat and spend the time and effort to go fishin', you're pretty well gonna take what you can get.

Fishing is always an adventure and what shows up on the end of your line is always a surprise. In the early days, one did not go fishing, crabbing, or clamming for fun—it was to put food on the table or up for sale. As long as whatever was caught was edible, it was fair game. This basic principle is still followed by those who put out from Greenbackville to catch fish. Yes, there are game wardens, locally known as *water cops,* and

legal seasons for different types of fish. But, *you can bet your bottom dollar that if it's edible, what comes in the boat in the morning will see the fry pan before sunset.*

As the crab population has declined, each year new rules are made about what size a *keeper* has to be. That size, point-to-point on the back side of the shell, has ranged from four to five-and-a-half inches. Water cops enforce these rules among commercial crabbers and *chicken-neckers* alike. Many recreational crabbers strangely believe chicken necks are the best bait and are labeled by locals as *chicken-neckers*. On the other hand, commercial crabbers know that bunker—lightly processed junk fish sold in bulk, is the best bait. Either way, those who crab regularly, especially watermen, can pretty accurately eyeball a crab and tell if it is big enough to keep.

A commercial waterman could have as many as 150–300 pots in the Bay at any one time. Every other day or so during the summer, he goes by boat to collect his catch. This means pulling the pots out of the water one at a time, emptying the contents on the culling board, re-baiting the pot, sorting the crabs by size, and tossing the pot back in. By the time 150–300 pots are emptied, re-baited, and re-deposited in the water, the waterman and his boat have been in one place for a fairly long time. Long enough for a water cop, if he chooses, to spot him from afar and come see if the catch is legal.

There was one waterman who—through bad luck, ignorance, or just plain Eastern Shore stubbornness—was always in trouble with the water cop for keeping crabs that were smaller than the legal size. The water cop, being a resident of the community and understanding that mistakes can be made, and believing the man needed the money, only gave a warning the first few times he caught him. With everyone talking about the water cop turning his head the other way, he had no choice but to give the man a ticket the next time he caught him with undersized crabs.

The following week a second, higher priced ticket was issued for the same reason. The man's friends told him, *You know better and you're gonna push it too far.* And that he did—the next time it was a summons to appear in court. The judge asked why he continued to violate the law when it would have been simple to measure the crabs. True to the unwritten waterman's code, you keep what you catch. The waterman replied, *I just ain't got the heart to let 'em go!*

Many a waterman and recreational fisherman has been in the same boat as the guy who just didn't have the heart to let 'em go. He has caught a nice fish and really wants to keep it. As the legal size of the catch goes up the

amount of fudging and finagling to keep fish that are less than legal size grows. Flounder are a prime example. For a long time there was no law governing the size of flounder you could keep. About 10 years ago a legal founder was 13½ inches long. In 2005 it was 17 inches. But there are some tricks in every trade and every local fisherman worth his salt knows that you can make a flounder a little longer by stepping on it. Check it with a ruler—you can make a flounder appear a half-inch longer just by using your foot. Also, if you have a flounder that might not be long enough to be legal, you keep it submerged in your cooler in nice cold water. Don't leave it anywhere where it might dry out—it will shrink up for sure. A perfectly legal flounder can become an illegal one after it's caught if you don't keep it good and wet.

There are lots of tricks involved in keeping what you catch. Just don't get caught by a water cop with an undersized catch. They don't buy that you didn't have the heart to let it go.

RAFTIN' IN THE WINTER
It's blowing a fierce east wind and rainin' thick—ice, sleet, and a little snow but its not so cold or the Harbor so frozen over that you can't fire up the boats and go 'drudge' some arsters.

Oysters are around all year, but in the warmer months of summer and early fall they are *poor*. Poor is a condition resulting from spawning, which makes them less plump than usual, not sweet or salty, and *milky*. Most agree they are wonderful to eat anytime from September to March, but after that, they are not so good and are not in season. That natural condition of the oysters plus the fact that a century ago in rural areas there was limited electricity and refrigeration meant oysters should be avoided in the warmer months. Cold weather provides a natural cool environment that is critical to fresh seafood. That said, there are many stories about practices and events on the water during the nastiest of weather. Interestingly enough many of the tales have a great deal to do with alcohol consumption.

It's blowing a fierce east wind and rainin' thick—ice, sleet, and a little snow; but, its not so cold or the Harbor so frozen over that you can't fire up the boats and go 'drudge' some oysters. That is indeed what the fleet of 12 or 13 workboats harbored in Greenbackville in the 1940s and 1950s did on blustery winter days. Work began well before dawn. That meant the men were pulling and hauling hundreds of pounds of shells out of the water by hand each time the

chain bag of the dredge was full. These men were amazingly strong to be able to lift such weight several times an hour for a whole day. When questioned about this, one with experience said, *Yes, but we did a lot of slightin' too.* In other words, they capitalized on the principles of momentum, leverage, and the use of inclined planes. Once the catch was on board, junk (shells, fish, and other non-marketable items) was identified and thrown overboard. Then, the catch was sorted by size and type. In later years, this process was mechanized but many oysters and clams were harvested with nothing more than sheer brute strength.

Regardless of whether the boat was equipped with a side dredge or stern dredge, as it was pulled to the boat by a winch there was water flying everywhere. If the bottom was especially muddy, the chain bag would be dunked several times to wash off the mud, causing more splashing. This was all done on the rear quarter of a workboat or near the stern. At that location, there was a culling board for sorting the payload of the dredge. The culling board hangs half in and half out of the boat or is simply a make-do table inside the boat resting on its *ceiling* (Landlubbers would call it the floor of the boat but it actually is the ceiling of the bilge).

If there was strong wind astern or the boat was rocking, more often than not, the mate and boys doing the sorting would *take a sea* getting nearly freezing salt water down the back of their pants and everywhere else. This typically went on until mid-morning but on one particular day, a couple of boats decided they had *taken enough seas* for the day and dropped anchor to rest and warm up. *We'd pull off to the side of the beds the fleet was workin' an' raft up our boats* [landlubbers would recognize that as tying up together]. *Purdy soon, another boat sees us and comes on over. Before you know it, all the boys out there are all rafted together. Before too long, someone decided that it would be soooo much nicer if we had some of that bootleg whisky to warm ourselves up. Being in the middle of the Bay, we were really much closer to Chincoteague than Greenbackville. Besides, you could always get bootleg whiskey in Chincoteague. The fastest boat slipped her lines and headed for Chincoteague. We didn't get home till much later that night. Not much profit for that day but everyone felt good about it except those who weren't there.*

The above tale was told by a then-boy on one of the boats. He said, *We took a day off from school each week to help out on the boats. We didn't get paid . . . that's just what you did and were expected to do. We didn't mind missing a day of school at all. If it was a day when one of the famous Chincoteague trips occurred it was an extra bonus!*

BOYS ON THE BAY
Boys still play on the water but few of them work with their watermen dads as they did years ago.

Better Than School

Most older men in the community remember school days less than favorably. They said it was expected that students would miss a day a week to work for parents or others. Meanwhile one woman said it had nothing to do with work, they felt entitled to a day a week off. Either way, in the minds of many, that extra weekday when school attendance was not required was the best day of the week.

It was different from the others of getting' on the bus, goin' to school, sittin' in classes and wishin' I was somewhere else doing almost anything else. This was the one day of each week when I was allowed to skip school and work on the water. On the days on the water, I had no trouble getting out of bed and by 4 a.m. I was dressed and ready to work on my dad's boat. We'd set out to the oyster beds in the Bay. The boat was long and low slung with a small cabin that had a boat stove, steering wheel, engine, and gears to control the drudge.

By 5 a.m. we'd be at the beds and ready to begin taking up oysters. We'd expect 100 bushels of oysters to be harvested a day. The owner of the boat steered from either the cabin or wheel near the stern while one or two men or older teenagers hauled in the arsters that the drudge had unearthed. Smaller boys on board sorted the shells by size, got rid of trash that came up with the haul and performed general "go-fer" jobs. We'd work from the time we got to the beds until around late morning. By then, a day's work was done and we'd got our 100 bushels for the day. By the time we came back in, unloaded, cleaned the boat, put stuff away, and made ready for the next day, it would be afternoon.

The boat owner was paid by the oyster or clam house where he sold the catch. Most other watermen and crew members didn't get a pay envelope with cash in it. Many were family members who were simply expected to help on the boat. Others were repaying debts involved in some sort of barter arrangement. For the younger crew members there was certainly no money involved. For them, a day off from school and being in the presence of men was quite enough.

Icing on the cake for the boys who had worked on the water all morning was that they had the opportunity to go hunting in the afternoon. They would walk the three to four mile shoreline from Greenbackville to Sinnickson's Swan's Gut Creek—pretty much the shoreline of what is now Captain's Cove. On the way, they would flush some ducks and shoot them. Different

from today's duck hunting with blinds, boats, and fancy equipment, this was simply known as going to *jump shoot ducks*. Although the boys received no pay for their morning's work on the water, by hunting in the afternoons they got to bring something home for the table.

I Built My Own Boat

Boys not only worked on the water, they also played on it. It was a central part of their everyday lives and occupied many an hour.

When I was about 12 years old I built my own boat. It had a flat bottom and was about six feet long and about three feet wide. The sides were only about eight inches high. I put it together from scrap lumber and nails. I had lots of fun with it. My dog Trixie and I would get in that boat and paddle out into the Bay. The sides weren't very high so we usually got swamped. When we did, Trixie would swim in to shore and I'd paddle in if I could or just pull the boat in and we'd do it all over again.

One day my Dad and I were takin' a houseboat over to Pope's Bay for a paying customer and I managed to put my boat on board. I had a little outboard motor for the back of it—don't know where I got it but I know I had one. Once we got over there, my friend and I put the motor on my little boat and the two of us had a ball. We ran around in Pope's Bay all day. So near the end of the day, we pull up to the dock over there and we killed the motor and the whole stern just falls off. The vibration loosened the nails and once the engine stopped pushing the stern the whole thing just let go. So I took the pieces home and rebuilt it.

A Father and Son's Relationship

Some days I just liked to devil my dad. He had a big boat shaped like a banana with a cabin in the middle, a 'shit house' cabin is what we called it, and you had to walk through the cabin to get to the back of the boat where the motor was. My job was to tend the motor. My dad would signal me with his hands to tell me what he wanted me to do. We always went out about 4 o'clock in the morning when it was still dark.

One day, we got on the boat and Dad said 'take the lines off.' I sort of did what he said. I untied all but the stern line. So he gave me the signal to push her off, so I pushed the bow off a little bit and started the motor and put it in gear and she didn't go nowhere. We did that a couple a times and all at once he realized the stern line was still on. He yelled 'Boy, you ain't untied that back end.' Fortunately for me he couldn't get to me very easy on account of the cabin. Sometimes I'd just intentionally do the opposite of what he signaled me to do. I made a habit of doing this only when we were around other watermen. One

finger up meant speed up. Two fingers slow down. We'd be gettin' near a buoy and I knew he needed for me to slow him down. He'd give me the sign and just for the fun of it I'd speed him up. He'd scream 'Wait till I get that boy docked. I'll wake him up.' There was so much to do when we got in he usually forgot all about it.

Then, there was the morning when I really did not want to go out crabbing at 4 am. I got up and when we got to the boat it was still dark out. I went to the stern and went through the motions of starting the motor. My Dad was in the bow and, again, remember that cabin was between us. I didn't untie the stern and I didn't choke the motor the way I should have. So it sputtered and coughed like I knew it would and then just to convince my Dad the motor was broke I pounded on the side with my bare hands and it made a terrible noise. Then, I put her in neutral and revved that motor to make lots of smoke an' sure enough the boat didn't go nowhere. I told my Dad 'Well the motor went up. We can't do no crabbing today.'

The friend of the teller of this tale later told his version of the story's end. *We were supposed to go out that afternoon and play but we couldn't find him. Next day, he said 'Dad took me home an' put me in the closet an' locked me up the whole day long.'*

Boys still play on the water but few of them work with their watermen dads as they did years ago. For one thing, few of them have dads who are watermen. Nonetheless, most of the boys (and many of the girls as well) grow up knowing how to back a boat trailer down a ramp, maneuver a boat in close quarters, and otherwise handle a boat. Maybe it's in their genes or maybe those boys who did go out with their dads and who are the fathers and grandfathers of today's younger generation simply taught them the tricks of the trade from their earliest days.

TOOLS OF THE TRADE
It is difficult to make a living by working on the water.

On the Eastern Shore when you say *waterman* you're referring to a man whose livelihood depends on the Bay, in this case the Chincoteague Bay. A waterman depends on his will and skill but also on the availability of the Bay's seafood, the boats and tools required to bring in the catch, marketing and transporting the catch, and all the people who work together to support any one of the above.

Boats

To understand the world of the watermen, you have to get a feel for the tools of their trade. Three kinds of watercraft with many individual variations played a significant role. *There's only really two kinds a boats 'round here—bateaus and scows. Bateaus are pointy at the bow and scows are square on both ends.*

You can always tell a scow 'cause it's squared at both ends. Most times it's long and skinny. Way back when, scows were poled but now everybody uses motors. That's what I started with—a scow. I'd pole out and tong oysters by hand. Nobody does that anymore. Now they all got motors and workboats with drudges and sortin' boards. When I started it wasn't so fancy.

The watermen of these parts were pretty ingenious about using their scows. They needed the boat for transportation to their oyster beds or clamming grounds, but once there, they needed a platform for their work. They accomplished both purposes with the use of some heavy line and poles. *When we got out to the beds we'd tie up.* When asked how he tied up in the middle of the Bay, he explained: *Well see, we had two holes in each corner of the deck of the scow. We put a line [a piece of rope] through one of the holes and tied a knot under the boat to keep it from coming up through the hole. Then, we took the other end of that piece of line and threaded it through another hole in the same corner. We tied a knot in the other end—again under the boat. This left a loop of rope on the deck of the boat that was long enough to extend slightly over the side of the boat. With this system of knots in all four corners, we could fix the scow when we got to the spot we wanted by putting poles through the loops and pushing the poles into the sandy bottom of the Bay. Then, we had a platform to tong oysters or clams from. Never had to worry about an anchor. It moved up and down with the tide, and when it was time to move on we just pulled the poles.*

Bateaus tended to go further distances than scows simply because they were usually larger and hence could handle rougher seas. *A bateau had her a pointed bow and was kinda shaped like a wedge. Before motors, you make her go by scullin'* (using a rear paddle that is rotated back and forth from within the boat) *or sailing. Them with bateaus generally did their oysterin' down to Queen's Sound and Red Hills and sometimes even further down.*

Watermen in these parts all used monitors tied onto their boats. Couldn't get the catch back without a monitor! A monitor was a wooden box-like barge that was towed by the scows and batteaus. *We'd tong or drudge and sort and then throw them on the monitor. Sometimes a big bateau would tow a couple of monitors. They were our wagons. We'd steady 'em up same way we did the scows with poles through loops of line at the corners and we'd fill 'em*

up and then tow 'em back into the Harbor. Without scows, batteaus, and monitors the oystering and clamming that was so crucial to the economy of Greenbackville and Franklin City could not have been sustained.

Floats

The train played a big role in delivering oysters from the Chincoteague Bay to northern city markets. *Shipping oysters and clams is tricky business. We had to keep 'em in the Bay up to the last so they wouldn't spoil. Then we'd pack 'em in barrels with ice and straw to keep 'em cold while they were on the train or trucked to market someplace. Later, it wasn't a big thing once refrigerated trucks came along. But, for a long time we used floats to keep 'em fresh for shipping and sometimes we used floats to keep 'em alive till the price came up and then we'd sell 'em.*

When asked to explain what a float was, one waterman said: *Go look down there in the Bay off Franklin City and you'll see the tops of some pilings. You'll see 'em in rows next to each other and there are about eight of 'em. That's what's left of one set of floats. Floats were big trays with high sides. Funny thing is, they didn't really float once you filled them with oysters and clams. Here's how it worked. You brought in your oysters* [and clams] *in your monitor. Then,*

Floats for shedding "soft crabs" are manned 24 hours a day during the season to save the helpless ones from canibalism.

you moved them from the monitor onto the float. The float [the tray part] *was attached to the rows of pilings in a way that let it ride up and down by using lines to raise and lower it. When the float was down the shellfish was in the water just like it'd never been caught. Just like the tides, we'd raise and lower it so those oysters and clams was like always. It kept them fresh but it also kept them ready to be sold off. That float was at Franklin City 'cause that's where there was a shucking house and that's where the train left from. Those oysters and clams lived in the Bay either on the bottom or in floats until they were ready to be shucked or they were ready to be packed to ship. The other good part about floats was that even though the oysters were kept in the salt water up to the last, the floats got them up away from the sand and mud that's on the bottom. A day or so of being on the float got rid of a lot of the grit from the bottom that people don't like.*

Floats also helped shucking house owners deal with oversupply issues and market price variations. If it was an especially good day for a number of watermen, the shucking house owner could buy low, hold the catch in the floats until prices were higher, and make a profit by selling high. The theory of supply and demand works, even with oysters.

Floats still exist to perform the same functions, but today they are all on land with saltwater pumped to them from the nearby Bay. The trays are usually found inside small open-air buildings. Because there is no natural tidal action, they require more attention including draining and rinsing out each tray several times a day—just like the rise and fall of tides.

Tongs

Other tools of the trade were tongs. Used for both oysters and clams, these long handled scissor poles with rake-like prongs on the ends allowed watermen to pull up shellfish from the bottom of the Bay. *I learned to tong as a boy. It was very hard work. My dad could tong for hours but at first I couldn't even lift the tongs with more than a few oysters.*

Nets

Nets have one major drawback—the waterman catches not only the fish he's after, he also catches and often kills turtles and other sealife that becomes tangled in the net. Some nets are pulled by a boat and are called seines. Others are called pocket nets, or purse seines, and are exactly as you would expect—a long net with a pocket at the end which is dragged through the water by a boat. Gill nets or other small mesh nets that are very long are typically strung across the mouth of an inlet, where the tide is behaving in a special way, or wherever the waterman believes the fish he seeks are feeding.

Oyster tongs are heavy and awkward unless they are in the hands of an expert. (Courtesy Brice Stump.)

And finally there are pounds, locally called *fish pots*, which include a bottom net as well as sides constituted by a series of poles and nets. They are placed with a series of stakes along the shoreline near currents or feeding grounds. The fish swim in but don't know how to get back out. Fishermen using this method have their own signature pattern for setting out their fish pots. *Our fish pots were set up right off Cockle Point between the point and Swan's Gut. We'd start them at the shoreline and take 'em out as far as we could. We didn't wind 'em around, just put 'em straight out there with a pocket at the end. The fish would be swimmin' in the shallow looking for food. They'd hit the net and then run deep right into the end of the net that was the pocket—you know, where the net curved around as a trap. We always had a couple of 'em set up in that area but we had to have some space between so they'd work.*

Another interesting device created by watermen was an *eel pocket*. This was a special kind of net designed specifically to catch those slippery creatures. Not unlike a fish pot, it was a net trap with a special extra-fine net mesh so the eels couldn't escape.

Both gill and bottom nets catch everything in their path, which means the sought-after fish are caught, but so is everything else. Although the other

fish are thrown back, many times they are so mangled from the nets they do not survive.

Crab Pots
Crab pots are a different story. They are three-foot by three-foot cubes made of chicken wire with either two or four holes for the crab to enter. Bait is inserted in a special compartment in the center of the cube and the top is wired shut. Commercial crabbers will string up to 300 of these pots on a line that is anchored on both ends. Once baited and *put over*, the line of crab pots are run on a regular basis. Before this method of catching crabs was invented, they were caught with trot lines.

Mudlarkin'
Mudlarkin' boxes, another creative Eastern Shore conveyance, were used to pick up soft shell crabs, clams, oysters, and turtles. *Mudlarkin' boxes were a wooden board, that looked a lot like a water ski, and had a box on the front.* The user slid along on mud flats on the board using a pole or with one-foot-on, one-foot-off, similar to a scooter. The catch was contained on the box or in a bag he carried on his back. When the box and bag were full, they took it back to the monitor or boat, unloaded, and started out again.

In the heyday, watermen used any of these tools and made a living at their chosen trade. Today, regardless of the tools of the trade and modern improvements to them, shellfish and other seafood have declined to such an extent it is difficult to survive working only on the waters of the Chincoteague Bay. Most watermen must hold down land jobs to help pay for the privilege of working on the water.

A HARBOR FROM A GUT
Times and tides change but one thing remains constant—the Harbor is the heart of Greenbackville, both literally and figuratively.

A gut is tidal water near a bay that generally takes the shape of a stomach—wide near the bay and meandering as it gets further away. Prior to the mid-1930s a small gut ran from Greenbackville into the Bay in the area where the Harbor now stands. This gut was not only narrow, it was shallow. In fact it was too narrow and shallow to allow boats, except the smallest pole boats, to go in and out. When the seafood industry began to take off, the gut became *the landing*. In that heyday, it was the site where workboats were

moored in deeper water just offshore because the gut was too shallow for such large craft. Smaller boats would ferry the watermen and their catch to shore or to floats.

As the area prospered and more were engaged in the harvest of seafood, the gut was dredged. It was widened and deepened to make a safe harbor and a more direct docking area. When that happened, the landing became known as *the canal*. During those days there were no slips, bulkhead, or other appointments of a modern harbor. *It was worth your life to get to solid ground. Back then there were planks for boardwalks. You had to be a tight rope artist to get to your boat.* Later, when government intervention happened and bulkheads, pilings, and slips were added, it became officially *the Harbor*.

Some say it was the Civilian Conservation Corps boys who did the dredging of the Harbor. The time is right—the mid to late 1930s during the Depression. Others say it was the Corps of Engineers with the help of some locals. Either way, making that gut into a respectable harbor was a major undertaking. Going from a gradually sloping bottom to 10–12 feet deep over an area large enough to bring a number of work boats ashore was no small job.

One man who was a small boy at the time remembers, *It was on a Sunday, when the dredge boat wasn't working. The crew was on the dredge boat and they were letting people come aboard. My aunt took me and my brother down to the canal and we got on that dredge boat and the crew showed us around. They told us what each machine did and how it all worked. What a thrill!*

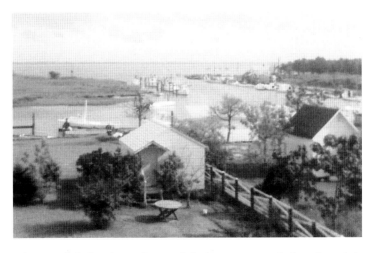

The canal, before boat slips and docks, was a workplace for adults and a playground for kids.

As with most major projects, there are some memories that hang on. *When the canal was dug the Corps of Engineers hired some local men to work on it. Most of them had only worked for themselves and were very independent but, they worked hard and did what they were told to do. The pay of up to a $1 an hour was great for that time. But when some of them got their first paychecks and found out the government had taken out Social Security and other taxes—which at the time was only a few pennies out of every dollar—they quit on the spot. They said 'We aren't working for no damn goviment that takes money away from you before you get it!' And that was that.*

Watermen kept their boats, baited their lines, and brought in their catches in the Harbor. It was the gathering place where they drank with their friends, swapped stories and lies, and cleaned their boats. The Harbor was the center of the world for crabbers, clammers, and oystermen. It was the playground of kids who swam, poled boats, and sunned themselves on the monitors that were tied up there.

Once the train stopped coming to Franklin City, the Harbor essentially took the place of the train station and loading facilities. It was the place where the seafood from boats could be loaded via an elevated platform directly into trucks.

On weekends and evenings when the platform was not being used for its designed purpose, the youth of Greenbackville hung out there. Girls sunned and burned themselves using the suntan lotion of the day—iodine mixed into baby oil—boys showed off, girls preened for boys, *progin' parties* into the marsh were organized, spontaneous crab boils were put together, and any number of other socializing activities occurred. One interviewee observed, *It's a wonder we weren't all killed down there. We'd jump off, ride bikes off, and Lord knows what all we did on that platform.* The platform was also the site of swimming lessons.

Although in the early days there seemed to be an indigenous respect among the people for nature, the water, and land, neither the earlier gut and canal nor today's Harbor have the cleanest water you'll ever see. Today, the Harbor's water is often clouded with byproducts of workboats—spilled gas, oil, and remnants of the clamming and crabbing business. The earlier gut and canal had all that pollution to contend with as well as some of the town's sewage that emptied into it rather than a septic system. One woman compared then to now and said, *It wasn't any dirtier then than it is now. It just had more clumps in it then. One of the boys got an eye infection and we always swore it was because he was swimmin' an' hit a turd.*

Times and tides change but one thing remains constant—the Harbor is the heart of Greenbackville, both literally and figuratively.

CATCHING CRABS THE HARD WAY
As fast as you could, you'd be dippin' them crabs off and throwin' 'em in the barrel with the crab net.

Crabbing with trot lines was the way they did it before they had crab pots. Crabbers were up by 3 or 3:30 in the morning. Most of 'em walked down to the landing to their boats, 'course it wasn't far, but they didn't have cars. Lots of 'em would be pullin' little red wagons behind them with their stuff in 'em.

When you were a waterman's son, if you weren't goin' to school you went to work with your dad. That meant you had to get up at 3 in the morning, go to the landing and put the barrels with the weights and lines on the boat. Then, once we were on the Bay, Dad'd take the weight, he knew just which one to take, an' he'd take the anchor, or sometimes if they didn't have anchors, it may be the starter from an ole car, he'd throw that overboard. It was connected to a chain about three feet long—what that chain was for was to hold that line down cause that line would float. Both ends were done the same way. So there'd be a weight, a chain, then the baited line, and at the other end another piece of chain and another weight. That way the line stayed down near the bottom where the crabs are. We had to get both lines set and be ready to crab by daybreak.

Everybody had two lines 'cause you'd go down one line and then you'd go over to the other line an' go up it. That way you didn't waste gas goin' back and forth an' the crabs'd have time to get on the line you just finished. When you were working a line, you had a hook on your boat an' the line would come across that. As fast as you could, you'd be dippin' them crabs off and throwin' them in the barrel with the crab net. One of the first things my dad ever taught me was how to pull those lines just so. When you were doin' this, you were going real slow. You'd pull them a special way so you didn't get that line tangled up. Then, you'd go do the second line the same way but you kept those lines separated—one line went in one barrel and the other line went in a different barrel. If you messed with those lines too much you could be 50 hours getting them straightened out. Lots of times my dad would be steerin' and I'd be pullin' up lines. You'd start just about daybreak 'cause you only had two or three hours to crab and then, for some reason when the sun come up high, the crabs just would grab hold an' then drop off. Once that started happening, they'd pull the lines up an' come in early.

They'd be back in by 11 o'clock, have the crabs off the boat by 11:30; then, most times, Dad would go to the store. He'd say 'I'll get you a hobo bun [a cinnamon bun] and a chocolate drink" and that was lunch.

In the afternoon, you would stay down there about another two hours baiting your lines up. First you'd get all the lines out of the boat. Then, you had to take

whatever was left of the old bait off the lines and put a new piece of bait on that line and throw it in a barrel. There was a piece of bait about every two feet along that line and each line would be 75 to 100 yards long. Once all the line was in the barrel you would salt it down good an' hook your weights on the barrel. The next day when you got out on the boat, everything would be ready.

The transition from crabbing with trot lines to crabbing with pots was quick. Crab pots were used in Crisfield before they were used in Greenbackville. In fact, two men from Greenbackville went to Crisfield to learn how to make them and came back home to make their own pots. They also taught others how to make and use them. A baited crab pot could catch a dozen crabs with one baiting, while with the old way, if you were lucky, you only got one crab every few pieces of bait. It was a much more efficient way to harvest crabs.

Women and men, and even kids, learned how to make crab pots. The pots were made of chicken wire and weights but crafting them was a skill. In the late 1950s and early 1960s, the going rate for making a crab pot, from materials supplied by the crabber who planned to use them, was $1 a pot. Those were lean days. *One summer day my husband and I made 40 crab pots in one day. We earned $40 and that was big money. At that time, my husband was makin' $75 dollars a week and we had three kids. So we needed that money. It was hard work but a dollar a pot seemed like good money to us.*

It wasn't hard for a crabber to decide to use pots instead of trot lines. Even though he had to come up with the money for the chicken wire, weights, and rings, the payoff in the number of crabs caught in a day was convincing enough to make even the most stubborn crabber change.

HEAVY LIFTING
It was never called a boatyard or marine maintenance service or any of the names that would commonly be used today, instead, in this area, it was simply called the railway.

Boat repair was an essential service in these communities by the Bay. Since workboats were large and made of wood they were very heavy, especially when they had been in the water for some time. To repair such a boat, it had to be raised from the water and worked on from the land. The device for raising it from the water was called a railway.

Think of the launching ceremonies for a large ship—the boat slowly slides into the water until it is floating on its own. That ramp is a much

larger version of what existed in Greenbackville. Then or now, it is a marine railway that brings a boat on dry land and re-launches it into the water.

In these two towns by the Bay, which relied on seafood for their economic survival, boat repair was an ongoing necessity. Railways were built in the very early days along the shoreline between Franklin City and Greenbackville. Over time, one of these businesses grew and was passed down from father to son. In those early days the Bay was full of workboats, and breakdowns, mishaps, and routine maintenance assured a steady stream of business for the owners of the railway. One veteran waterman said, *none of our old wooden boats ever ran without water in the bilge. Even so, they still had to be pulled every now and then for serious repairs.*

It is the railway along what was then called the canal that is best remembered. It was never called a boatyard or marine maintenance service or any of the names that would commonly be used today, instead, in this area, it was simply called the railway. This was not an unusual term in the days when it was built. It started with one set of rails but at its peak there were three sets, so three boats could be worked on at the same time.

In early days, building such an enterprise was not easy although it was relatively simple. Trunks were trimmed from several large trees and laid side-by-side at right angles to the shoreline and gradually slanting into the water. They had to be anchored on land and in the water so that when the weight of a large boat was on them, they would hold steady and not give way. On top of those trees, two wooden rails were attached. The rails were kept well greased—a chore handled by the small boys of the family. The rails had to extend some distance into the water until it was deep enough for the bow of a large workboat to mount the rails without going aground. Once the rails were in place, shorter smaller logs were placed across the ones going into the water to act as rollers. Then, a boat could be attached to a line that was used to pull it up the incline.

Early on, it was basically brute strength that got the boats out of the water and up the incline. Manpower alone was used to pull the boats, along with a system of pulleys, wheels, other *hand machines*, and the cross logs that acted as rollers. Later, the boat line was hooked to a noisy one-cylinder engine that did the pulling. One who worked there recalled *We had all kinds of machinery, belts, pulleys, drills, lathes, and things. When I was real little, I remember my dad pulling belts and levers and they'd be flying from the ceiling and all over the place.*

Once the boat was on dry land sitting on the rails, the real work began. Scraping barnacles and other sea life off the bottom was no small job. In

those days, in the absence of power tools, all the scraping had to be done by hand. Re-caulking is never fun but before caulk guns and tubes of caulk, it was done by using a metal tool to force strips of cotton between the boards that made up the hull and then hammering it in with a mallet—this allowed the wooden boats to swell and shrink with temperature and saturation. Paint is paint but in a salt environment and with no cover or temperature control, painting relied on the weather. And, bottom paint (used to repel barnacles and other sea slime) with high copper and other metal content doesn't dry well when there is a lot of humidity in the air—which is almost always the case on the Eastern Shore.

Not only did the exterior of boats require attention, the engines, props, and other mechanical parts also were often in need of repair. Today, you order parts by phone, mail order, or the Internet, and when the parts arrive you make the repair. During most of the early railway's days, there was no waiting for parts—they were made on-site. The broken part would be removed and repaired or used as a pattern for a new one. This meant the railway business included a forge and someone with enough skill as a blacksmith to make new parts. *A lot of the boat engines were Model A Ford engines put in backwards because the fly wheel was too big to have it down in the rear so it was in the front.* (Workboats on the Eastern Shore's shallow bays are traditionally long with low drafts to get in and out of shallows. There is very little room in the rear of these boats below the floor). *One of the repair jobs was . . . the gear was on the outside of the flywheel next to the starter. It'd break or crack and we'd have to get in there, heat it up so we could get the old one off and then put a new one on.*

It was Dad's business but I had to do pretty much the whole thing. Dad drank so much . . . I had to take over. They'd come to Dad an' tell him what was wrong and he'd say to me—'Get it done' and I did. From my early teens, I worked the railway full-time in the summers an' then did what I could once school started. Once winter came, there wasn't much business. In the spring and summer, the Harbor was full of boats—not just where the slips are now but all the way down by the railway. There were slips there too. And, then some boats would be moored around by the railway waiting for a turn to get on it. By the time I was in the last years of high school, the Railway business pretty much had dried up. There weren't that many boats around anymore and I went summers to work for an uncle across the Bay. Another guy came and worked one set of the rails for a short time working on pleasure boats. But that didn't last long.

The people who ran the railway were the boat repair specialists. A problem with a boat—be it the engine or the hull—warranted a visit to

them. They also had responsibility for picking up and delivering some of the boats they repaired. Even today, a combination of creative ingenuity coupled with fierce independence, intelligence, and resourcefulness leads natives of Greenbackville to try everything and somehow make do. The son of the railway owner recalled, *It was a drizzly day but Dad and I were takin' somebody's boat over from Chincoteague to Greenbackville to the railway. It was getting dark, an' it was rainy an' stuff an' the boat's engine quit halfway across the Bay. Dad gets into the motor and takes the distributor cap off an' points in there—there's a little spring-like thing that holds it together an' that spring was broken. Dad cuts the finger off a rubber work glove and stuffs it in there an' it works just like a spring! At least it worked till we got back to the railway and could fix it right.*

Ancient builders had nothing on Franklin City's watermen—many of the principles used in a railway are similar to the ones that are believed to have been used to build Stonehenge *c.* 3000 B.C. In that case, they moved colossal boulders many miles using logs, lines, and manpower. A boulder or a large boat—doesn't make much difference when it comes to moving them. Either is a formidable challenge only mastered by intelligence and determination.

PROTECTING YOUR TURF
Anyone who treads, carelessly or intentionally, too close to the territory of a waterman needs to understand that he is trespassing.

Generally speaking, the law of the sea and the nearby land that adjoins the sea is that whatever is out there and not accompanied by its owner is fair game. In other words, *it's there for the pickin'*. Indeed, this is the origin of the practice of beachcombing practiced by hundreds of thousands of people around the world looking for treasure.

In Greenbackville, Franklin City, and the entire Chincoteague Bay, what washes ashore is fair game but what is still in the water and a source of someone's livelihood is a very different story. Anyone who treads, carelessly or intentionally, too close to the territory of a waterman needs to understand that he is trespassing and will have to pay a serious consequence if caught.

In the very early days, wild oysters grew on "rocks" (underwater expanses of solid land, piles of shells, or reefs). Spat (young oysters) would attach themselves to these rocks and grow into the salty succulent delicacy of an adult Chincoteague oyster. Claims were staked out in different areas sometimes by the owner of a shucking house or by a waterman himself.

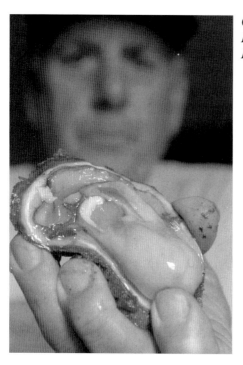

Oysters, sweet and tender, fresh from the Bay, shucked by skilled hands. (Courtesy Brice Stump.)

Oyster and clam beds were believed to belong to whoever worked them regularly and marked them with flags on stakes or poles.

When there were plenty of oysters, things went pretty smoothly. Later, when oysters became scarce for a host of reasons, the competition for grounds to harvest them intensified. As the wild oysters diminished, local watermen would take their monitors all the way to the James River and bring spat back to the Bay to grow to maturity. Either way, a waterman had a significant investment in protecting his territory on the water.

One solution was described as follows: *My grandfather's job was to go out of a night and keep anyone from stealing or poaching the oysters. He'd leave on Sunday evening around 5 p.m. Each hour he'd start the motor, pull the anchor, and move to another one of the two or three beds he patrolled. He'd stay out all night watching over the beds an' just before daylight he'd come home and make breakfast of ham, eggs, coffee, and canned plums—my favorite! As the sun would be breaking, he'd go back on the water and dredge oysters till around noon. In the summers, I'd go with him during the daytime an' then, we'd go home, have a hot lunch, and go to bed. I got to sleep the rest of the day and night but poor Grandpa had to be back on the water by 5 p.m. to guard the beds. He did this every day and every night from Sunday till Saturday.*

Watch houses were different. They were used mostly on the eastern side of the Bay near Chincoteague Island and in the back bays such as Pope's Bay. The oyster beds were similar to those elsewhere in the Bay. Their protection services were provided by a man hired to live in a small house up on pilings, usually in the middle of a bed or strategically located in the marsh between several beds. The watchman who agreed to this employment also agreed to live in a watch house—sometimes alone and other times with his whole family. The only way to get to the watch house was by a small boat. These protectors of property used a different technique than the patrolling of the watch boats. Their approach was strong lanterns or spotlights scanning the beds at night and the persuasion of a few shots in the air from a 12-gauge shotgun. If an intruder was spotted, he usually made a quick get-away after the first shot. If the warning shots were not heeded, the watch house occupant would jump in the small boat in hot pursuit.

THE SECRET OF CLAMMING
It makes one wonder if the old way didn't help preserve a natural resource and follow the principle of taking only what you can use.

There isn't a real skill to clammin', well maybe some if you're signin' or wadin', but there is a knack in knowin' what kinda bottom a clam likes to live in, grow in, and be in and where in the Bay you're gonna find that. That's the trick to clammin'. There's a lot of ways to catch clams. There's signin', wadin', rakin', drudgin', and tongin' and, well I wouldn't be right to leave off mudlarkin' but that's just kinda signin' from a board.

In Greenbackville, everyone knows what it means if you say *Want to go signin' on Sunday?* It is not about billboards or sign language or even an autograph party for a local author. What it amounts to is a special way to locate clams in the Bay.

At low tide, go by boat or foot to a shallow area or bar—a sand bar, that is. 'Old heads' say the best time to sign is toward the end of fall or into winter after you've had a couple of frosts or a freeze. That's when the water gets clear. You can sign as long as you can see the bottom—doesn't matter if it's a few inches or two or three feet and sometimes you sign clams where bars ebb out or the shoreline ebbs out [a sand bar or the edge of the shore that is usually underwater becomes exposed as the tide goes out] *and you can actually sign out of water. The thing with signin' is once you're out there you start looking for small holes on the bottom about the size and shape of an old fashioned door's keyhole. Sometimes, around*

the keyhole you'll see darker mud or sand that the clam has thrown out as he settles down into the sand. There might also be a very fine string of other stuff coming out of the hole produced by the clam's digestive system—you probably won't need to know exactly what it is. Those are pretty sure signs that there is a clam buried in the sand. Once you see the sign, you use a two-tooth rake-like tool—usually has a short handle maybe six inches long but some people who don't like to bend over have 'em with long handles—then you pick up the clam and throw it in a bucket and keep on going. When the old timers went out signin' they would carry a jug or bottle of coal oil or kerosene with 'em and when the wind rippled the water and they couldn't see that clear, they'd throw that on the water to make a slick to see through. 'Course you do that today and you spend time in prison. Signin' is a skill that is being lost. People don't go signin' like they used to. It don't take a lotta equipment but it takes some time and patience.

Wadin' for clams, we do a lot of that. When we're wadin' for clams we always put on a couple of pairs of old white socks to protect your feet from shell cuts and jump overboard. But goin' back, the wives made moccasins outta felt. They liked to use that but if they didn't have felt they'd use what they had. I've even seen them made outta rubber inner tubes. But them moccasins, they was all homemade.

Now back to how it's done. You can wade as deep as you want as long as ya can breathe, you don't have to see nothin'. Here's where the socks come in. You go to a spot where you know there's clams, and then feel around with your toes until you feel the clam and work him loose with your toes. Once the clam's loose, stand on one foot, bring that clam up your leg with the other one. Some get the clam on top of their toes and lift it, others pick it up with their toes and slide it up their leg with the ball of the foot. The trick is getting that clam high enough up your leg that you can reach down and grab it with your hand and throw it in a basket.

One story that was told and retold was about a very tall Greenbackville man wading for clams. *One day he was out there clammin' and ya know it seemed like he was seven feet tall. Anyway, he was taller than most everybody else. 'Cause he was so tall, he could clam in places that were way too deep for most others. Well on this day, he was over there on the flats by Chincoteague* [Island], *an' the tide had come up but he was still havin' a really good day, he was catchin' right many clams. One of those short Teaguers* [Chincoteague Islanders] *saw him and came right out in his boat. The Teaguer asked how he was doin' and the man said real good. The Teaguer jumped in to get his share of clams and all you saw for a while was his hat floatin' off with the tide.*

Before dredging, wading was the way that clams were harvested commercially. In fact, there was a legend of several men that lived near

Chincoteague Island who could catch a thousand or more clams a day using this method. They were called *clam jumpers* because once the shell was free from the bottom, they would put it between both feet, jump, catch it with their hand, and throw it into their boat—all in one seamless motion. Back then, they were lucky to get a penny a clam. Today, commercial clammers using dredges quickly and efficiently can extract more than a thousand clams an hour from the Bay. But today there are fewer to be had. It makes one wonder if the old way didn't help preserve a natural resource and follow the principle of taking only what you can use.

Raking clams is more popular with outsiders. *Come 'eres will take out their special high-priced clam rakes coupled with their new bushel baskets floating in new inner tubes, stir up a lot of sand, and maybe get a few clams. The thing is they don't know where to be when they put that rake to the bottom. Some people rake clams in waders and some people even do it in them diver suits* [wet suits]. *There isn't any skill in rakin' clams—only knowing where to find em.*

Clamming was and is a recreational, as well as commercial, activity in and along the shores of the Chincoteague Bay. Signing is almost a lost art but wading clams is as popular as ever.

POLING THE BOAT
I'd put the pole down till I felt the bottom and then push hard and as we moved, I'd pull it up and put it down again and push as hard as I could.

A pole boat was a small, flat bottomed, wooden boat, often with squared off ends, not unlike a rowboat except that instead of oars and oarlocks, one propelled the boat with a long pole. From the early to mid-1900s there were many such boats around. The Bay was shallow enough in some places that one could go some distance into the Bay and especially along the shoreline, putting the pole down into the water until it touched bottom and pushing against it. Pole boats were used for work as well as recreation and were easy to operate.

As a small work boat, the pole boat could go where other boats could not. It could go over a sandbar with just a little water on it, up creeks, and in other places that were simply too shallow or overgrown with seaweed or shoreline reeds. There are many stories of using the pole boat to go signing.

Even children could make a pole boat go. *When I was just a little girl, it was a hot day and my friend and I decided to pole the boat out into the Bay. That was always a fun thing to do. So I was poling and she was just sitting on there. I'd put the pole down till I felt the bottom and then push hard an' as we*

The Waterman's Memorial in Kent Island, Maryland, illustrates how boats were poled.

moved, I'd pull it up and put it down again and push as hard as I could. We were moving right along. But one time when I was pulling the pole up out of the water, I really whacked my friend in the head with the pole. I hit her so hard I feared she'd fall into the Bay. I was really scared. We knew how to swim but not out in the middle of the Bay.

Swimming was one thing. Being knocked off a boat into the Bay by being hit in the head with a pole—that was quite another.

There is a phrase used by some locals when the weather is bad or they are too sick to leave home, *I'll not be likely to be polin' outta here today.* Or in other words, conditions are so bad, even the pole boat will not work. This reference to the old pole boats still endures, even though pole boats themselves are rare.

A SURVIVAL SKILL
Every parent knew that not knowing how to swim was dangerous for kids with so much water and so many boats in their lives.

With so much water and so many boats, swimming is something every child in Greenbackville and Franklin City needs to know how to do. In earlier days,

there were no formal lessons such as those offered by the Red Cross or the YMCA, but almost all the kids learned to swim early and well enough to avoid disaster. Today, those who can afford it send their kids to swimming lessons at nearby Captain's Cove. The rest may or may not be safe around the water.

Say *learning to swim* and you hear one man's name from many people who were children 50-some years ago. *He taught most of us how to swim. His house backed up to the Harbor and he had just one way of getting us to swim. He'd take a really big rope and tie it around your middle. Then he'd get you into the water at the Harbor (some said he threw you in but he never threw me in, I just got into the water somehow). Finally, he'd stand there on the shore tellin' you what to do—'kick your feet,' and 'move your hands like this.' He'd keep doing that with you until you were swimming. I think he could tell from holding the rope when you were swimming on your own. When he said you could swim—you knew you could!*

Accidents often pointed out to parents the importance of having their children know how to swim. *I was four. Just four! I know that because my mother told this story so many times and she always mentioned that I was 'just four.' My daddy was working at the Harbor. So I went down to there with my dog. I was throwin' stones off an old boat. I liked to see the splash and see the water go out in rings. One time I threw the stone so hard I lost my balance. I went in with a big splash—soon after my dog came in too. I grabbed the dog and hung on for dear life. He swam to shore and we both got out soaking wet but we got out. My dad had watched the whole thing and that day my dad took me to the man who taught all the kids in town how to swim and said 'It's time for him to learn to swim.' In a week or so I could.*

A woman remembered the swimming teacher but was more intrigued with his miniature boat—*that boat was so little, no more than two really small kids could get in*. It was moored at the Harbor and used as part of the teacher's reward system. *If you learned really good or did something special and behaved yourself he'd let you tool around the Harbor in that little boat.*

This kindly soul who took the time and effort to teach kids to swim had his own method, but it worked. Some learned through less kind and more dramatic experiences.

With three older brothers, we often would go out in the boat fishing or clamming just for fun. One day, we were in the boat and my two oldest brothers jumped off the boat into the water. They told me it was shallow enough for me to stand and told me to jump in. I jumped in. It was way over my head. I came up for air and I swam because there was nothing else I could do. From then on, I was a swimmer.

Another reported, *I was a big dog paddler. I'd hang around down to the landing and get in the water with the other kids. They knew I couldn't swim so they'd go out just a little deeper than I could to tease me. I'd dog paddle around where I could touch bottom and then gradually, I'd go farther and farther out where I couldn't touch. Gradually, I got confidence enough to start swimming normal and gave up the dog paddle. Confidence! That's what it's all about.*

Whatever the kids thought about learning to swim, every parent knew that not knowing how to swim was dangerous with so much water and so many boats around. Interestingly enough, in the interviews that serve as the basis for this book only one instance of drowning was mentioned. Even then, it did not appear to have anything to do with knowing how to swim.

NOBODY PICKED MORE CRABS
In addition to working on the water, picking hard crabs, and cleaning soft ones, this woman followed the pattern of many women in the community of working several other jobs as well.

This is a woman's description of her early years as a resident of Franklin City and later Greenbackville: *When I came to live in Franklin City, it was 1922, I was a 17-year-old bride from Chincoteague. My husband was a crabber—though he caught clams for the fun of it and, of course, he fished. When I came to Franklin City, the streets were lined with houses and there were two grocery stores, a post office, shucking houses, a hotel, two churches, and the railroad came through several times a day. My days were mostly spent on the water with my husband. Oysters were the town's big business but my husband was always a crabber. My husband said if he could ever get 50¢ a [bushel] basket for crabs he'd be tickled to death.*

In the early days there was lots of everything—oysters, crabs, and clams. They were all out there and easy to get but the prices for them were really low. Back then crabbin' was done by trot line. The hard part was keepin' the crabs alive long enough to get them to the pickin' house or to market. If we shipped by train, he stood a chance of getting more money but it could just as well mean we'd get lots less. My husband usually sent his crabs on the train. He had contacts at the Fulton Fish Market in New York and they treated him right most times. If the crabs didn't go to New York or to the picking houses in Crisfield, I picked them at home. I guess it would be fair to say I've picked my share of hard crabs and cleaned a whole lot of soft ones too.

When this woman said *I've picked a lot of crabs*, it was probably a gross understatement. She was still picking crabs at age 99. *My husband had me go on the boat with him most days when he crabbed. Crabbers always get out early—4:30 or 5 a.m. We'd generally crab till about 11. Once the crabs were on the train or to the picking houses in Crisfield, crabbers—like my husband—became fishermen and clammers. Crabbing was work but fishing and clamming were fun. We started out raking the clams but then we learned everything about signing—looking for the keyhole, or the 'drop of rain,' or that line in the sand that showed where they were.* The smile that covered her face as she described learning to sign clams would convince anyone that this was recreation. Fishing fell in the same category. It wasn't done to earn a living, it was a hobby. The fact that it was done on the Bay in the same boat that was used for work was not even a consideration. Everyone knew that fishing was done for the fun of it. Sure the fish were eaten and the clams were too. But they were different from the crabs—crabs were the cash crop.

There was more to the life of this crabber's wife than going out on the Bay to work the crab and enjoying the fun of clamming and fishing. In addition to working on the water, picking hard crabs, and cleaning soft ones, this woman followed the pattern of many in the community of working several other jobs as well. *I've worked in lots of places—the tomato plant, the Birdseye plant in Stockton, and in the sewing room at Snow Hill. I had a right nice big vegetable garden in the back and some flower gardens too but now they say I can't do that anymore. I really like to work. When there's nothing else to do, I crochet.*

What made life good for the nearly 100 years she lived, most of them in these communities, was summed up in three simple statements: *the people are so good, I've got wonderful friends, and most of all it's home!*

WORKBOAT ADVENTURE
It was so cold they had to pour antifreeze from a glass over the engine parts to get them thawed out enough to start the boat's engine.

Watermen were good at many things but they excelled at fishing and drinking. When they weren't doing one, they did the other and sometimes they did both at once. If they weren't doing both at once, they were thinking heavily about the one that was not currently being practiced.

Prohibition did not stop drinking in Greenbackville. Like elsewhere in the country, it only sent it underground. When prohibition was over, there

was a new freedom to drink and many went way beyond what they could handle or afford, just because it was legal again.

On a day of fierce wind and snow, known anywhere else as a blizzard, but locally as a nor'easter, a few watermen had been *nipping* at different locations where they hung out in town. Finally, one decided he should go home because he knew his wife would be greatly agitated about his condition. He hopped on his bicycle and headed home. After a few slips into the ditch, he had a better idea, *We need to go fishin!*

He went back to his drinking buddies who were still cogent enough to say *No way*, and then he started home again. When he passed the house of another buddy, he stopped in to see if his friend wanted to go. By then he was getting belligerent. *If you don't want to go, FINE, I'll go myself.* Being afraid to let that happen in his condition, his friend said *Wait, my wife and I will go with you.*

Out they went, in an old work boat. It was so cold they had to pour antifreeze from a glass over the engine parts to get them thawed out enough to start the boat's engine. Once the engine started, the glass, half full of antifreeze, was set aside. By the time they got underway, they all decided they needed a warm-up drink. After finishing his drink, the instigator of the trip shortly was asleep in the bow, holding his lit cigar next to a gas can. The wife went to throw away his cigar and on returning saw her husband drinking from the glass with the antifreeze—he had mistaken it for his warm-up drink. She yelled. He emptied his stomach overboard and at the same time pulled off the steering wheel he was holding on to for balance. They were underway with one passenger passed out, another deathly ill, and no steering capacity.

Finally, they returned to the Harbor with the woman hand-pulling cables from the back of the boat to steer, the friend of the trip's initiator trying to keep more cigars from being lit, and the instigator happy that he had been both fishing and drinking with his friends!

THE HANDWRITING ON THE WALL
Many failed to see it comin'.

To look at the towns of Greenbackville and Franklin City at the dawn of the 21st century is to look at one town all but consumed by the marsh and another with a questionable future. All commerce had long since ceased in Franklin City. Except for the post office, the clam shack at the Harbor, and

a small beauty shop, all commerce in Greenbackville had stopped during the last half of the 20th century. The entire economy, which was based on the seafood industry, declined from 15–20 work boats with each hauling 12,000–15,000 clams and oysters as well as equal numbers of crabs per day, to the current two or three work boats and disappointing harvests of only a few bushels of crabs or clams a day. And there are not enough oysters to sell commercially.

Many explanations are given for the decline of these towns. What is undisputable is that they were both active, thriving centers of commerce from about 1875 until the 1920s. The decline started sometime after 1920. Looking at each of the reasons given for the decline provides some insight.

The Causeway
Before the causeway to Chincoteague was built, Greenbackville and Franklin City were the nexus of activity on the Chincoteague Bay. The only way to get to Chincoteague Island from the mainland was by ferries based in Franklin City. Equally important was the fact that the railroad in Franklin City linked the entire area to the rest of the world; conversely, it brought the outside world to them. Watermen and farmers brought the fruits of their labor to the train in order to reach a larger market. That same train also delivered newspapers and people from the cities and greater outside world.

A shucking house shows the ravages of storms and the demise of the oyster business on the Chincoteague Bay.

They in turn brought word of issues, styles, and culture of the day to this part of rural America.

The presence of the train and ferry system was a strong incentive for the founding of other businesses. The train and community served as linchpins between suppliers and the markets. Boat repairs, barrel makers, canning factories, ice houses, marine hardware, shucking houses, barber shop, post offices, bars, and stores all supported those who used the train as well as local commerce.

The trains and ferries that plied the Bay delivered locals as well as sporting hunters and tourists from faraway places to Chincoteague Island. The budding chicken businesses on Chincoteague Island were all supplied with chicken feed and other supplies delivered by boats from Franklin City and Greenbackville.

When a couple of enterprising citizens of Chincoteague Island got the idea of building the causeway as a toll road, it changed not only the island but the whole surrounding area. Fortunately for Assateague Island and the many non-human species that inhabit it, these speculators were unsuccessful in extending the toll road from the mainland to Chincoteague Island and on through Assateague Island to Ocean City. Nevertheless, the impact of that roadway across the Bay had profound irreversible effects on the quality of life in and around the Chincoteague Bay. Once the causeway was established, there was little reason for ferries and other commerce to come and go from Franklin City. At the same time, the American love affair with the automobile was just beginning. It was not long before cars were the personally preferred way to reach Chincoteague Island. Not long after, trucks became the backbone of commercial transportation delivering goods there.

The Oysters Got Sick

There were two diseases that attacked the oysters—MSX and Dermo. *No one knew why or what to do about it . . . once the oyster beds were infected, the oysters began to die and were unfit for human consumption.*

One group of scientists believes that the diseases were able to gain a foothold because of a change in the Chincoteague Bay's salinity and water flow. Two events combined to cause this change in the character of the Bay's waters. One was the major hurricane that hit the area in 1933. Until then, what is now known as Assateague Island wasn't an island at all, it was a peninsula running down the coast from Maryland and to the south end of Chincoteague Island. The 1933 hurricane cut through

that peninsula just south of Ocean City. This inlet funneled a great deal of salt water into the Bay from the ocean. Had the tides been able to continue to change the Bay's water twice a day, the salinity would have soon been equalized and corrected. That could not happen because just a few years earlier the causeway to Chincoteague Island had been built—the second event. The causeway did not stop the flow of tides but it certainly impeded the natural flow of water. Consequently, the Bay's salinity began to increase. A waterman explained it as follows: *Where previously the tidal flow had been unrestricted, it now was artificially channeled around the causeway's roadbed and bridges. At any rate in the late 50s and into the 60s it wasn't worth drudging oysters. You couldn't sell 'em and you wouldn't even eat 'em yourself.*

At the beginning of the new millennium, there were some efforts to re-seed areas near Chincoteague Island and there was talk of introducing an Asian strain of oysters. At the time of this book, no significant progress had been made to restore the oyster to its heyday in the late 1800s.

The Railroad Left
Transport of oysters was the main impetus for construction of the railroad line to Franklin City. As oyster production diminished from the 1930s on, the need for, and use of, the train for shipping oysters dropped off drastically. Also, trains became fewer when the causeway was built. People drove cars to Chincoteague instead of taking the train to the ferry.

Even so, the trains kept coming through the 1940s and into the 1950s to bring chicken feed in, not to take seafood out. One Greenbackville waterman noticed that *there were more folks on Chincoteague who were growin' chickens than working on the water.* He astutely shifted the focus of his business from harvesting and marketing seafood to hauling chicken feed by his own boat to Chincoteague. Even though this waterman could no longer make a living catching clams, oysters, and crabs, his change in focus allowed him to stay in business and still work on the water for a few more years.

The Navy Left
During World War II the Naval Air Station at Chincoteague brought a lot of people to the area. They spent money all over the Eastern Shore including Greenbackville and Franklin City. When the war was over the air station downsized and finally closed. What the navy had contributed to the economy of the area disappeared as quickly as it had arrived.

The 1962 Ash Wednesday Storm
The Ash Wednesday Storm on March 5–7, 1962, is often credited as being the *last straw* for Franklin City. Technically, it was a *nor'easter*. A fast moving system is typically not a problem, but this particular storm bombarded the area for three days. The winds were bad but the flooding was horrific. All of Franklin City and most of Greenbackville was underwater by the third day. Even the then-new Greenbackville Firehouse (well inland from the Bay) had floodwater in it. Citizens were evacuated to the Stockton Firehouse and homes of neighbors and family living away from the Bay. After this storm, there was little left of Franklin City. Greenbackville survived but the storm took a serious toll. Many houses were not habitable and much loss of property was recorded. Few had insurance or any way to recover their losses. Some lost all they had. Even so, they managed to survive and rebuild their lives in Greenbackville.

Chain Stores and Cars
Some insist that what really killed commerce in Greenbackville and Franklin City were automobiles and the chain stores. Once people got cars they went where the big stores were. *Those chain stores put our local stores out of business. They had more variety and they had more things. It wasn't the storms or the high tides that got us. It was the car and the chains that took us down.*

The Fatal Blow
There will never be agreement as to which of these events was the fatal blow. Truth be told, the decline was likely caused by all these factors. The interesting point is that many failed see the *handwriting on the wall*. They stayed in their homes, worked at lifelong occupations, and did things pretty much as they always had. *Life had been good and when it went bad, they just thought it would get better and it never did. Businesses were closing up, watermen couldn't make a living, and people couldn't pay their bills. They'd charge things everywhere. They did business and promised they'd pay when things got better. For many, it never did. When I was comin' up it was a pretty depressing time, we just didn't have enough money and I'd say it has had an effect on me all the rest of my life.*

In the Midst of Decline
In the midst of economic decline, some institutions survived and one even flourished. The Union Methodist Church is surviving if not thriving. This church, which resulted from merger of Franklin City's Methodist Church

that burned in the early 1940s with the Greenbackville Methodist Church, has maintained an important role in this community. It has succeeded in keeping a minister in times when many other rural churches were unable to do so. It has always had an organist and a choir. It has provided Sunday school and even vacation bible school for this and other surrounding communities. When one views all the abandoned churches in the local area, or churches that open only once a year for a homecoming or reunion service, it is clear that in this community, the church is a survivor.

The volunteer fire company flourished even as the towns of Franklin City and Greenbackville languished. A new firehouse was dedicated at the turn of the new century, and ambulances and other equipment are regularly added to the resources available to the community. It seems that that torch has been passed to the next generation by the men who started the fire company. The new leaders are men and women in their 20s and 30s who are clearly dedicated to their mission. They have sought out not only new equipment but the training required to operate it and protect their community as well as the new growing communities nearby.

Old towns that lose their primary institutions—their churches, schools, and their volunteer fire companies—are doomed to permanent decline. In sustaining the church and strengthening the fire company and rescue squads during the most difficult years, part of the infrastructure for the rebuilding of a more economically stable community was preserved. If the town is to be reborn, it will likely be due to the economic impact of real estate and land development. Influx from these sources will provide a short term financial shot in the arm but at the same time it will forever change the land and the people who live in this community.

3. No Such Thing as Nine to Five

Many enterprising ventures and much gainful employment happened away from the water. These other areas of work often required a discipline typical of production and service businesses. Crops had to be planted and harvested at certain times, stores had to open on time, and if you worked for someone else you worked when they wanted you to, not when you wanted to.

Some prospered, others survived, and still others had a hard time. Everyone worked very hard physically, often held several jobs, and most adult waking hours were spent working, six days a week. There was no such thing as a predictable nine-to-five routine.

MAKING A BUCK
The future is unclear but one thing is certain. Greenbackville has begun another change in its evolution—again, driven by commercial interests.

With the decline in seafood business, coming of the automobile, leaving of the train, and the 1962 Ash Wednesday Storm, Franklin City and its businesses disappeared. Likewise, from the middle of the 20th century until around 2003, there was little commerce in Greenbackville. You could usually buy all you might want of clams and oysters at the Harbor, and stamps at the post office, but that was about it. But when old timers, or as one person called them, *old heads,* talked about the stores and businesses they remembered, different pictures were painted.

Commerce
From the earliest days of Franklin City and Greenbackville, when the economy was booming, the range of business enterprises was widely varied. Individually owned businesses included a hotel, eating establishments, bars, an ice cream parlor, a barber shop, a millinery shop, two canning factories, and at least three general stores. Both towns also had post offices.

The significant difference from other towns' businesses was that in Greenbackville and Franklin City, the majority of commerce was related to the catching, buying, and selling of seafood or serving the watermen and their families. Seafood was the perishable commodity that caused these communities to be founded, and served for many years as the bedrock of their economies.

The seafood business was oiled by the presence of the train, ferries, and later on, truck traffic. Also critical to those working with seafood were two boat repair businesses with railways, a barrel factory, an ice house, and several brokers who bought directly from the boats and sold to markets elsewhere. Some reported as many as 14 shucking houses that shucked, bottled or canned, and resold clams and oysters to vendors and brokers in faraway places.

After the destructive 1962 storm, Franklin City's commerce ceased abruptly and completely although it had been declining since the 1940s. Greenbackville's businesses also began to disappear but they took longer. As it became less possible for a host of reasons to earn a living on the water, the businesses that supported that way of life could no longer survive. Staple commodities ranging from grocery stores, boat repair, gasoline, and seafood brokers were the last to go, but even the ever-durable barbershop was gone by the dawning of the 21st century. The only businesses left were Greenbackville's post office, a beauty shop, and a house builder.

The center of commerce in Greenbackville included these stores.

Historically, seafood from the Chincoteague Bay was the major force behind the birth of these two communities. Even in the fairly recent days when the only places you could spend cash in Greenbackville were the post office, beauty shop, and the clam shack at the Harbor, seafood constituted over 30 percent of the town's business establishments. Shortly after the turn of the century, the clam shack's land was sold by its original owner to a native son, and, for an all too brief period, it morphed into a very successful seafood restaurant—the Bay Witch. Then, the march of development entered sleepy little Greenbackville and with that came more businesses. The clam shack and its 41 acres of waterfront land were sold again to a developer; another restaurant, Leo's Landing, took over the Bay Witch; a convenience store opened next to the post office; and a boat seller set up shop. While all this was going on, several large homes and many acres of land were sold, according to one native, *at prices and with plans that would make old timers turn over in their graves.*

Ice

In an area whose commerce relied on transporting seafood, chickens, and vegetables to cities hundreds of miles away, ice was a critical commodity. In the very early days when the weather extremes were much greater, the only sources of ice were the Bay and nearby ponds when they froze over in the winters. Special long saws were used to cut blocks of ice from them. Once cut, it was wrapped in a great deal of paper, rags, and sawdust to insulate it for storage in ice houses.

When the railroad arrived in Franklin City, ice made a round trip. It would arrive freshly imported from an ice plant in a city that the train passed through en route to Franklin City. It was unpacked and repacked around local seafood and produce headed back to city markets via the same railroad car that it arrived on. Later, ice was made in Stockton at a plant believed to be owned by the Stockton Power Company and then delivered by train or truck in large blocks to businesses in Greenbackville and Franklin City.

Although the Rural Electrification Act (REA) was passed in 1936 and literally made it possible to turn on lights in rural America, it had little effect in Greenbackville or Franklin City even though they were exactly the types of places it was designed to address. There appears to be only one reason that the REA legislation did not help these two communities—the early seafood industry's need for ice for shipping. That need was met by ice plants that required generators. These ice companies, with generators already in place, became investor-owned electric utilities. The arrival of electricity

was dependent on these private businesses building transmission lines that enabled them to offer electricity for sale.

Though privately owned power plants strung lines to these communities in the late 1930s or early 1940s, many households could not afford to pay for electric service. Consequently, it was not until much later that they had access to the benefits of electricity. Private business already had a stronghold as an electric provider, so the rural electrification movement that could have offered lower government subsidized electric rates did not come to these communities. To this day, this small remote area is still served by an investor-owned utility rather than a rural electric cooperative such as those that touch its borders to the north and the south.

Before electricity was readily available, most households had ice boxes. Another business was created by the need to hand deliver blocks of ice, typically 25–50 pounds, once or twice a week. Stockton's ice was delivered to homes in Greenbackville, Franklin City, Girdletree, and Sinnickson as well as Stockton. One person reminisced: *Three things I remember most about my summers with my grandma in Greenbackville—ice boxes, outhouses, and mosquitoes! We could always get her to chip off a little piece to suck on.*

Barter and Banking

There were no banks, savings and loans, or other financial establishments in either Greenbackville or Franklin City. In a town called Greenbackville, named after the new paper money issued after the Civil War, it seems strange that there was no banking establishment. This was likely due in large part to the communities being so far removed from larger population centers where banking and use of currency flourished.

In the late 1800s and early 1900s, local business was often conducted with some cash and a lot of bartering, good faith, and sometimes, even more elaborate systems of trading services and goods. The major transaction in the area was a waterman's sale of his catch on a cash basis to a broker. Once paid for the catch, the waterman was out of the profit loop. The broker would then package and market the seafood and see that it got to northern cities. Urban areas typically have a high demand for seafood; consequently, prices there are top dollar. The problem was that the waterman had already accepted cash for his catch so he seldom shared in the high prices paid for his seafood in the cities. Only the brokers and others who handled the seafood between the Bay and a dinner table profited from the sale.

Anyone with money could buy anything he wanted, but if your pockets were empty it was a different matter. If one person had something for

sale and another person needed it, its worth all depended on the age-old principle of supply and demand. *If there were lots of what I had for sale, it weren't worth much. But if you needed it really bad and I had what you needed, I could pretty much get in return from you whatever I wanted.* This truism applied to personal shopping at local stores as well as to the harvest and sale of clams, crabs, and oysters as well as chickens, corn, beef, pork, and lumber. Market-driven prices were nothing new to residents of Greenbackville and Franklin City.

Barter and exchange was an established custom throughout both communities. A woman remembered that as a child if she wanted candy from the store, *Mom would give me an egg. I'd put the egg in my pocket and walk to the store. I'd give the man behind the counter the egg and then I could have my favorite piece of candy.*

Likewise, if you had a skill, such as welding or mechanical ability, you could get into some good bartering. *When the motor on my drudge or the hay baler went up, all you needed to do was tell me what I had to do for you or give you in exchange for fixing it, and I didn't have a lot of choice if I wanted my family to eat.*

Cash and Carry Retail Businesses

Grocery stores, filling stations, and the like had long lists and file drawers full of notes and IOUs from people who very much needed their product but didn't have the cash to pay for it.

Usually the debts were paid as soon as possible but some were never paid. This system was in place in nearby Stockton clear up until the beginning of the 21st century when the last locally owned store there finally closed. The store closed for a number of reasons but it was speculated that one big reason had to do with the fact that the drawers full of unpaid debts were greater than any profit that could be made from the sale of goods on hand.

One storekeeper learned the hard way that if he did not get cash at the time of a sale his odds of getting it diminished in proportion to the time that passed after the goods were transferred to the buyer. Finally, he had to resort to a "no charges policy." His daughter remembered: *We just couldn't give them any more credit, they never paid. So they would go clamming, catch a bushel of clams, bring them to the store, and in return receive credit for fifty cents. Then, they could buy a nickel's worth of flour, a nickel's worth of beans, a nickel's worth of sugar, and so on until the fifty cents was gone.*

The same woman told another story reminiscent of the old adage about the shoemaker's kids going barefoot, although in her case it was the shoe

In front of this store the bench was usually occupied.

seller—her father. Most watermen were known for *spending money when they had it and going without when they didn't.* After an especially productive day on the water, a particular waterman's pocket was full. Even after a few drinks with his buddies, he still had some cash to spare. He showed up in her father's store wanting to buy new shoes for his daughter. The girl had just gotten new shoes in September for school and it was only November. The father insisted and the girl got the new shoes. After they left, *I asked my Dad how come she got new shoes when she didn't need them. My shoes had a hole in the bottom and I had to put cardboard in them till it wore out on one end and then I'd turn it around and wear it till it had a hole on the other end. I didn't even get new shoes every year for school.*

Businesses were started up because of need and the ability of customers to pay. They closed because the need was no longer present or the customers could no longer pay. It was as simple as that. The stores that catered to those with the most money—the millinery shop and the ice cream parlor—were likely the first to go. As the seafood industry declined, boat repair, shucking houses, the barrel factory, and dozens of other businesses no longer had a market for their services and they closed. It was the grocery stores and the barbershop that stayed open until the very end.

SHAVE AND A HAIRCUT
In rural America, there were, and still are, a limited number of gathering places available to men.

Greenbackville's barbershop was not only a business, it was an institution. It primarily served the men of the community and surrounding area but also occasionally cut the locks of women and children. It was a landmark, a gathering place mostly for men, a debating society, a weather station, a place to get insider fishing and hunting information, a travel planning agency for adventures on both the land and sea, a hangout for the male *old heads*, a source of information about moonshine and bootleg whiskey, and generally the town's men's club.

In rural America, there were, and still are, a limited number of gathering places available to men. With the exception of the occasional woman's or child's haircut, women and children were generally not welcome or comfortable at the barbershop. This was not out of the ordinary as women only began to appear in traditional men's establishments such as bars, barbershops, and the like after the mid-point of the 20th century. Children, then and now, generally are not encouraged to frequent adult male places of business or hangouts.

Saturday mornings at the barbershop were busy times. *I'd go in there on a Saturday and there'd be four men ahead of me and I had to sit and wait my turn. That was OK with me because the barber liked to tell stories and talked to everybody. Generally it took the whole afternoon to get a haircut. My mother would send me there when I really needed it cut so I'd sit there quiet and listen and wait my turn.*

Another boy was given a quarter to get his hair cut on Saturday morning and was in big trouble when he arrived home at 4:00 that afternoon. He read the situation correctly and preempted his mother's wrath. He walked through the door and said, *Look Mom, I got my hair cut and made $2.50.* That was a lot of money in those days so his mother expected a full accounting of how he had gotten it. When questioned, he said, *Aw come on, all I did was sell my turn in line to those boys in a bigger hurry than I was. I told 'em if they paid me a quarter they could have my place and I'd go to the end of the line. Next time I got to the head of the line I'd do it again.*

The enterprising nephew of the barbershop's owner, whose shoe shining business often resulted in his being summoned to the barbershop, was an exception. *For some reason, I used to like to listen to the old heads talk. Whether they were talkin' 'bout oysters, buildin' a boat, or whatever they were talkin' bout . . .*

usually it was somethin' simple. I liked to hear 'em talk. I could go in an' out of the barbershop 'cause my uncle owned it and his son and I were always playin' together. He'd never say nothin' to me but it wasn't a place where too many kids went . . . I knew to keep my mouth shut an' stay out of the way. On Saturdays, I used to shine shoes. I had a box with all the stuff in it so I'd take it in with me. Pretty soon, someone would put his foot up on it an' I had a customer. I charged 10 cents for shoes and 15 cents for boots. I liked boots best 'cause I made more money and could work on 'em for 20 minutes or more an' at the same time hear more talk. I never asked them if they wanted a shine. I'd just work real hard and pretty soon another one would say 'Come on over here when he gets through' and I'd have another customer plus a good cover to be there with the men listenin' to their stories.

For the most part the barbershop was male territory, but every now and then a woman or girl would invade its inner sanctum. For example, a girl might have her life-long braids removed there because her mother couldn't bear to do the deed. When a young girl's hair was cropped, at least for the first time, she was rewarded with a big white bow.

One memory was of a mother who was a friend of the barber's wife. As she got older, she'd get her friend's husband, the barber, to cut her hair as short as he could get it. *She'd have him scalp her! I used to say to myself, 'I do not believe this!' I really didn't like it at all. I couldn't imagine why she wanted it that way. An' now that I'm older what do I do? Get my hair as short as I can get it. When I go by the graveyard today, I say 'Sorry mom, now I understand.'*

FILLING THE CANS
It was a hustle bustle.

The scene was always the same: no air-conditioning, large noisy fans running constantly, a big conveyer belt, a concrete floor covered with wooden pallets for workers to stand on, big buckets with numbers on them, tokens dispensed as a record of each bucket peeled, tomatoes steamy from scalding, tomato skins everywhere, sharp knives, and fast hands. The factory was open for business when the tomatoes ripened fastest and the heat and humidity was greatest—roughly eight weeks between mid-July and September. As one might expect, it was a little slow at the beginning of the harvest, ramped up to full capacity for a few weeks, and then slowed down again as the tomatoes were *picked out*.

There is hardly an adult alive from Greenbackville or Franklin City who doesn't have a canning factory story. Almost everybody seems to have

worked there some time or another. All agreed that money was the only reason to endure working at the cannery, but no one reported getting rich while doing so.

Men did the heavy work of lifting and operating machinery, women did the peeling and filling of cans, and children helped with cleanup. Jobs were specialized and included such things as *unloading trucks, scalding the tomatoes, putting empty buckets on the conveyer belt, dumping the buckets full of the peeled cored tomatoes, putting cans on another belt to be filled, sealing cans, labeling, boxing the filled cans, and loading boxes on a railroad car or a truck for shipping.*

The Peeling Line

The daily drill on the peeling line was well defined, or so it would seem, since it can be recited from memory by every woman who worked on the line. They arrived for work dressed in everything from jeans to housedresses but before they started each one was issued a rubber apron and sharp knife. Some wore galoshes or rubber boots with the tops cut off so their feet would stay dry. Each woman had an assigned number. *When we arrived for work, we each went to our spot on the line and stood*

These women and hundreds of others like them worked in the canning factory. (Courtesy Brice Stump.)

on a wooden ledge made from the pallets that were left over from shipping in the cans. Each of us waited for the bucket with our number to come around on the conveyer belt. Once you had your empty bucket you pulled a basin of just scalded tomatoes from the conveyer belt to you and peeled them into your bucket as fast as you could. Some really fast peelers wrapped tape around the thumb of the hand that held the tomato. When you were peeling fast, you'd like to take off your thumb and never notice the blood with all that tomato juice and peel around. I taped my thumb rather than wear gloves 'cause I could work lots faster.

For eight hours a day, five days a week, and half a day on Saturday, a peeler stood doing only one thing—peeling tomatoes. The only break in that routine was a half hour for lunch. It was a long day. *On the peelers' line you earned one token* [early on worth 5¢ and later 25¢] *for each bucket of tomatoes you peeled. On a good day one of us could earn eight tokens. For two dollars a day? We all hated it!*

If any of the tomatoes in a bucket arrived at the dumper's post with skins on them or cores still in, the whole bucket was returned to that peeler. That peeler would then have to go through and be sure each tomato was done completely and then return the bucket on the belt. You didn't get your token till every tomato passed inspection. It was better to do it right the first time—nobody wanted to have their bucket sent back because that wasted time that you could have been starting a new bucket with.

As I think back to those days on the peeling line, I remember that little pouch where I kept my tokens. Each time my empty bucket came back with a token in it, I took my token and put it in my pouch that I tied to my apron. I didn't count them as I went along, I just kept working. At the end of the shift, I had to put my tokens in the box by the office that had my number on it. I made a game of guessing how many there would be, but I almost always knew exactly. You don't peel a bucket of tomatoes and then not remember it! We only got paid once a week. We got a check instead of money because they had to do all the government deductions at the office.

Anyone who has ever worked with tomatoes knows that tomato worms are particularly big, fat, ugly, and very *gushy*. During the peeling process, the peeler had to get rid of any worms that were in the tomatoes. Women on the line were neighbors and friends so, of course, they teased each other. *I just hated the worms! All the others knew it so as soon as they found a worm, they'd figure out which fan was blowing my way and throw the worm in the wind from that fan and that worm would come flying' right at me. I ducked if I saw it comin' but more times it got me! An' then they'd all laugh.*

One woman on the peeling line whose husband was a bucket dumper said, *when he and I were both working, he would sometimes tease me by not dumping my bucket and sending it around the belt a second time full. He said he knew I would know it was his way of giving me a break since I never left peels or cores in. If an inspector was around, he'd always empty it and give me my token.* Of course, every time she failed to do a new bucket she was also a token short for the day.

By the end of the week, rubber aprons were stained red from all the tomato juice. Even if the apron was washed every night with great care it was still stained red. *The only way you could get the stain out of that apron was to wash it good as soon as you got out of work on Saturday and let it hang outside in the sun until Monday morning.*

You couldn't talk very easy when you were on the peeling line. The fans were really noisy and the machine that ran the belt was noisy, and all those metal basins and pails were noisy as they were moved around. But you know how it is—you get a bunch of women together and they'll always find a way to talk. We yelled at each other above the noise but we never took our eyes off those tomatoes and our hands and knives kept peelin'.

Though we think of the concept of job sharing as a fairly recent phenomenon, a few women who worked on the peeling line worked part time. *We split our days. She worked half and I worked half. I had young children that I couldn't leave all day and she had weak legs and couldn't stand all day. We both had different numbers so it didn't matter that I was there in the morning and she was there in the afternoon. One of us was always on the line.*

Time Workers/Can Fillers
Unlike those on the peeling line who were paid by the bucket, those who filled cans with the tomatoes peeled by others were paid for the time they worked, not the number of cans filled. Hence, they were paid more than the peelers.

When the conveyor belt stopped because the electricity went out or a part broke, *the supervisor recorded a stop time for each girl and they had to stay where they were because the belt might start again anytime. They didn't get paid for the time the belt was stopped 'cause we weren't fillin' cans.* When the belt restarted, the supervisor was responsible for clocking in a re-start time for each worker on the filling line. *Here she comes with the tablet!* was a warning that the supervisor was going to watch each filler and record the exact minute when the conveyor belt delivered an empty can to her place on the line. Only then was she considered *back to work.* The first person on the

line always got an earlier restart time than the last person and consequently, more pay. In this case, it literally paid to be first.

Filler jobs were usually held by women but sometimes a responsible teenager was promoted from the cleaning crew to be a filler. Teenagers being teenagers, they worked hard to dream up things that they could slip into the cans without detection before they were sealed. A favorite was hot dogs. One 65-year-old native son remembered himself as one of those teenagers: *We had to experiment. You couldn't do four hot dogs to a can 'cause they'd expand an' blow the can up an' that'd stop the whole line. We only did that a couple of times. We found out that one or two was just about right. Don't know how many city folks bought their canned tomatoes an' got a hot dog too!*

Office Workers

There were a few people who worked in the office. They were considered to be the fortunate few and usually had been promoted from the peeling line or filling line. They performed many clerical jobs such as accounting and helping with payroll as well as keeping track of inventory and production. Most believed these workers were paid more than all others.

Cleanup Crew

What really surprises me as I think back about it was the cleanup crew. Almost all the kids in town were part of that crew along the way. Kids wanted their 12th birthday to come so they could get a job on the cleanup crew. Well, the truth is, it wasn't really legal to hire the kids until they were 16 but at our factory, everybody knew the game. The kids who were under 16 worked until the inspector showed up—then, they'd hide or leave till the inspector was gone. A favorite hiding place was the outhouse—not a good place to be on a hot humid summer day but better than lettin' the inspector catch you an' getting fired.

Everyone agreed being on the cleanup crew was a dirty job but someone had to do it. It didn't require using a knife, lifting, scalding tomatoes, or even moving boxes full of cans. All it took was time and toil and one adult to supervise. Early in the season, when things were getting started, the cleanup crew only worked two or three days a week. When the factory was running at full tilt the crew worked every day—only then did those children see a full paycheck. *I'll always remember that night that my daughter got her first full paycheck from working on the cleanup crew. She all but fell through our front door covered with tomato peels and juice stuck to her everywhere. She had a brown pay envelope in her hand. The first words out of her mouth were 'I'm Jackie Onassis'—she thought she was rich. We've laughed about that a lot in the*

years since but the money in that pay envelope was the most money she'd ever had in her whole life an' it was all hers.

Community Impact

This seasonal business brought an important source of income to individuals in the community. It also contributed to the economy in a variety of ways. One such injection of money into the local economy resulted from the noontime bus that brought cannery workers to stores in downtown Greenbackville for lunch. *Every day at noon, they'd come up an' get spiced ham an' bologna. I remember as a child, I couldn't wait to see all them people. It was a hustle bustle.*

KID'S WORK

That wasn't work for money, them was just our chores. They had to be outta the way or we'd be in trouble. What we did to get our own money, that was something different!

Children in most homes in Greenbackville and Franklin City contributed to the family by doing chores, but they also worked for money. Sometimes a kid's chores were part of a family's business—working on the water, helping in a store, or delivering things. In those cases, there was usually no money earned—it was simply what you were expected to do. On the other hand, boys and girls who could find a way to be useful and get paid for it usually were

Regardless of age, all kids had chores. Feeding the chickens was something even a three-year-old could do.

allowed to keep the fruits of their labor. Money earned by the sweat of the brow is always recalled fondly especially when it was among one's first jobs.

Some of the jobs involved pay while others did not, but clearly they were all seen as work:

> **Delivering milk**—*In the morning when I left for school my mom would pack my wagon with milk bottles wrapped in paper so they wouldn't break. I'd deliver them and then leave my cart in a yard near school. After school I'd wheel the cart home and mom would pack it up again and I'd deliver milk in the afternoon to a different set of houses.*
> **Shining shoes**—*10¢ is what most would give me for shining a pair of shoes but boots were 15¢. I did that for a long time. I had my little shoe shining box and I always was ready. I did best when I could get inside the beer joint, but soon as my dad saw me there I knew to finish up what I was doin' and get outta there.*
> **Delivering eggs**—*My granddad and I delivered eggs all over town. Sometimes we'd just trade 'em for other stuff at the store.*
> **Cleaning up at the Canning Factory**—*It was messy but we made real money.*
> **Delivering ice**—*As soon as I was big enough to carry ice in the tongs, I started delivering pieces to people who had ice boxes. Some got a 20¢ piece and some got a bigger 40¢ piece.*
> **Selling seeds door-to-door**—*I'd walk a route of 11 miles.*
> **Delivering papers**—*Soon as I was old enough, 10 or 12, I'd deliver* The Grit *out of Pennsylvania and when I got older* The Salisbury Times. *When I started I had 21 customers and built to 64 but never could get 65. They had contests and I won baseball gloves and other junk like that.*
> **Clerking in a store**—*During the winter months, I clerked in a store for a man who had a heart attack. I'd open up at 6 a.m., catch the school bus at 8 a.m., and then come home and work there from 4:30–9 p.m. I made $15 a week.*

One person wanted to make it clear: *We did chores—that was one thing. We slopped the pigs, milked the cows, worked with our dads on the water, and cleaned the privy. The girls helped with the canning, did the dishes, burned the trash, and took care of the chickens. That wasn't work for money, them was just*

our chores. They had to be outta the way or we'd be in trouble. What we did to get our own money, that was something different.

WORKING THE LAND
We just don't know if it's worth it.

For about 70 years between mid-1800 and 1920, the seafood industry dominated life in Greenbackville and Franklin City, but the real roots of these towns were in agriculture. The land was granted by the Virginia Company to its individual investors or those who served as indentured slaves and earned their freedom. Over time it was passed down in families, divided, and otherwise fragmented from the original land grants. When Greenbackville and Franklin City were created, they were carved out of what was seen as useless marshland on the edges of two farms.

Anyone who flies across this country knows that farms and fields from the midwest to the west coast are not only large, for the most part they are squares and rectangles. This is the handiwork of surveyors who after the Louisiana Purchase determined, according to the Jeffersonian grid, how land would be divided and owned. Long before Jefferson mandated an ordered scheme for surveying, Eastern Shore lands were divided into farms and plantations by a system of "metes and bounds" (defining land parcels according to visible natural landscape features and distance resulting in field patterns usually very irregular in shape).

Original land grants on the Eastern Shore of Virginia were strips of land that spanned many acres between the Chesapeake Bay and the ocean. These strips ran all the way up the peninsula from the Hampton Roads area. The dividing lines between land grants were usually creeks, old Indian trails, and other natural landmarks. As the original owners passed on, the larger grants were divided between heirs and others; consequently, farms became even smaller and property lines more erratic. As with many other things on the Eastern Shore, the patchwork of farm lands follows no logical pattern.

Family Farms
With the process of dividing farms into smaller and smaller units with each generation, small family farms became the norm by the 1900s. One such farm was described as follows:

Dad bought that farm out on the edge of town with the idea he'd have a little somethin' to do when he retired. 'Course we lived there from the time I was

seven. Because he was a conductor on the train, he was gone every day except Sundays. First thing he did was buy a cow but 'course it was up to my Mother to milk and take care of it as well as the chickens, ducks, pigs, mule, and garden.

One day she said 'Come on out here, I want to show you how to milk this cow. You know she has to be milked twice a day an' I could be sick some day and you'd have to milk her.' Well, I never did get the hang of it. I don't know, I don't think I wanted to learn to tell the truth . . . I can remember one time I was in the brooder house, she'd just got the little biddies in, an' I stepped on one and crushed that biddie. I ran down the road hollerin' and I never would go in that brooder house anymore, never.

I delivered the milk from the cow to my mother's customers but I had it in my mind I should try to be more helpful. I especially liked cats so I tried to build a fence for all the strays I could find. Sort of my own farm of cats! My mother went along with it. I guess it gave me something to do, but you know that wasn't ever goin' to work.

We never were hungry. My mother canned all summer from the garden, they'd butcher a pig sometimes in the fall, and of course, there was the cow and chickens that produced eggs and meat too. What we didn't have much of was seafood. An' oysters, oh how I love them. One day I found a quart in the icebox and every now and then would snack on just one more. My mother came home and was not happy: she was keepin' that quart for a neighbor!

Today

In modern times, on the Eastern Shore as elsewhere, it is difficult to survive or make a living on what is traditionally known as the family farm. In the first place, the farms have been divided so many times that they are too small to graze large herds of livestock or plant many acres of crops. In the second place, the economy of scale, large equipment, commodity markets, and other factors have driven the trend to specialization in farming. In other parts of the country, these facts of life have led to agribusiness—big companies buying up the family farms and operating their enterprise as more of a corporation. That day may come to Virginia's Eastern Shore, but so far individual ownership of farms is still the norm.

Today, serious farmers on the Eastern Shore have very few large tracts of land available; therefore, they must work a collection of what used to be several smaller farms. This happens in three different ways, all of which reflect the fierce independence that blends with the need to help each other. When you live in a rural area on the edge of the continent, survival can depend on cooperation. Sometimes, a father and sons will work several farms

together, with ownership being spread among them. Others will form a loose cooperative with several neighbors and work their farms jointly. And a few others consider themselves more businessmen than farmers and will buy every small farm that they can and then hire labor crews or migrant workers to farm them. These latter ones are an Eastern Shore mini-version of agribusiness. But it is local agribusiness, not controlled by a large corporation that is owned and managed elsewhere. This is consistent with the strong measure of independence and individualistic attitude found throughout the area.

Because of the mild climate and long seasons, any given field can produce several crops each year. For example, potatoes planted in March are usually followed by soy beans or string beans or other vegetables crops. Winter wheat is usually followed by soybeans. Depending on available rainfall and other growing conditions, hay is mowed and baled at least two to four times a summer. On the other hand, corn and tomatoes are full-season crops.

Another major way to farm is raising chickens. Not a little flock for your own family, neighbors, and friends; rather, tens of thousands of them housed in giant long houses on farms across the Peninsula. Raising chickens is done by a lot of farmers on the Eastern Shore but few of them do it exclusively. The land and chicken houses are owned by the farmer, who has stewardship of the flock from the day chicks are delivered until six to nine weeks later when the trucks arrive to take them to the processing plant. Each farmer has an arrangement to grow for a particular producer whether it be Perdue, Tyson, or Mountaire or some smaller production company. That agreement includes how they will be cared for, what they are fed, when they go to market, and the like. Much of the work is automated but that doesn't mean the farmer can walk away from this responsibility. There are always equipment malfunctions, diseases, power outages, weather events, and if that isn't enough, before the next flock arrives, all the houses must be cleaned.

Although they are few and far between, there are two other types of farming that occur in modern times. They are the U-Pick farms and the several-acre farms specializing in one crop or another. For example, strawberries and peaches are often U-Pick crops while the local delicacies—Hayman potatoes, Eastern Shore cantaloupe, tomatoes, cucumbers, turnips, and the like, are regular offerings at road side stands. In both cases, the farms are somewhere between the large operations and the family farm and usually consist of several acres. These smaller crops are more than any one family could consume but not enough to make it economical to take them to larger markets. The harvest is sold in three ways. One way is when consumers pick their own produce and pay, usually by the pound. A second way is to buy

from un-staffed, very small roadside stands near fields or orchards where the harvesting is done. These roadside stands consist of a display of whatever is ripe or in season, a hand-lettered sign announcing the prices, a container of plastic Wal-Mart bags, and a mayonnaise jar where the passing motorist deposits his money for the produce. Often, there is a dog chained near the house who earns his or her keep by barking to announce that someone is at the stand. If you come along and want to buy something and don't have the right change, you can make change out of what's in the jar or just leave a little extra if there's no change available. The third way these harvests are sold is in larger, staffed roadside stands on major thoroughfares. In all instances, the prices generally are much lower than any chain grocery store and the produce is many days fresher than that found in grocery stores.

The bottom line is that farming is hard work and the payoff is uncertain. Much of the work is done during the heat and humidity of the summer. Even when the planting, fertilizing, and harvesting is done correctly, the outcome is often out of the farmer's control due to rain, hail, wind, and other factors over which there is no control. Farmers with large acreage and herds have additional market issues related to the cost and operation of large equipment, plus supply and demand that affect their take-home results. Regardless of all these negatives, you'll not find a person alive who calls himself a farmer who doesn't love and respect the land and his way of life. Sometimes there is a large paycheck at the end and other times, the farmer of a few acres is barely getting by and can only keep working the land by holding down another job. But every year they seem to go on farming. Large farm or small, a phrase that is often heard is *We just don't know it if it's worth it.*

WORKING WOMEN
Most able-bodied women had to work outside their homes to help make ends meet.

Many women in these towns worked outside the home, or at least those alive to tell their stories did. Life was hard. Other than those few who inherited money or were part of a well-off family, most able-bodied women had to work outside their homes *to help make ends meet.* In addition to cooking, cleaning, and being a wife and mother as well as the household and financial manager, many also had an employer to answer to. Until the 1950s, when the towns began to decline, there were many local opportunities for working

women. Canning factories, oyster and clam shucking houses, stores, shirt factories, eating and drinking establishments, and farms all were employers of women.

Field Work
The work was primarily physical labor and they got paid in cash each day they spent in the field. They worked for farmers picking tomatoes, strawberries, string beans, and other truck farm crops. In the early days the Eastern Shore was the country's largest producer of strawberries, but once the railroad left, there was no cost-effective way to get them to market. It was hard physical labor performed in the hottest part of the summer along with the sun and humidity. The farmers were hard taskmasters. For example, in the string bean fields, they would not accept loosely packed baskets and containers. More often than not, the picker would come to turn in the fruit of her labor and the farmers would *push down* the produce in the basket and send her back to the fields to fill it to the top. Today, much of the harvesting is done by whole families of migrant workers who likely have no easier time than these women.

Canning Factory
There were two different tomato canning factories—one near the Harbor and one closer to the northwest end of Franklin City. They hired women to peel and prepare the tomatoes for canning. There were also a few office jobs at the tomato factories. It was a real step up to go from the factory floor to an office job. Tomatoes being seasonal meant that these jobs were only available in the late summer and fall. Consequently, they were second jobs for most of the women.

Other Food Related Work
Serving as a cook or waitress in local restaurants was another work option for women. Home canning fruits, vegetables, and meat for home use and for sale was another way women brought in money to pay the bills.

Water Women
Women worked beside their men in the water trades as often as not. In the winter months, it was bitterly cold and working near or on the water multiplies the chill. It is wet, heavy work, but if it was a family's livelihood, you could be sure the women of that family were involved in some way.

If your husband ran a clam business you had a lot of experience sorting and bagging clams as well as keeping the books and carrying on if he got sick. Likewise, if your husband had a crab boat it was highly probable that you would be the crew. Working on the boat all depended on your children being big enough to be left alone or you being lucky enough to have a good neighbor or family to tend them.

Women made crab traps by cutting and forming the chicken wire into the tools of the trade for both commercial and recreational crabbers. *It tore up your hands and you had to be strong enough to bend and control the chicken wire.*

Post Office

The post office hired women as clerks and later as postmistresses—the only professional position held by women in town. For many years, as stores and other businesses closed, the post office was the only commercial establishment. Usually the postmistress was the only person in town receiving a regular salary, paid holidays, and a retirement plan.

Housewife

Seldom did a mother, father, and their offspring live under one roof without a few additional people being there too—grandparents, aunts, uncles, cousins, and perhaps a local person who had no family. Without modern conveniences and appliances, housekeeping took more effort and energy than any full-time job! As one son said, *My mom was something. In addition*

Many women worked in local sewing factories and a few "sewed for the public" at home. (Courtesy Brice Stump.)

to taking care of all of us, she cooked full time at a restaurant, canned every vegetable and meat you ever heard of for our use and for sale, and when anyone was alone and sick you could be pretty sure she'd bring them home to take care of and sometimes to die under our roof.

Factories

Some employers of women were sewing factories in Snow Hill and Salisbury. Others were food processors that made ready-to-eat foods and were located in nearby Pocomoke, Stockton, and Snow Hill. This work was only available to those who could get to the factories 10–40 miles away, so many carpooled. Like modern women, they had to fit the commuting time, the factory job, and home and family into their day. Some also had second and even third jobs when their shift was over.

A daughter of a working mother remembered, *One of the saddest things for me was that some of my friend's mothers didn't go out to work an' it seemed like they had a cozy little home life. My mom worked, she was always tired, supper was not made on a regular basis, you know what I mean? I wanted her there. Matter of fact, talking about it hurts me. I remember one Christmas Eve she had to work—I was so devastated. She started out at Birdseye on the line but as the years progressed she got to be a government inspector. She worked all of her life an' her health wasn't good. She was always tired an' cranky. I wanted that apple pie. Consequently, because she was tired and worn out there was a lot of arguin'... My sister was prim and proper an' kept the house all straight and I was a tomboy an' always messed it up. What people remember about me was gettin' on the school bus half-dressed with a Pepsi in one hand and Tasty Cake in the other.*

Retirement

After a lifetime of the hard work these women did, they do not take easily to retirement. One woman's son took her to the grocery store every Friday to take advantage all year long of all kinds of sales, especially sugar; then, at Christmastime she made 85 pounds of fudge for her children, grandchildren, friends, and neighbors. Another cooks supper for her grandson and his girlfriend two to three times a week and keeps very busy preparing and planning it. Still others, living alone, have a garden big enough to feed a family of ten. And many, just when their childcare days are over, are engaged, by necessity or choice, in helping raise their grandchildren. Often you hear them say: *Sitting in the rocking chair just isn't for me!*

SALTWATER LUMBERJACKS
Serendipity or luck, the nearby landowners had their forest harvested and the lumberman had a new very productive site with a railroad nearby for taking the lumber to market.

In the early 1900s, lumbering was done by moving all the equipment, manpower, and workers' families to a given tract of land with sufficient trees. Back then, it was not simple. The mainstay of such a business was a very large steam boiler plus the belts that drove power from the boiler to the large saws. In addition to the saws there were blades, tables, and the machinery necessary to support the saws and large logs, crosscut saws, ropes, cables, tools for handling large logs, and oxen. All of that had to be moved, usually by train, once the lumber was harvested and the tract was cleared. Every time the operation was moved, entire families and all their possessions also had to be relocated. Today, harvesting lumber as well as moving about is a much easier process with motorized equipment, cranes, large trucks, tractors, power saws, and the like.

Both Greenbackville and Franklin City were laid out from marshland. Within their boundaries there were hardly any large trees to harvest nor businessmen or workers who knew how to make money from trees. Nevertheless, there was a need for new lumber to build the growing towns. Fortunately, there was a virgin forest of over 1,500 acres in Sinnickson—just a couple of miles around the shoreline from Greenbackville. That tract was owned by a man and his brothers. These owners had no expertise or desire to do the work necessary to harvest the forest, so they hired a man with a lumbering business who had recently resettled in the area.

This man and his lumbering operation first settled and worked on a tract of land well to the south. They landed there because, back then, the only way to move such an enterprise was with the railroad and that's where the railroad went. Once the lumberman's first tract in Virginia was cleared, he began looking for more forests to harvest. This search brought him to Horntown, just south of the 1,500 acres of virgin timber. Serendipity or luck, the nearby landowners had their forest harvested and the lumberman had a new very productive site with growing communities and a railroad nearby for taking the lumber to market. The great-grandson of the lumberman remembered some of what his father told him: *They'd take the operation right to where they were workin'. First, they'd have to clear an area to work. Then, they'd set that big ole boiler up, get the belts adjusted just right, level the saw table, and build a big fire from the trees cleared so the boiler'd get hot enough to produce steam, which drove the belts and then the saws.*

While all that was happenin' a couple of crews would be cuttin' down trees. By hand with a crosscut saw—that's a large saw, some were eight foot long an' I've seen 'em long as 12 foot. They were run by a man on either end pullin' it back an' forth—no chain saws, no motorized anything. They had to be smart too 'cause you had to figure where the tree would fall and you wanted that to be somewhere that the oxen could get to an' nobody'd get hurt. They'd control the fall by notchin' and sometimes drivin' wedges at a place on the opposite side of where the sawin' started or where they wanted it to go over. Then, they'd start sawin' till the tree went down. That was the easy part, then' they'd have to trim 'er up and saw through that trunk as many times as necessary till there was nothin' left but 12 or 13 foot long logs. They'd get the oxen and hitch 'em up to the log—sometimes double-treed and sometimes single—an' the oxen would drag them to where the steam boiler and saw was. If they were way big, they'd use a sled to keep 'em from diggin' into the ground an' to save the oxen some work. Sometimes, they'd do three or four trees a day. Man, we don't have any idea what kind of strength they had.

When my father was 12 or 15, he was taught to drive the ole truck that had solid rubber tires—probably a good thing otherwise with all the weight, they'd probably have been flat all the time. The men at the site'd load up the truck an' then one night my grandfather'd tell my dad he didn't have to go to school the next day, he could take the truck of lumber to Franklin City and get it on a railroad car. My dad loved that—not havin' to go to school. He worked hard tho'. He'd get up there and put the truck long side the railroad car an' by himself, he'd offload all the lumber and pack it on the car. Sometimes it would take a half day or better. An' then the lumber was off to Philadelphia, Baltimore, New York, and wherever. When he'd drive up or back to the railroad, folks would stop him and put in orders to bring lumber right to building sites in Franklin City an' Greenbackville. An' you know those builders had a time; it was all green wood and rough hewn—no planes, sanding, or even necessarily straight boards. When you put a nail down thru green wood you know it is gonna warp. I expect 80 percent of the lumber in houses in both those towns came from right here in Sinnickson.

MAKING HAY AND DRUM FISHING
That's the trouble with farmin', ya account for everythin' and then somethin' you have no control over comes along and bites ya on the butt.

There is hardly a resident of the Eastern Shore who fishes and has gone on a quest to catch drum, who doesn't have stories to tell about those adventures. This is one such tale.

Once the waters begin to warm in the spring, migration of the drum begins. As they move from warmer southern waters to their summer territories, they pass along Virginia's Eastern Shore. Many congregate around the mouths of bays to take advantage of the array of tasty morsels that wash from the bays into the ocean as the tides change. It is not unusual to hear of a 30–50 pound drum, and occasionally a 70 pound or bigger drum is boated. The red drum is a smaller variety of the flavorful fish while the black drum is larger. Today, due to overfishing and pollution in Virginia waters, it is illegal to possess the red drum. But in earlier times, both kinds of drum were far more plentiful and it was the catch of choice in the spring.

Half a century ago, a local farmer was in the never ending race to get his hay cut, dried for a few days, and baled before a thunderstorm would pop up. Without fail, there would always be complications, not the least of which could be a breakdown of machinery. *I was bound on getting' the hay up this one day and wouldn't ya know the baler went up. I messed with it for a while but I couldn't get it goin' so I got in the car and went down to see my neighbor who was a good mechanic.*

When he got to the door step of his friend the mechanic, he found the mechanic and his man were working on another piece of broken farm machinery. The exchange went something like this:

> **Farmer:** *I'm out there tryin' to get the damn hay up before it rains and then she goes an' blows a tie rod.*
>
> **Mechanic**: *Well just a minute. First, we'll have a little drink and my man here will finish this job while we go have a look-see. Two fingers or three? Depends on where she's broke—a weld may not hold 'er. If that's the case, we'll hav'ta have the part shipped and you'll be outta commission till it gets here. Maybe we better take another nip with us for the road.*

They both go to the field to examine the problem and determine that the weld will not hold and a part needs to be ordered. They return to the mechanic's shop to look up the part numbers and make the order. When they return, the mechanic's helper appears to have had another drink or two while they were gone.

> **Farmer**: *That's the trouble with farmin', ya account for everythin' and then somethin' you have no control over comes along and bites ya on the butt!*

Mechanic: *Just don't get your bowels in an uproar, we'll all have another drink. There's nothin' we can do right now but order the part and then we should go drum fishin'. Besides ya know, you're never gonna become a Shriner if you don't study your rituals with me.*
Farmer: *Ya know I did a favor for that boy three farms over and he owes me one, guess I'll call and see if he'd come finish up my hay. By God, I'm a wheeler an' dealer an I'm not gonna lose what I got invested in that hay.*

The call was made, the other farmer agreed to finish the hay, and all were free then to go drum fishing.

Mechanic: *Go get your fishing pole and tackle. My man will hitch up the boat to the truck, and we'll be on our way. But, for good luck we should first have another drink.*

As preparations were made, many more drinks were had and finally they were off driving and drinking their way toward the boat ramp. When they arrived and the *boat went over* (local term for launching the boat into the water), the farmer and mechanic determined that the mechanic's helper was quite inebriated. Being ever responsible, they determined that it would only be safe if they tied a rope around his leg and made him sit in the bottom of the boat.

All gear and personnel secured, they motored off toward a spot where they hoped to catch drum. It was such a pretty day, they decided to slow down, have another drink, and troll a few lines along the way. As they were putting lines out, the mechanic's helper was supposed to shuck some clams that they brought along for a snack. Shuck them he did; but, in his somewhat drunken state, he threw both shells and the clams overboard. Even before they reached the fishing site, their troll lines began catching large drum that they pulled in one after another. Their lunch—the shucked clams that went overboard—had acted as bait and schools of drum followed them wherever they went.

4. Life Goes On

Just as the sun rises and sets everywhere, there are some aspects of life that are fairly universal. As these routines are woven into the fabric of lives they become the substance of memories.

Looking back through the perspective of today's economic and educational standards, most of the tellers of these stories said it was a hard time and that they were poor and uneducated. They also said that they were lucky and rich in ways that cannot be measured in dollars or degrees.

The descriptions and tales speak to the strength of character, creativity and innovativeness, intelligence, sense of humor, caring, ability to cope and master new challenges, and the sheer heart and determination of these people.

WE TAKE CARE OF OUR OWN
He said he had to help his neighbors—they came first.

Though no community is without day-to-day petty irritations among its residents—from the person who monopolizes the party line to the gossiper who too often gets the story wrong—it is fair to say that Greenbackville and Franklin City were caring communities. There is so much evidence of this over so many years that this truth is seldom openly discussed, so one must listen to the stories before the picture comes into focus.

Newlyweds
One of the native sons of Greenbackville courted a girl from a nearby town. Finally, they decided to get married and he brought her home to Greenbackville. In this case, the groom said, his new wife was not a come 'ere. *She came as my wife and so she was my family. I brought her into the fold, so I call her a bring 'ere and that's different!*

The new young couple *didn't have two wooden nickels to rub together.* Times were tough and it was unlikely that their situation would change in the foreseeable future. They had love and got by; but, many of what today

would be considered necessities were missing. For example, they had no washer or dryer and only one set of bed linens.

Once a week, the new wife would strip the bed of their only sheets and pillowcases. Along with the rest of her laundry, she would walk to her mother-in-law's house, do her washing in the mother-in-law's washing machine, and take it all back home to hang out to dry on the clothesline. After several weeks, neighbors, not wanting to be *butt-in-skis* but also keeping an eye on this new woman in their midst, began to talk among themselves. Their observations were that the same sheets and pillowcases dried on the line every week. Soon they figured it out—the newlyweds only had two sheets and two pillowcases.

In no time at all, the word was around town and a shower was planned. The organizers subtly let invitees know that they probably could use things to set up housekeeping—especially a few more sheets and pillowcases. The day of the shower, the women arrived with their gifts and the festivities began. The recent bride began to open her presents. *The first gift was pillowcases.*

> *the second—more pillowcases,*
> *the third—still more pillowcases,*
> *the fourth—checkered pillowcases,*
> *the fifth—flowered pillowcases,*
> *the sixth—striped pillowcases,*
> *the seventh—blue pillowcases,*
> *the eighth—white pillowcases,*
> *the ninth—small pillowcases,*
> *the tenth—large pillowcases, and on it went.*

That day ended with the newlyweds being proud owners of 22 sets of pillowcases—nearly enough to last a lifetime!

Adopted Mom

A story of caretaking and empathy was told by a woman who became Mom to another woman's child. As she told the story, it was clear it wasn't the first time nor was it likely to be the last time that she stepped in where there was a need. *My daughter's best friend's mother and father separated. The mother took the two younger children with her to her new home but left my daughter's teenage friend to live with her father. When her father decided to go back to his parent's family out west she became a part of my family. She lived with us for several years and to this day she calls me 'Mom.'* The smile on her face as

she ended the story made it clear she was pleased to be called Mom by this adopted daughter.

To The Rescue
When the 1962 nor'easter came, what was left of Franklin City and Greenbackville was forgotten by emergency officials. Many talk about helicopters evacuating Chincoteague Islanders and how much federal and state aid went to the Norfolk and Hampton Roads area a hundred miles to the south. No state or federal aid came to Greenbackville or Franklin City. Whether this was a result of officials' oversight or fierce independence and telling outsiders they needed no help is not clear.

When those with boats were sure all Greenbackville's citizens were safe from the three days of high tides and gale force winds, they headed to Franklin City, where the water was even higher, to try to rescue the few people still there. Even in the face of great personal risk to themselves, it never occurred to them that they should do anything other than rescue their neighbors.

One man who had a farm outside town was especially well-remembered. *He had a right brand new Massey-Ferguson tractor. He put a farm cart behind that tractor an' he come through all this salt water with that tractor takin' people out. The tractor was ruined after he'd gone through all this saltwater. But he said he had to help his neighbors—they came first.*

Nearly to a person, those interviewed mentioned the fact that *if it had not been for Stockton, I don't know what we'd have done*—Stockton, Maryland, is five miles up the road. As water started to come up, some people went to the then-new Greenbackville firehouse (dedicated in 1956). After three days of high tides it too began to take water. Tractors with trailers, buses, and whatever they could load people onto took them to Stockton. Some stayed there for up to two weeks until they could clean the mud and silt out of their homes. The Stockton citizens fed them at their firehouse, collected canned goods for later, shared their clothes, and even gave them furniture to rebuild their lives.

When the waters went back down, it was time to clean up. Houses were full of mud, silt, and gunk. The job was so big no one could accomplish it alone. Firemen with their pumper truck manned the hoses and the women got out the brooms. Each house that was flooded was hosed and swept out so the occupants could begin to start over. Together they prevailed.

Funerals

Dealing with death is always difficult. In most small towns a death is a community event regardless of the role the deceased played while alive. In Greenbackville, there is one thing you can count on when you hear someone has died—the women of the town start cooking for the family that has lost a loved one. One member of the community said *As a kid I figured people who are around dead people just must get hungry 'cause people always take the food to the family of the dead person and then everybody who's been to the funeral comes back to the house and eats all that food.* Of course, taking food to the family is not an exclusive Eastern Shore tradition. This is a way friends and neighbors express caring. In Greenbackville, it is not just a few people who participate in this traditional outpouring of concern—virtually ever household makes a contribution.

In the towns of Greenbackville and Franklin City in the days when most of the men walked to work and there was no family car, there was one tradition that stood out to those who remembered funerals. This story was told by the daughter of the family with a very special car but it was remembered by others who benefited from her dad's generosity. *My dad had a black Model T sedan that he always kept shiny and in the garage. People didn't drive around all the time back then. Whenever there was a funeral in town he*

A Model T Ford was a prize few could afford, but those who could were proud of this treasured possession.

always made the car available to anybody that needed it 'cause there weren't that many cars in town.

The kindnesses people showed to one another, the putting of neighbors' safety ahead of personal risk and financial loss, the effort of working together to help those who suffered in the floods, all of these and more tell of the unspoken commitment to taking care of each other that is so characteristic of these towns. Someone said *You know, most of us were poor but what we had, we shared—the good and the bad.*

The authors of this book experienced caretaking first hand shortly after moving to the area. They went to the Bay Witch (then a fledgling business serving as a bait shop and a place to get coffee and boat gas) at the Harbor for boat gas. As the tank was being filled they were asked, *Your radio works don't it? Don't know where you're going but if you ever have any trouble out there, you call here first an' we'll see you get in. Don't go messin' 'round with the Coast Guard, they'll just charge you a whole pile of money an' git you into a bunch of red tape.*

It was no idle offer. Before we left the gas pump we knew what channel the Bay Witch would be listening to. We felt safer out there on the Bay knowing our friends were just a call away.

There are so many ways this caretaking happens. Most of it is in simple day-to-day kindnesses—sharing extra tomatoes from the garden, taking someone to the store when they can no longer drive, cutting up that big tuna you just caught and delivering some of it to your neighbors, simply taking the time to listen to a person in need of understanding. When people talk about community, this is the stuff it's made from.

MAKING ENDS MEET
It wasn't easy but then if you've never had it, you don't miss it when it's gone.

In the early days, boomtowns like Greenbackville and Franklin City were places where some struck it rich. On the other hand, hardly a boomtown exists that has not experienced its comeuppance. In the case of Greenbackville and Franklin City, when diseases and *screw bores* made the oyster harvest much smaller than it once was, well-to-do men become far less affluent. Those who just got along during the boom found themselves in much more difficult conditions when the bubble burst. Many residents of Greenbackville, who did not leave when the boom was over, found themselves in the latter category. In the end, their coping skills, determination, and resilience won

out but it wasn't a smooth ride. As one current resident said, *It wasn't easy but then if you've never had it, you don't miss it when it's gone.*

Examples
We went to the Savings and Loan to get money to buy our house. All we needed was less than a thousand dollars. The man there asked what price we had agreed to pay for the house. After we told him, he said 'Well is it worth it?' We said we thought so. So he said 'I know you and I know you'll pay it off, so, how about if I lend you the money instead of you borrowing it from the Savings and Loan. That way you won't have to pay the high interest rate.' We thought that was a good idea so we paid him $10 a week every week for a long, long time until it was paid off.

Another story was of a man who kept a secret for a whole year. He joined a Christmas Club at the bank and made arrangements for the bank to take 25¢ each week out of the deposits from his business. Every week 25¢ went into that account. He surprised his wife with a check for $13 on the day before Christmas. To this day with a smile on her face she remembers, *Oh, I was so surprised. I was so happy. That money meant so much to us especially at Christmas.*

Food and clothes were homemade; gardens supplied vegetables; meat came from fishing, hunting, or farming; but, for some things, a store was the only option. Today's cashless society is nothing compared to the cashless society of an earlier time. *We paid for our groceries lots of times 'on the book' and paid them off when clams, oysters, crabs, potatoes, or tomatoes went to market. The storekeepers knew who were good payers and who weren't. I was always proud when the store owner said don't worry about it, I'll put in on the book. I know you'll pay me when you can.*

Another remembered: *We got our food lots of ways. The farmers used the railroad to get their crops to market. Some farmers brought their produce on monitors to the train but others filled carts and pulled them to the train station with horses and later tractors or trucks. The farmers had to drive those carts through town to get out to the tracks. One way we got food was to pick up potatoes, tomatoes, and other stuff that fell off the carts on their way to Franklin City. All we had to do was follow the carts and pick up what fell off. We ate good on that food.*

Hunting and fishing were always a part of making ends meet. The game warden might give a warning for hunting out of season but was unlikely to penalize the hunter. One warden is said to have told some boys who were hunting deer when it wasn't deer season, *Why don't you boys just go home now*

even as they stood there with the deer they had already shot. Then, there was the son who as he left to go hunting, would ask *Well, Mom what do you want for supper?* If she said rabbit he wouldn't come home until he had enough rabbit to feed the family. If she said deer, the season be damned, she could count on not seeing him until he had the meat for a venison dinner. Boys walked the beach and would *jump shoot* ducks (flush ducks by walking through the deep marsh) for the fun of it but also because they could take those ducks home for dinner.

Of course, the Bay was rich in free seafood. *We ate so many crabs, flounder, clams, and oysters, it's a wonder we didn't grow fins.* Again, rules about seasons and fish size requirements were largely unknown or at least unheeded. Many a fisherman has left the Harbor saying: *Goin' out for flounder today but I'll take what gets on my line.*

Another told of times that they didn't know were hard but by today's standards were tough. *My mom tells about her mom, all of us born in Greenbackville. She told a story about when they were coming up an' had a big family and things were tight. You didn't have what you got now. Grandmom'd get a pound of hamburger and she'd mix it with bread, an potatoes, an' whatever an' it would be a gigantic dish by the time she got done with it.*

Some of the stories about paying your way would be sad if they were told by self-pitying people. Instead they are warm, touching, proud, and sometimes funny.

WOMAN TIED DOWN
Being pregnant was a fact of life and sometimes an inconvenience but seldom would it be used as an excuse to do less or no work.

Until the middle of the 20th century, babies in rural areas were born at home. In some cases, the pregnant woman was sent, along with her young children, to her parents' home for her mother's supervision of the child-bearing process. If that was not possible, an older sister or other relative was recruited to take the woman in until the child was born. Or, the relative might come to stay in the expectant mother's home until the baby arrived. When there were no family members nearby, there were some women in the community who were on call and helped with the birth. This meant that some women went away a month, or often longer, to give birth. In other cases, female relatives came to Greenbackville from Chincoteague, Girdletree, and beyond to be with family or friends for the event.

Only if there had been problems with an earlier birth or worse, if a newborn had died, might a physician be involved. Seldom was the doctor called; after all, by the time he traveled from New Church or Pocomoke City, there was a good chance that the baby would have already arrived. If a doctor was called, *the going rate was $25—a lot of money in those days and more than most had on hand.* If payment was not available in cash, more than likely the doctor left with a lot of oysters or crabs and with luck a nice big fish as payment for his time and expertise.

Unlike modern days, the father's job in the birthing process was pretty much limited to a shared role in the initial creation of the baby and to putting food on the table for the family. Birthing was a female thing and men were generally not part of the process unless they got in the way; then, they were instructed to boil the mythical water, which kept them busy but served no functional purpose.

The term of a pregnancy has not changed over the years but the manner in which a pregnant woman is treated and presents herself has. Remember, women worked just as hard, and in some cases harder than, the men in those days. Because a woman was pregnant did not excuse her from any responsibilities right up to the time she went into labor. She still had a house to keep, other children to care for, and most also did extra work for others like canning, sewing, cleaning, and gardening, to make money for the family. Being pregnant was a fact of life and sometimes an inconvenience but seldom would it be used as an excuse to do less or no work.

As a woman got closer to her delivery date, her size could become an issue in terms of the physical work she was able to do. The expectation was that such things simply were not publicly discussed or acknowledged.

In those days, being pregnant was not necessarily to be ashamed of but it just wasn't talked about or made an issue of. Back in those days women tied theirselves down. They didn't let themselves go like they do today. The custom of *tying themselves down* allowed a woman growing daily in girth to contain herself somewhat, possibly provide some support for the baby, and importantly, mask the fact that she was pregnant up until the very end.

One story was of a storekeeper whose wife was pregnant and delivered a baby boy. The day after the birth on a cold January morning, the conversation around the stove in the store went as follows:

Customer 1: *Did ya know Mr. _____ had a baby boy last night?*
Customer 2: *Naw that couldn't be, his wife wasn't pregnant.*
Customer 1: *Yep, she was.*

Customer 2: *Naw, she wasn't big enough.*
Customer 1: *Yep, she sure did have a baby boy.*
Customer 2: *Well she must a got him out the meat case then! Cause she sure couldn't a been pregnant when I saw her at the store yesterday!*

She had in fact been very pregnant, but in bulky winter clothes and *tied down* as she no doubt was, her pregnancy was not readily visible.

Though being pregnant was not something openly discussed, it was dealt with in what now seem quaint euphemisms like *she's in a family way, she's with child,* and *she's expecting.* Pregnancy was a fact of most women's lives but was treated like a very private problem. Prenatal care was not commonly considered important and even if it had been, there were no doctors available to provide it. Many healthy children were born and flourished even though the expectant mom never saw a doctor, bound herself tightly throughout the pregnancy, and worked until the day she delivered.

BRING 'ERE WIVES
They meet, they do things together, and sometimes the relationship grows.

Generation after generation of young people from Greenbackville and Franklin City, like their counterparts elsewhere, found times, places, and ways to meet and get to know members of the opposite sex. Sometimes these events were simply exploration while other times they would develop into adult relationships that lasted a lifetime. The story is ultimately always the same. They meet, they do things together, and sometimes the relationship grows. Stories range from meeting on the ferry between Chincoteague and Franklin City, dancing at the Red Men's hall in Franklin City, going to the movies in Pocomoke, and even sitting on the front porch on a summer evening. The bottom line was *we just found fun where it wasn't too expensive.*

Interestingly, when it came time to actually marry and settle down, it seemed women tended to marry and live outside the immediate community where they were raised while men sought brides from other nearby communities and brought them home. One man described this phenomenon: *Well you know about come 'eres. My Dad and I have wives not from here an' we call them bring 'eres—that's different than being a come 'ere. They are special and were chosen. Come 'eres just show up.*

One woman described a young man who was persistent. *How'd we meet? Well I lived in Pocomoke and was a car hop at a local drive-in. He kept showin'*

up . . . first with his buddies and then by himself. He'd meet me after work and take me home and then one day, he asked me to go skating at The Dream. We'd go to church suppers and stuff and one thing led to another.

Every story is a little bit different: *When I first met her, I was goin' with someone else. I had a car, an old '48 Chrysler, and not all the boys had cars in that time. So when we went on a date, I'd take two or three boys and they'd take their dates and we'd all go together. She was the date of one of the other boys and we all went to the movies together. I thought she was nice. So the next day I got ready and I went to her town and I went to her house even though she didn't tell me to come. I know she was playing the piano when I knocked on the door and she said 'Come on in' and said the other guy's name. So I said 'I'm not him.' So she said 'Come on in anyway.' So when I got in I said 'He won't be here today. I'm here!' She didn't know it but her boyfriend had asked me to take him to see her 'cause he didn't have a car and I wouldn't take him over. A while after, I went into the service and she'd write me letters and stuff when I was in the Marines. When I got out, I married her.*

For some the memories are soft and pure: *One of my best memories is of sitting on the porch after dinner on a summer evening. I would sit with some of my friends on the front porch and we'd swing and sing. While we were sitting there singing, the boys would come by to see us. It was fun in lots of ways—we enjoyed being together, we loved to sing, swinging was fun but probably the best part was the attention of boys!*

Dances at the Redmen's Hall offered opportunities for girl to meet boy.

Great effort went into being at the right place at the right time. Most families did not own a car, or if they did it was usually dad's car and children didn't get to use it. *Lots of summer nights I rode my bike from Girdletree to Greenback so I could hang around with the girls and boys from over there. Getting there was a 24-mile round trip on a good ole Roadmaster—no gears or other do-dads to make it easier. No bike lights to help see the road on the way home. Oh I didn't mind a bit. It was fun.*

During the Depression, it was common for a bunch of boys from Chincoteague to put their money together and buy gas for a friend's car. Out of one such car load of four boys, four Greenbackville girls found their future husbands. The eight of them were friends for life.

Of course parents were very aware of who their children were *going around with* and wanted them to marry well. A Greenbackville girl was dating a Chincoteague boy who was one of the few with a car. She and her mother were impressed with him and his wheels, but her father was less impressed. *One day, my Dad was with me as my beau drove up to the house. We noticed that one of the windows on the boy's car had no glass and was covered with a piece of cardboard. My dad leaned over and said 'If he's not got money enough to fix that window, he's not got money enough to be over here seeing you.'*

Courting and marrying during the Depression never slowed down but families were very concerned about the economic prospects of the person their daughters might marry. *When my cousin was going with a guy who was a farmer, I can remember tellin' her I don't think it's a good idea to marry him, he's a farmer. My dad was a waterman an' we were poor but farmers during the Depression, they were poor, poor, poor. But you know what? She married him and they made out fine. The Depression didn't last forever.*

For some, future spouses were from afar—for many years the navy base at Wallops Island was a temporary home for both military and non-military young men far away from their own homes and ready to find a pretty girl to marry. Some local girls found themselves living in places far removed from the only home they had ever known because they married guys from the base. So, boy found girl and girl found boy in good times and bad.

DON'T GO RUNNIN' OFF TO THE DOCTOR
Between a person's arrival and departure from this world, for the most part, health problems were managed with home remedies.

When a community is located 12–15 miles from the nearest physician and 40 miles from the nearest hospital, its citizens become quite self-sufficient in

tending to their health care needs. This was the case in Greenbackville and Franklin City a hundred years or more ago and it is still true today at the beginning of the 21st century.

Even in modern times, emergency medical technicians associated with the local volunteer fire company's rescue squad handle many health issues that would send a city dweller to the doctor or hospital emergency room. The community is blessed with these folks who are the only ones consistently in the community with some degree of training to handle medical situations. Before there was an ambulance and EMTs, folks were on their own. Those who live in rural America simply *don't go running off to the doctor for every little thing.*

In earlier times, if a doctor was needed, there were three. One was in Greenbackville—Dr. Mallory, though little is known about him other than he went to World War II, came back for a short time, moved to California, and was never seen in these parts again. As for the other two, each of them was 12–15 miles away—one in New Church and the other in Snow Hill, Maryland. At best, even by automobile, it took better than a half hour to reach either of them. In much earlier times when travel was by horse, it took much longer. Both would make house calls to the elderly and others not able to come to the office. In several households, *he came once a year to check everyone out. Kind of like a physical but no x-rays or blood stuff and Daddy paid him with two geese.*

Women helped each other during childbirth. They usually managed quite well on their own. Only if there were problems anticipated would a doctor be involved in the delivery process. Going to the hospital was rare and only occurred in very complicated cases.

At the end of life, a dying person would be tended by his or her family or friends. Usually, that person would move in with the caretakers and stay there until the end. There were also a few households known for taking in those who had no family. Those loyal friends and caretakers would treat the person as family and see them through the last of their days.

Between a person's arrival and departure from this world, health problems were usually managed with home remedies. Rarely were prescription drugs used, probably because they simply weren't available. Some over-the-counter preparations were available but they were expensive and for the most part, tonics, antiseptics, analgesic agents, cold remedies, and the like were concocted from readily available materials. The following examples are provided solely for the purpose of historic interest:

- **Cough**—*suck on a sugar cube soaked in kerosene, or honey on a lemon.*
- **Head cold, cough, sinus trouble**—*boil water in a sauce pan, put Vick's Vapor-Rub in a small glass in the boiling water, cut a corner out of a large paper grocery bag, and have the patient inhale the fumes.*
- **Cold prevention**—*keep a pan of water with onions simmering on the back of the cook stove. Another option, far more attractive to some, was a hot toddy—one cup hot water, two shots whiskey, one tablespoon sugar. Drink quickly, go to bed with lots of blankets, and sweat it out.*
- **Burn**—*make a poultice from the aloe vera plant.*
- **Upset stomach**—*burn and eat a dry piece of toast. Also, a tablespoon of baking soda in water balances an acid stomach.*
- **Arthritis**—*drink diluted vinegar with a little honey.*
- **Bowels out of sorts**—*drink lots of water and if that doesn't work, take Castor Oil. For kids, use Castoria—a sweeter concoction.*
- **Constipation**—*eat prunes or take milk of magnesia or epsom salts and when all else fails, enemas.*
- **Skin problem (cut, scratch, sunburn, infection, rash, acne)**—*apply St37, a liquid procured from the drug store and applied with a cotton ball.*
- **Earache**—*put warm sweet oil (olive oil) in it and plug it up with a cotton ball.*
- **Gas**—*drink six ounces water with two ounces of vinegar mixed in it.*
- **Sprained joint, sore muscles, ingrown toenail**—*soak in hot water with Epsom Salts.*
- **Poison ivy**—*wash with brown laundry soap and then put calamine lotion on it. And don't scratch!*
- **Homemade toothpaste**—*dip your toothbrush in equal parts baking soda and salt and scrub away.*
- **Kids with worms**—*some parents wormed their kids annually whether they needed it or not. The same pills you used for your dog worked just as well for your kids.*

Regardless of the complaint, these and other similar remedies using available items usually either solved a problem or allowed enough time for it to solve itself—the old *tincture of time* cure. However, please remember that

these remedies are described only to provide a window into the past, not as prescriptions, advice, or for any purpose other than entertainment.

There were at least two registered nurses who once lived in the community. Both had very responsible positions at the nearest hospital and one was nationally recognized in the Planned Parenthood movement. Although exposed daily to the wonders of modern medicine, when it came to their own families, more often than not these were the remedies they turned to and trusted.

GO ANYWHERE, DO ALMOST ANYTHING
As a boy I never knew what it meant to be bored.

There were few rules when I was growing up in Greenbackville. In fact, the ones I remember are:

1. *Stay out of town and other places where adults are unless you have business to do. I could go to the barber shop to get my hair cut but, as a kid, I couldn't hang around there.*
2. *Don't go to the Harbor until you can swim.*

As long as you followed these rules you were free to go pretty much anywhere and do anything. We were never bored. Land lines and property ownership were not a part of our lives. We hunted in the woods without knowing which farm we were on. It didn't matter to the owners and it sure didn't matter to us. I got my first gun when I was pretty little. If you asked me who taught me to hunt I'd have to say 'I was born into it.' It was open country with lots of small game. Hunting was more about putting food on the table than it was sport but I'd be lying if I didn't admit I enjoyed it most of the time.

We hunted and fished year 'round. We crabbed, clammed, and oystered depending on the season. Sometimes we'd go out and catch a bunch of crabs and go out by the edge of the Bay, build a fire, and have a crab steam just on the spur of the moment. We spent lots of time on boats and in or near the water.

We ice-skated in the winter and raced our bicycles and played baseball in the summer. One of the biggest and best winter pastimes was ice skating on Big Mill Pond and Pikes Creek. We usually had a month or more of weather cold enough to freeze those ponds to a smooth thick hard surface.

As a boy I never knew what it meant to be bored. I never thought of locking a door. I never knew what trespassing meant—nor did I need to.

At twilight, a third rule was added to the two general rules above. It was—*be home by 9 p.m. Otherwise everything else was fair game. My mother wanted me home by nine. I didn't have a watch but I didn't really need one. One of the mothers could be heard all over town when she called her kids. I knew once I heard Miss _____ hollerin' I'd better get my butt home. Thanks to her, I never got in trouble for bein' late!*

WHEN HOUSES WERE HOMES
The durability of the people who called early Greenbackville and Franklin City home is, at least in part, attributable to the closeness of family.

Taking care of family was implicit in being a member of the Greenbackville and Franklin City communities. Many extended families lived under the same roof and almost everyone was either real or assumed family to others in the community.

Cousins were often as close as sisters and brothers. They all worked and played together. And they ate at the same table so often, it wasn't an occasion when this occurred. When grandparents could no longer live independently they packed up their belongings and moved in with younger, more able family members, usually one of their children. One person recalled: *After my grandmother died, my grandfather lived by himself for several years, then one day he showed up at our house with all his belongings in a wheelbarrow and announced 'I'm here now' and his son, my father, without a hesitation took him in and gave him a home for the last 12 years of his life.*

Another said: *When my PopPop got too old to live alone, he came to live with us. He had a little pension. He saw that my mom got that pension money and Mom always said his pension money made a difference for us.*

Although a few brought along small pensions to contribute to the family budget, others contributed by finding ways to make money. For example, oystermen sorted their catch when they got back to shore and threw back in the canal (now the Harbor) those oysters not large or whole enough to send to market: one elderly resident went to the canal every day and re-harvested these less than perfect oysters, which he shucked and sold. The money he made went to the family to help pay his part.

Another grandpa who came to live under his son's roof was *the gardener and he took care of the smoke house that cured the hams and beef. And then, he would go out and sell stuff. He was kind of my babysitter when I was a kid. I'd go with him and his wagon when he was selling Mom's canned goods. She*

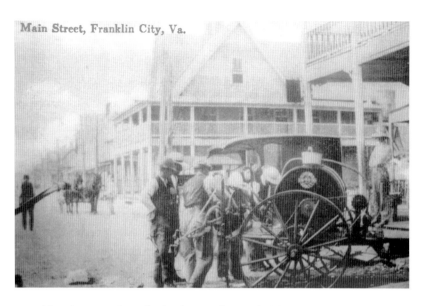

Franklin City Hotel in the background provided hospitality to visitors and was home to a few senior citizens who could afford to live there.

canned duck, chicken, beets, all kinds of produce, and he sold it all. Even sold fish at certain times of year.

Since there were no assisted living facilities or nursing homes, sometimes when a man was no longer able to work, if he had means, he went to live in the hotel in Franklin City. One granddaughter fondly recounted *being kept by PopPop while Mom and Dad worked the crab boat. He'd keep matchboxes and we'd play with them like kids do today with blocks. Then, for a special treat, he'd put two slices of bread and a piece of cheese in a waxed paper bag and put it on the pot-bellied stove that was in each room in the hotel. Those grilled cheese sandwiches were the best I ever had!*

Even when relatives did not live under the same roof, they lived close enough to tend elderly or infirm family members. They shared the joys of births, the grief of deaths, the caring for the sick, the disruptions caused by high tides and storms, and the always unpredictable clam and oyster business. To this day, you can find living examples of this practice in this community. It is a generous gift, in most cases, of one generation to another. The stories that confirm these observations abound.

> *When I was four years old my mother died. I went to live at my grandmother's house along with my cousin and her*

parents and was a part of that family until I got married when I was 16.

My cousin and I had been very close friends since childhood and took care of our grandmother in her own home until the day she died. We did all the cooking, cleaning, and personal caretaking required by a sick bedridden person and we were glad to do it.

When we were married we just didn't have any money. We lived with his parents for the first years of our marriage and later bought the house when his parents moved to a different house.

Even though I was her son, when my mom got sick I tended her right three meals a day, changed her and everything, in that room right there, until the day she died.

When good fortune smiled on someone in town and there was a way to include family, the effort was made. *My uncle ran a business in town. We lived across the street from his shop and I was in and out from the time I was a kid. When I was a young man in my 30s, one morning pretty early, he called me up and asked me to come to the shop. I didn't know why he was calling but since I was home, I went right down there. And he said 'come on in I'm gonna get your picture taken.' There was some newspaper fella from Salisbury there. So I sat down on the bench with two other guys and they took our picture right in front of the shop. I was the youngest one—the others are gone now. Next week, there we were in the newspaper. I think my uncle wanted some family in that picture so that's why he called me that morning. You know if he had a chance to do somethin' special, he wanted his family to have a part in it too.*

Even when you grew up and moved to another town, the family ties were strong. *I married early and had my children but I never was very far away. When my brother was killed, I was the only one who could help my parents so I was back in Greenbackville at least once in every week. But they did for me too. My husband and I got to go to the movies more than one Saturday night because my mom and dad took care of our kids. We'd drive over to Greenbackville and leave the kids at my parents' house and then go out to a movie. That was a real treat for all of us.*

The durability of the people who called early Greenbackville and Franklin City home is, at least in part, attributable to the closeness of family. There is a standing joke that in Greenbackville *there are ever so many Marshalls* but

The barber's nephew proudly displays a 40-year-old newspaper with his picture and a feature story on his uncle. (Courtesy Brice Stump.)

the same could be said for many other family names like Sharpley, Selby, Pruitt, Mariner, Merrill, and Bowman. There was an unspoken commitment to welcome and take care of family and it is pretty true that *almost everybody is related to everybody else.*

GOING VISITING
I don't ever remember when Sunday dinner was just my mom and dad and me.

Back in those days we didn't have TVs, computer games, and all the stuff people have today to fool around with. As kids, we entertained ourselves—progin' in the marsh [poking a long stick down holes to see what happened or appeared], hunting, fishing, and some had bikes.

As a family, we'd go visitin' a lot. We'd go see one or the other of my folk's friends or some relative. Before we went in, my dad would be sure I remembered my manners and respected the adults. When you were around older folks, you kept your mouth shut unless they spoke to you; and then, you could answer but always called them Mr. or Miss followed by a first name. "How you doin' Mr. So and So" or "How you doin' Miss So and So." You didn't go nosin' into things, openin' closets and drawers, and you sat in the chair until invited to do something else.

We'd go through the door and after everyone said hello my dad would look at me and then look at a chair and say sternly 'Boy.' To him, I didn't have a name. It was just 'Boy this' and 'Boy that.' When he looked at the chair and said 'Boy,' there was no doubt in my mind what that meant! I sat there quiet until someone spoke to me or it was time to go home.

One of the best times I remember was Sunday dinner. Now ya see, to us Sunday dinner was your noon meal after church. It was always a big meal where you had more of everything and variety too. Sometimes it was just our family and a neighbor or two that lived alone; but other times, it would be lots of family and friends that didn't live here. I don't ever remember when Sunday dinner was just my mom and dad and me. And when those folks would arrive, the women always brought something for the meal. My mom would make either chicken and dumplins or a roast chicken, Hayman potatoes, mashed potatoes, green beans, stewed tomatoes, apple sauce, biscuits, and two or three kinds of pies—probably at least one sweet potato pie—depending on who all was coming. We'd also have the other dishes that guests brought too. You see we had crabs, oysters, fish, and other seafood all week; for us, chicken was a real big deal. And, we didn't eat and run like they do today either. After the meal, the men would smoke and probably nip a little while the women cleaned up and talked. We kids would play board games or other less active things because we weren't s'posed to mess up our Sunday clothes. By the time people went home, it was late afternoon. And some even would stay for leftovers for supper.

Another person interviewed recounted essentially the same description of Sunday dinner but added, *If we were lucky we'd have homemade pineapple ice cream too.* To this day, that delicacy is produced and sold (along with vanilla and chocolate) as a fundraiser for the Greenbackville Fire Department. The first flavor to sell out is—you probably guessed it—pineapple.

Similar descriptions were plentiful. Going visiting, or being recipients of visits from family or friends, was a primary form of entertainment. One story in particular was passed on by a granddaughter about her grandmother and great aunt who were twins. Times were always tough in those days, so getting a new outfit for one child was a big enough challenge, let alone two. Somehow, the mother of the twins was able to outfit her daughters in two identical new dresses. The family went visiting with the twins all decked out in their new dresses. As soon as greetings were over, the kids of the family invited the twins to go outside and play. Before they left, the twins' mother cautioned, *You be careful and don't mess up your nice new dresses.* After a while, the adults decided to check on the kids and discovered, as is often the case with twins, what one didn't think of the other did. They had carefully

Going visiting was an occasion and you wore your Sunday best.

taken their new dresses off, folded them neatly on the porch, climbed up a tree, and both were found *hanging upside down by their knees on the branch of a big tree. And both were naked as jay birds!*

Regardless of the families or friends involved, going visiting had a lot in common with Sunday dinner. It was a time spent with family and friends sharing food, laughter, and the pleasure of the company of others.

BEFORE REFRIGERATION
Although the towns were founded on seafood, dealing with a family's everyday food requirements was always a challenge.

Even though there were two canning factories in town at different times, never did anyone mention taking canned goods home from the factories or eating commercially prepared food. These women, like their rural counterparts throughout the country, had great pride in all the different foods they had and the ways they canned, preserved, and handled them. It must be remembered that electricity did not come to individual homes on the Eastern Shore and especially in remote rural areas until much later than the rest of the country. Consequently, there were no freezers, no microwave ovens, no blenders, or other modern kitchen appliances.

Canning

The color and arrangement of the food in jars, the number of quarts *put up*, the methods used, the spices and flavorings, were all of critical importance to the women who described their canning. Some canning days would be all-day affairs and involve washing, peeling, coring, and chopping several bushels of vegetables or fruit. Other times, it would take only a few hours to handle whatever was ripe from the garden near the house or what was leftover that was too good to throw away.

Butter beans, string beans, asparagus, beets, peas, sweet potatoes, Hayman potatoes, tomatoes, peaches, plums, apples, cherries, as well as any other fruit or vegetable that could be grown, was canned. A few were known to can oysters, tuna, and meat as well. But one person reported, *Never corn, it won't keep good.*

Once the produce was cleaned and chopped or sliced, it was put into glass jars topped by a thin steel lid with a rubber ring to seal it. Before lead was found to be a heath risk, lids were made of lead, which was flexible and could be bent around the rubber ring and jar top. Sometimes salt, sugar, or spices would be added directly into the canning jar. Once it was sealed, it was put into a pressure cooker or a pan with water in the bottom and heated. The full jars have to be heated to a certain temperature and for a certain time, all depending on what is inside the jar. This heating process seals the rubber ring airtight and brings the food to a temperature that will discourage spoiling and decay.

Many still continue canning to supplement commercially frozen and prepared foods. And they will assure you that the home canned food is always best.

Ice Boxes

Even in the early 1900s, ice boxes—precursors to the refrigerator—were found in many homes. To this day, many born before 1950 still refer to their refrigerator as the ice box. Thanks to the railroad and the seafood business, ice was an available and affordable commodity in this area. Early on, there was an ice house in Franklin City that harvested ice from the Bay and from Big Mill Pond. Later, there was an ice plant connected to the power company in Stockton.

The household version of an ice box was a sturdy piece of furniture that consisted of a four- to five-foot tall wooden box lined with tin. It had one or two doors on the front and a drain pan below. The two-door models had a special compartment in the top for ice while the one-door models simply

Ice boxes were common until the middle of the 20th century.

had a shelf. Either way, it had to be able to support a 20 to 50 pound block of ice that was delivered once or twice a week. Butter, produce, and other perishables were stored in the compartment below the ice. The available space for food was probably one-quarter of the space in today's refrigerators, so decisions about what went into the ice box were made judiciously. And always, hot foods were cooled naturally before putting them in the ice box—a practice today believed to promote spoilage and food poisoning.

Lockers
Once electricity became available, longer-term storage, especially of meat and seafood, was possible. In the period of 20 to 30 years when electricity and refrigeration were available but not in every household, there was another option. Often businesses that made and sold ice had freezer storage areas that they would rent to the public. If you butchered or had a large seafood catch, had transportation, and had enough money to rent the locker, you could freeze and store your food collectively in a big freezer room. Different-sized trays or boxes were available for rent. The food was not as readily available as it is from our freezers today, but it did offer another option. The coming of large refrigerators with freezers and the availability of many models of home freezers has made lockers obsolete.

Meat

Hog killing day was a neighborly community event. The men killed and cleaned the hog, the women scraped the intestines for sausage casings, and kids, depending on age and ability, pitched in wherever they were needed from catching the hog to turning the crank on the sausage machine. Always, there was plenty to share with friends and neighbors. Still there was usually more than could be immediately consumed. Consequently, there was a need to preserve it for later use.

Fresh meats such as bacon, hams, pork chops, and sausage could be hung in the smokehouse to cure. This was a small building usually at the back of a property with plenty of rafters to hang the meat from. Curing requires a steady temperature, a dry environment, and time. The smokehouse, where a low fire was kept constantly smoldering, provided the perfect environment. Often senior members of a family made it their business to tend those smoldering coals and keep the smokehouse at just the right temperature. One woman said *Whatever meat you couldn't smoke had to be cooked and eaten right away.*

Another family's method of keeping fresh pork chops was to partially cook them and then cover them with rendered fat in a large stoneware crock. *When we'd have pork chops, all my mother had to do was fish them out of the crock full of fat and cook 'em the rest of the way.*

Seafood was a different story since it is far more perishable. Although some were known to can oysters and tuna, others believed it was not practical to do so. And after all, oysters are in season through the winter months and summer brings crabs, and other fish. And fresh clams are edible all year. So canning of seafood could be done and was, but locally, for the most part, seafood was eaten fresh.

During the oyster boom, for commercial purposes, fresh oysters were routinely shucked, put in cans, and kept iced or refrigerated. They were simply fresh oysters delivered for transport or distribution in pint and gallon cans. Now those commercial oyster cans are collector's items. Though transported in cans, they were not processed as they are today. Later, the practice of washing and pasteurizing oysters extended their shelf life but changed their natural salty taste.

Dairy Products

Today we believe that milk, eggs, and butter require constant refrigeration. The reason refrigeration is required is that most dairy products are stored over longer periods of time than in the early days, hence the opportunity for bacteria

to grow and spoilage to occur. In the early days, all that was available were ice boxes and their space was very limited. Unlike other parts of the country where cool streams, root cellars, and spring houses were used for cooling food that might spoil, seaside communities did not have these options.

A milk cow gave milk after calving and continued to do so until her biological clock told her it was time for another calf or she became too old; then, *she'd dry up*. Unless you were a dairy farmer, the milk produced daily was consumed by the family or used in cooking. It was important to keep the milk out of the sun or in the icebox, if you had one. If the cow was especially productive, there was always the opportunity to barter for some other form of food that another person raised. When all possibilities for using the milk were exhausted, it was collected for several days, allowed to sour, and hand churned into butter.

Very long ago, butter was churned in a wooden bucket-like container with a vertical plunger, called a dasher, that was agitated up and down until lumps began to form; soon, there were enough lumps of butter to put into a butter mold. Butter molds were almost always made of wood because metal or other materials would interact unfavorably with the butter. For day-to-day use, they were utilitarian wooden boxes usually the size of a pound of butter and open on one of the long ends. There was a slightly smaller piece of wood with a handle that went through a hole in the top of the wooden box. Once the pieces of butter formed in the churn, the buttermilk was poured off, and they were packed tightly into the mold, which was then cooled until it was firm. Once firm, the handle was used to force it out of the mold. There it was—one pound of butter! There were also fancy carved molds but they were not for everyday use and many households could ill afford two molds let alone a fancy one. Later, butter was churned in glass jars whose capacity was usually four to eight quarts. They had wooden paddles on a stem that were made to go around by a hand crank on the lid of the jar—not unlike an egg beater.

Regardless of the time and equipment, butter did not need to be refrigerated to the extent it is today. Once it had been cooled enough to get firm and be unmolded, it was often kept on the table or countertop and always was soft enough to spread. One might speculate that the covered butter dish was invented to cope with the problem of keeping dust, flying insects, and other contaminants out of the butter.

In the old days, if a family had chickens, there were only enough to meet their immediate need for eggs. Eggs were consumed within a few days of being laid and fresh eggs don't require refrigeration.

Pickling

Another method of preserving fruit and vegetables was pickling. Selection of the correct subject for this method was important. It needed to be a fairly firm fruit or vegetable such as cucumbers, cauliflower, carrots, onions, or watermelon rinds. Next, it would be important to determine the exact ratio of spices, sugar, and vinegar to keep the produce from spoiling. And finally, storage was an issue. Sometimes the pickled item could be canned but as often as not, especially in the early days, it was kept in stone crocks that resided in as cool a spot as was available.

Cooking

Possum was alright but I don't want any now. I cooked it. I roasted it in the oven. Muskrats and everything, I'd cook it all as long as my husband cleaned them. I'd put onions and potatoes in there. Those potatoes will take up the wild stuff. Then I'd throw out the potato 'cause you wouldn't want to eat it with all that wild taste in it. You use what you have, eel, conch, raccoons, I've had it all. We'd go to my grandparents' on Sundays and we'd have guinea birds there. Anything that was killed and eatable, we ate.

Although the towns were founded on seafood, dealing with a family's everyday food requirements was always a challenge. It took knowledge, skill, and resourcefulness to prepare and preserve the food that was available. Small local grocery stores played a role as suppliers of items for use in preparing food such as salt, pepper and other spices, flour, sugar, and baking powder—not for the array of frozen and canned prepared foods available today.

NEWFANGLED INVENTIONS

I remember being there and thinking that it was an amazing machine.

Many of the people who agreed to be interviewed remembered times when today's commonplace conveniences were not part of their lives. In fact, it is clear that a fair number of the modern conveniences came to the area at least 20 to 30 years after they were in common use in more urban areas. The adoption of new appliances and gadgets in part was due to the late arrival of electricity as well as the insularity and socio-economic status of the people. Starting on the next page are a few memories of the arrival of modern times.

Washing Machine

I sure do remember our first washing machine—I also remember how hard my mom worked washing clothes on a washboard before we got it. 'Course she worked hard washing even when we did get one.

Our first washer had a separate wringer. It had a place of honor in one of the coldest places in our house, a little added on room my dad built next to the house. Mom carried the clothes out there, 'tached up the hose, filled the tub, an' put 'em in the washer with some soap powder and it swished around for a while. Then, she'd drain out that water and put clean water in and it swished around again for a while. If she thought the water still wasn't clear enough she'd empty it out again and refill it so she could rinse it all once more. Next, she'd reach into the washing machine and pick up one piece of clothing at a time and turn the handle on the wringer as she fed the clothes through. Once they went through the wringer they went into the laundry basket. When the basket was full, she carried those wet clothes in that basket out into the yard where my dad had strung a clothesline between the barn and a tree. Then, she hung the clothes on the line to dry. Before the 'first damp of night' she'd bring those clothes in and fold some but mostly she ironed them. She ironed for hours with a heavy iron that she'd set on the stove to heat it up. The ironing board was where you could find her at the end of the laundry day.

She never had a clothes dryer. She always hung the clothes on a line. On real cold winter days the clothes would freeze stiff and our long johns would stand straight up when they came off the line. Those days, Mom would re-hang the clothes in the kitchen to get them really dry. I'll never forget how good the sheets on my bed smelled after they'd hung on that line to dry.

Electric Refrigerator

I'm a little older than some of the people you've talked to but the greatest modern invention as far as I'm concerned is the electric refrigerator. We had ice boxes and they kept things cool if it wasn't too hot for too long. You were always worried if the iceman didn't come soon enough or the temperature was so high the ice melted too fast; then, the milk soured and the meat went bad. If it was really hot you'd have to put the butter in the icebox so it wouldn't melt right down or turn rancid, but if the ice was gone, didn't make any difference.

Our first electric refrigerator was a Kelvinator—not a brand name you hear today—and we didn't call it a refrigerator, we called it a Kelvinator. By today's standards, it wasn't very big. It was probably five feet high and three feet wide. It had a freezer compartment just big enough for two metal ice cube trays. That compartment was at the top and next to it were shelves on either side. We kept

the milk right up there next to the freezer so it would always be cold. It didn't have anything but shelves all the way down and they weren't moveable shelves like today. There were no shelves in the door or anything fancy. It was always cold and there was no ice to worry about, like in the ice box, but it would frost up somethin' terrible an' my mom had to defrost it every week or so, 'specially if it was really humid.

Oh there was one other thing it had. It had a light inside. That light was always on when I opened the door and I often wondered if it was always on or if it went off when I closed the door. Sometimes I'd try to open the door extra fast to see if I could tell. I never could.

Indoor Plumbing

Till I was eight or nine the outhouse was our only bathroom. It wasn't quite like the shed with a half-moon in the door that they show in the comics but it was pretty primitive. It was hot and stinky in the summer and so cold it was hard to remember what you came for in the winter. If you were a real little kid or you were old or sick, you could use the slop jar inside at night. We thought it was a big deal when my dad ran a wire off the pole that carried the electricity to other houses and put a light in our privy.

Another said about indoor plumbing, *I guess it's hard for people today to think how wonderful that was. It was somethin' we had to work an' save for for a long time. You think about it. First my dad figured out where it should go and then he tore out a closet and part of a wall to make the space. Then he had to save up for a toilet, a "pretty sink" (that's what my mom called it), a bathtub that had a drain, as well as pipes, a water heater, and everything else. Before that, we'd mostly take spit baths with a basin and hot water heated on the kitchen stove. There was a big tin tub that my mom used if we little kids were really dirty.*

One person was quick to say, *We had electricity long as I can remember but we didn't have a bathroom—we had a two-hole stall. At mom and dad's house when mom went to work to the shirt factory, she borrowed the money to have a man put a pump out back. We didn't have hot water but we had running water—never had a bathroom in that house till after 1956. When I came back with my kids we went visitin' to my cousin's house. The kids were pretty little and they came to me and said 'Ma we have to go to the bathroom' so I said 'well just ask the kids where the bathroom is and go.' A couple of minutes later they came back a whisperin' sayin' 'We can't go, there. Their bathroom's outside.' Well, I packed them up and took them to mom and dad's so they could go to the bathroom 'cause they thought they couldn't go in an outhouse.*

Television
My mom and dad were pretty much the first ones in town to have a TV an' it was a console. You got one station if you were lucky. Anyway, one day, Mom and Daddy had a neighbor over to see the new TV. An' on there was this lady all dressed up with a hat, an' gloves, an' everything. An' the neighbor gets up, walks over to the TV, presses her face against the screen, an' she's like this [screwed up her face as if it were pressed against the TV screen, cocked her head, and looked down]. Mom says, 'What are you doin?' An' she says, 'I'm lookin' to see what kinda shoes she's got on!

Air Conditioner
When I was a teenager we got our first air conditioner. It fit in the living room window. It was big and noisy but it was wonderful. The air conditioner was only used when my dad was home and in the living room. No one dared touch it except him. When he turned on that air conditioner everybody came to the living room. We closed the door to the kitchen and the door to the hall. We made sure the front door was closed tight and we enjoyed the cool. I remember he had rags stuffed all around the edges of it so no hot air could get in through the part of the window that wasn't covered by the machine itself. I have no idea what we did while we sat in that cool room but I remember being there and thinking that it was an amazing machine.

Electricity and the things that were possible because of it changed the amount of work required for daily life—especially in the lives of the women who were responsible for their family's homes.

WAYS OUT
Even when trains and cars made going places easy, there was always the issue of staying in the town where you grew up or leaving to find your way in the world beyond the Bay.

The only transportation in the early days was by horse, wagon, buggy, and later, railroad and ferry. The peninsula was isolated from the mainland because of the Chesapeake Bay and there were only a few ferry connections to the Western Shore from places near Crisfield and Onancock. Discovery of bivalve gold—native oysters—brought a railroad terminus to Franklin City. It, along with the ferries it funded to Chincoteague Island, was one of the first ways for both people and freight to leave the area.

Once the railroad came, it brought people, products, and outside ideas and ways as well as money to the area. At the same time, it provided a means for residents to leave—both temporarily and permanently. Until the 1950s, there was a passenger train and some say two, others four, freight trains each day. The train, from Franklin City to Snow Hill and then beyond, made it possible for local oysters, clams, fish, and produce to be sold up and down the East Coast. Likewise, it became possible for at least some locals to be exposed to the wonders of the cities and for some to never return. The railroad supported the boom in the economy and population; but at the same time, it provided a vehicle for native sons and daughters to seek what they perceived as a better, or at least different, life on the Western Shore. This migration contributed to the decline of both Franklin City and Greenbackville. Until the day the railroad no longer came to the area, there was an influx of money, ideas, and people from outside and it was possible to go many places.

During the time of the railroad, there were excursions or day trips to Baltimore, Philadelphia, Atlantic City, and even the World's Fair in New York. These special trips were organized for sightseeing, shopping, or an event such as a concert, art exhibit, or the like. You could board the train in Franklin City and be in one of the major urban areas within several hours. In addition to recreational pursuits, you could see doctors, dentists, family and friends, and still be back home, at the latest, by the next day.

After the railroad was gone, there was the Red Star Bus. It ran on weekends from Greenbackville to Pocomoke City, Maryland, 12 miles away, and cost a quarter each way. Once in Pocomoke, there were many things to do—two movie theatres, restaurants, grocery stores, specialty businesses, doctors, fairgrounds, bars, and other amenities of small cities. Many residents have fond memories of both the travel to and from Pocomoke by bus as well as the things they did there. In addition to the regular weekend schedule, the bus served as a charter service of sorts and was hired for special trips. Examples would be the summer trips to Ocean City with church groups and when the bus was used to celebrate the baseball team's winning season by going to Philadelphia to see a big league game.

Before the causeway linking Chincoteague Island to the peninsula, there were ferries that plied the Bay on a regular schedule between Chincoteague Island and Franklin City. Their cargo included produce, seafood, kerosene, and chicken feed as well as passengers. Travel on the ferries was frequent by Chincoteague residents seeking a link to the mainland via the Franklin City railroad. Likewise, Greenbackers who had business on Chincoteague or simply wanted a place to go for a meal, a drink, or a change of scenery,

took the ferry. On more than one occasion, as a barge loaded with chicken feed pulled out of the Harbor in Greenbackville, boys who were old enough to be at the Harbor would swim to the barge as it left and hitch-hike a ride to the Island.

Transportation by private boat was always an option to a people that lived near the water. Trips could be made at will to the Red Hills to hunt and fish, to procure bootleg whiskey from Chincoteague during Prohibition, and to visit friends and family living elsewhere near the Bay.

At the same time the automobile became popular and the causeway from Chincoteague to the peninsula was built, the oyster diseases began to take their toll. Soon the ferries as well as the railroad disappeared. The coming of the automobile was a great modern stride forward for those who could afford it. It cannot be denied that automobiles also contributed to the demise of mass transportation and consequently deprived some residents of Greenbackville and Franklin City of the ability to go beyond their everyday environs. Not everyone had a car; in fact, there were very few cars in Greenbackville and Franklin City. The cars that were there were not used everyday—some only on Sunday, for a specific trip to town, or a funeral, not just joy riding.

Even when trains and cars made going places easy, there was always the issue of staying in the town where you grew up or leaving *to find your way in the world beyond the Bay.*

For example, one man reported: *Some boys wanted to stay at home but I wanted to get away. I wanted to go somewhere. As soon as I got out of high school I left home. I got a merchant marine job sailing on tankers. One of my friends from here went with me on the tankers. There was good reason to do that. At that time the wage here was about 75¢ an hour, but I could go up there on those tankers and earn at least three times that. Compared to people back home, I was a pretty rich young man! All my food and my bed were furnished so I did that for three years or so. I went to Italy, Africa, the Azore Islands, South America, even out to California. I got to go a whole lot of places. After that I joined the Marine Corps. I was in the Marines for about six years. Then I came back here and got married. When I came back to live here, I'd be sittin' around with some of the boys, one would say 'I went to Atlantic City for three days' and I'd be a sittin' there thinkin' to myself 'and he thinks he's really been somewhere!'*

In more recent times, at least one family would go on trips to the Hampton Roads area. The man of the house worked at Wallops Island Naval Air Station and consequently knew Navy folks who later were transferred to Newport News. They would drive 80 or so miles south, catch a ferry across

the Chesapeake Bay to Hampton Roads and visit Navy friends. *I remember when they were buildin' the Bay Bridge Tunnel an' you'd be on the ferry an' at night you could see all those lights out where they were buildin' the bridge.*

By the 21st century, some have been on airplanes and gone to distant places. But even that does not happen on a regular basis for two reasons. In the first place, airline travel from Greenbackville requires at least a 40 mile drive to the nearest commuter airport or 100 miles south to Norfolk. Planes from either airport only deliver passengers to the hub cities where transfers are required to larger airliners. To many the necessary arrangements to fly are seen as a hassle and not worth the effort. In the second place, many simply have not flown or have a fear of doing so, and use other means of transportation or convince themselves they simply *don't need to go away that bad.*

Cruise ships are another matter. Not many have been on them but those who have, love it. Undoubtedly, their love of the water and boats, contributes to their praise of cruises; but also, to the inexperienced traveler, having someone else worry about negotiating all the unknowns—ordering food, hailing taxies, tipping, making reservations, and the like—is very reassuring and secure.

Leaving town to get away or going on vacation simply was not on many people's minds. Besides, staying close to home was comfortable. *I know folks and they know me . . . it costs way more than I can afford . . . I don't need all that traffic . . . what if a storm came up, an' I weren't around to tie down my boat lines . . . that city food doesn't agree with me . . . Why leave when things are so good here?*

STOKED AND SMOKED
Greenback is a drinkin' town with a fishin' problem.

Alcohol
Alcohol has always been a part of life in these communities whether acknowledged or not. Some prefer to ignore this fact and will deny to the end of time its presence and impact on the community. On the other hand, others were anxious to tell stories about moonshine, bootleggers, and white lightning in the early days as well as more recent incidents spinning out of control due to imbibing alcoholic beverages. Several people summarized it as, *Greenback is a drinkin' town with a fishin' problem.*

For the most part, stories about alcohol involved the men of the community—often to the dismay of their wives, sisters, and daughters

and even some of their sons. With a very few exceptions, they were not alcoholics. Simply put, when the weather was good and they could work on the water or in the fields, consumption went down. Conversely, when weather prohibited work, there did not seem to be too many other activities that occupied the men as much as getting together with friends, telling stories, and drinking. There are many stories herein where alcohol was the root cause of the problem or situation. When a man had cash and spent most of it buying booze for himself and his buddies, it often resulted in colorful tales. Those tales and the drinking are often funny in retrospect but, at the time, families of the drinkers did not think they were so amusing.

A good deal of drinking happened on Saturday afternoon, usually by the men, often in local business establishments including stores, the barbershop, and the town's beer joint. *Talkin' bout the beer place . . . Everybody 'round here worked for theirselves an' they worked on the water . . . didn't have anywhere to go much. Dredged oysters, clams, crabs, and when they weren't workin' they were down there drinkin' beer or whatever—basically that's what they did. No different now 'cept now you go in town where nobody don't see ya. Back then, lot a people didn't have cars. Dad did but I 'spect two-thirds of the people in town didn't have cars. They just walked down to get a drink. Used to be big hedges around my house an I'd hide in them when I'd see them comin' out the beer place. One day, there was a car parked in front of the barber shop. Back then, the bumper was way out a couple a feet in front of the front of the car. Everybody wore boots an' turned them down so when they wanted to, they could just put 'em up. Even if they weren't going to work they wore 'em—they were part of their daily uniform, I guess. I was a little kid playin' in the sand long side the road. I seen this guy comin' so I was keepin' an eye on him cause, as a kid everybody looked big to me, but this guy looked like a giant to me! Well, I seen him comin'. Seemed like everybody, or just about everybody, that left that beer place couldn't walk straight. Today when people drink, they walk OK but back then, they'd be staggering all over the place. Well anyway, this big ole man, come out the beer place an' got down in the car some kinda way 'tween the bumper and the radiator and couldn't get up. It scared me. I's hidin' in the hedges but pretty soon one or two come out the barber shop an got him straightened up. Now, I been out an' had a few drinks but I don't remember doin' much staggerin'. Maybe it was 'cause of the high-test moonshine back in those days. Nobody couldn't walk right, everybody had to stagger.*

When the men of the town were drinking the kids saw it all and remember just how silly they acted. *One thing about my dad, he loved to drink. Lots of the men were that way. One time they were all sittin' 'round the store drinkin'*

an' the iceman had come an' left a block of ice on the front bumper of a car. Back then, they didn't have refrigerators, they'd put the ice on that bumper that stuck out in front of the car an' carried it on home for the ice box. That cake of ice would keep stuff fresh for a week. One of the men said to another, 'How'd you like to make $10? If you'll go out there an' sit on the cake of ice for one minute, it's yours.' The other man was ready! He had just enough liquor into him an' everybody around was lookin' and laughin'. Well he went right out to the street, dropped his pants, and sat down on that ice. Don't you know, he didn't sit on that ice five seconds and he gave a whoop and tried to get up but his butt was stuck to that ice block.

A man remembered as a boy when it was his job to get his father home from the beer hall. *Once I'd get him to our backyard, I'd fish around in his bib overalls till I found the bottle and then I'd break it on that back fence post. Back then, you know, they'd drink pints that fit just fine in those big pockets. Sometimes, the bottle'd be half or more full. I didn't care, I just wanted to get it away from him. You know, for the longest time after Daddy died, grass wouldn't grow around that fence post.*

Moonshine was the early waterman's most available alcoholic beverage. Many kept some aboard their boats as "personal antifreeze." *My uncle had a boat and he always kept some moonshine on board. One day, he noticed some was missing and each day he checked it and each day it seemed like a little more was missing. Soon, he knew for sure that someone was getting into his moonshine. So he solved that problem. He put a fly in that jug. Seems like after that, whoever was getting into it didn't want no more.*

Tobacco

No one can say for sure why smoking is such a part of old times as well as modern times in Greenbackville. Yes, it is Virginia and yes, some tobacco is grown locally. But, to be a big cash crop, tobacco requires far less humidity than the Eastern Shore of Virginia affords.

In earlier days, before the Surgeon General's report in 1965, smoking was just what a lot of folks did. Most of the smoking was done by men but women were not exempt. There were several reports of early women residents who smoked pipes. In more recent years, their sisters certainly tried cigarettes: some to launch a lifetime controlled by when they could get their next smoke and others to get a teenage developmental task off their "to do list."

Tobacco use, like anything else, depends on availability. When there were stores in Franklin City and Greenbackville and if you had the money,

cigarettes and chewing tobacco were readily available. Until the late 1950s, most cigarettes sold were Lucky Strikes, Chesterfields, and Pall Malls—all without filters, menthol, and other modern day accoutrements. Others found it far more economical to roll their own. This resulted in a cigarette loosely packed with twists at each end that would flame up when lit and singe your eyebrows if you weren't careful. Then, before it was finished, because it was so loosely packed, it would often fall apart.

American ingenuity to the rescue—a cigarette rolling machine was invented. It was a half cylinder of rubberized material about five or six inches in circumference and the width of a cigarette with a lever that would pull one end up over the other. *First, you put a small amount of tobacco, usually Bull Durham or Bugle, in a little trough on one end of the machine. Then you'd take a cigarette paper and put it right along where the pile of tobacco stopped. Next you'd wet the paper, usually with spit, and pull the lever up over the tobacco and paper. There you were—a tight packed cigarette without those twisty ends!* Rolling enough cigarettes for the week ahead filled many a man's Saturday night. Some kids were especially motivated to roll cigarettes for their fathers. Not only was it a special privilege for a kid to use the machine, such service provided an opportunity to cop a few cigarettes to try with a friend.

Tobacco use by citizens of these towns, both now and in years gone by, seems to have more to do with the addictive nature of smoking and rewarding yourself for hard work with a smoke break. Then, there's the fierce independence factor again. One person said *Yeah, I know its bad for me and I'll probably die from it, but God damned it, the government an' all those smart-assed research people aren't gonna tell me what I can and can't do. Besides I like it!*

To this day, it would be accurate to note that there is a lot more smoking done by people in this area of all ages and both sexes than in the general population. About the only place you don't see smoking in Greenbackville is at the church or church-related events. There are few very old men and several middle-aged ones with cardiovascular issues before their time—possibly due to the enjoyment of the smoking habit as well as their genes.

One person remembers a typical childhood smoking story for which Greenbackville does not have a corner on the market. *We were very young, no more than 10 or so, an' at that time there was a hedge row back of our house. My sister and I and two boys went behind the hedge row with a pack of Lucky Strikes. I'm sure they were Mom's. We probably grabbed 'em up when she wasn't lookin'. We were just puffin' away behind the hedge. Mom caught us an' my sister an' I got it. The other two? She told their parents. An' I guess that's why I've never smoked 'cause I knew I'd have the wrath of a smoker on me!*

5. Characters in Their Own Right

Describing landmarks, events, the weather, and a host of other things is easy but pretty boring until the human factor is introduced. It is the individuals who inject life into a remembrance. Interesting characters and interesting events focus our attention on a certain individual or a group and, for a few moments, we know them.

Those interviewed searched their memories and came up with accounts of all sorts of events, but it was the actors in them who made the difference. The result is this collection of legends and character sketches. All the accounts here were shared with love, laughter, and compassion.

AIRPLANE IN A CRATE
Somebody said 'it looks like the pieces of an airplane except there's no propeller and no wings.'

This story has been told and retold through at least three generations. Since all the men involved were long gone before this book was even thought of, a version of the retold story is what appears here. The way this story comes to light is usually by somebody starting out saying *My dad was one of the guys who flew in the airplane. You've heard about that haven't you?* If you ask the person to tell you about it, he will say *Well, my dad told the story to me this way . . .*

Me and some of my friends got hired by a guy up near Wilmington, Delaware to work on his boat. It was a big job an' it took us a few days so when we got paid we had real cash in our pockets. As we was comin' home, we were drinkin' some—in fact pretty much. We came on an auction in Delmar, Delaware [on the Delaware/Maryland state line]. *The stuff being sold was in real big wood crates: You could sorta see in the crates but just could tell what some of the stuff was. You couldn't see it all. One crate had a good big wrench that one of the guys really wanted for workin' on his boat. He promised if the others would chip in and buy that crate he'd let 'em use it* [The rules of the auction were you bought the whole crate if you won the bid]. *We put our money together*

and sure enough, he bought that crate for $19.80. Then, we had to get it back to Greenbackville and that was a problem. Well we started lookin' for somebody who could move that crate and sure enough a black man with a wagon and team of mules came along. We asked him if he did any haulin' with that wagon. He said 'depends—where do you want me to haul to?' We said 'Just down over the line.' He said sure. We shook hands on the deal and loaded that crate on his wagon. We gave him directions and went on home. We don't know when the guy with the wagon realized that 'just down over the line' was the state line between Maryland and Virginia, not Delaware and Maryland. He thought he was haulin' 10 miles, not 50 miles further south. But he'd shook on the deal and he did right.

A couple of weeks later, that black man drove his wagon into Greenbackville on its way to Franklin City. Everybody who was out and 'round started walkin' behind that big crate on that wagon. It was a parade right to the door of the guy who bought it. The man with the wagon was paid the agreed on price and we took the wrench out of the crate and then the fun started. We all started pullin' the other stuff out of that crate. You never saw such stuff—a good sized engine, pontoons, a whole bunch of other stuff. We had it all laid out on the ground. All of a sudden somebody said 'it looks like the pieces of an airplane except there's no

The French military sea plane that came to Greenbackville in pieces and later was flown around the Bay.

propeller and no wings.' Come to find out, it turned out to be a French World War I seaplane.

Any time we had when we weren't busy with what we had to do, we worked to put the plane together and tune up the engine. The engine wasn't much different than our boat engines and if we could keep our old boats runnin', we knew we could get that engine up and runnin'. The body was there but we had to put it together. At first, it seemed like we were stuck when we got to the propeller. We didn't have anything big enough for a plane—our boat props just weren't anything like what a plane used. We kept lookin' at pictures and finally one of the guys who was handy with a knife said he'd make a wood propeller. So he just carved it like he was makin' a decoy or somethin'.

Once we had everything together, except the wings, we tried it out. None of us knew how to fly but we didn't have wings anyway so we just ran it like a boat. We drove it on the Bay runnin' the pontoons on the water like the hull of a boat. It worked good. We could even tow monitors and other boats around the Bay with it.

We were happy enough with our plane but then we had some good luck. Somebody heard that a plane had been grounded and the pilot thrown in jail up in Berlin, Maryland, 'bout 40 miles up the road. The pilot needed bail to get out of jail and we wanted wings for our plane. We went up there to Berlin and said we'd bail him out if we could have the wings from his plane. He took the deal an' even helped us to put the wings from his plane on ours.

One of the guys had an old leather helmet, so we decided he should be the pilot. Only two of us at a time could get into the plane—the pilot in the front and the other guy in the seat behind him. We went out in that airplane every chance we got. We used it as a boat till one day there was a fierce wind blowin' down the Bay and we headed into it and that plane started goin' up. Scared us at first but after a while we figured out how to make it go up anytime we wanted. We never went up very high. It was a lot a fun.

One Saturday, the four of us was down cleanin' the workboats and gettin' ready for the week ahead. We were also havin' some booze we'd gotten from the moonshiners on Chincoteague. Sometime in the afternoon, we saw we was runnin' out of liquor. Our pilot said *'Hey I'll get my cap an' fly over to the Island to get some more.'* As soon as he said that, all the guys wanted to go. We all knew the plane only held two but we'd been drinkin' enough not to care. We kept talkin' about who was goin' and who wasn't when all of a sudden one guy said *'Don't worry, two of us will tie ourselves onto the pontoons then all four of us can go.'* They did an' the pilot started the engine and tried to take off. With twice the load the plane could handle and the amount of booze we had drunk, the seaplane didn't work like we thought it would. We sheared off the cabin of one of the workboats

in the Harbor and then pitch-poled right before Marker 14 just outside the Harbor's entrance. When the seaplane stopped it was upside down—the pilot and co-pilot were underwater, and the two men strapped to the pontoons were dangling upside down in the air. Through much effort and with as quick thinking as they were capable of at that point, they all freed themselves and swam home. Others in town took every possible opportunity to remind them for many years afterwards that God looks after little children, fools, and drunks—as well as inebriated and inexperienced aviators.

DRIVING ON HOME
I spent as much time off the road as I did on it.

The first tale was told on herself by the then-oldest woman in town. Most residents have heard her tell this story on more than one occasion. The second tale is not as widely known but equally descriptive of the times.

It all started when my husband bought a boat in Wachapreague [nearly 45 miles from Franklin City, where she lived]. *He bought the boat but, of course, it was a used boat—I don't know anybody in Greenback or Franklin City ever bought a new boat. It needed some work done to it before it'd be ready so he left it there in Wachpreague for them to work on it. One day my husband says 'Let's go down to Wachapreague and see how they're doin' on my boat.' I always liked to go, so I thought we were off to take a nice ride of an afternoon. We took our 12-year-old daughter along. My husband drove as he always did. I had tried driving just once for a few minutes. I didn't have a license, and I didn't see a need to drive, long as he did.*

So off we went to Wachapreague. It was a long ride. All the roads were only two lanes and wound around quite a bit. But it was a real nice ride. Once we got there my husband went off to talk to the man who sold him the boat and my daughter and I sat in the car and looked around some. When my husband came back, he said 'I think she's ready and I'm takin' her home today.' By now it was pretty late in the day, 'round 4 o'clock or so. There was only one way he could take his boat home and that was by water. We had a little discussion that went something like…

> **He**: *I'll take the boat home and you drive on home.*
> **She**: *I don't know how to drive.*
> **He**: *It's easy!*
> **She**: *I don't have a license.*

He: It don't matter. Nobody'll know whether you have one or not.
She: It's getting dark and I don't even know how to turn on the lights.
He: Just turn them knobs, you'll find the right one.

After that comment, he took off to board his boat.

The 12-year-old in the back seat chattered incessantly all the way home and gave her mother gratuitous information such as *there's a policeman right behind us* (when there wasn't). The non-driver was already rattled and the girl's prattle and distractions were not helping. Anyway, she gave it her all.

Turning the car around and finding the main road was the first hurdle. Next was the stick shift—in those days there were no automatic transmissions. New challenges emerged all the way home. Here's her account of the trip.

I got the car started and got it into gear an' then I ran it right off the road into someone's yard. In the house on that yard were a woman and her son. I asked the boy if he would get in the car and turn it around and tell me where the main road was. He was a nice young man and he turned her around for us and I was on my way. Every time I changed gears the car bucked and kicked and I never did figure out how the clutch and gas pedals worked. There were too many things to do. I was trying to change gears, steer the car, and deal with my daughter in the back seat. I spent as much time off the road as I did on it. I never got the car out of second gear so I drove the whole way home goin' under 25 miles per hour. It took a long time to get home—I know it was more than two hours. Once I got to Franklin City and could see my house, I thought, 'Well thank God I at least got home safe.' I counted those chickens a little too soon. As I was trying to turn into my driveway I hit a telephone pole and finally, to stop the car, I ran into the fence in my yard. But I was home.

The worst of it was the boat wasn't done after all. My husband had to hitchhike home. He was mighty glad to see his car in the driveway and didn't seem to mind that I'd run into a few things. As for me, I never ever drove a car again!

Another story about driving came from a woman who remembered how special the occasions were when her dad asked her as a young girl to drive. *My mother had a colored girl there helpin' her and the carpenters were there remodeling our house. My father taught me to drive when I was 12 years old an' he knew I could drive. It came time for the colored lady that lived out in the country to go home an' he didn't want to take time to take her. He said "You go on an' take her, I know you can do it. Go ahead—you can do it.' I think he wanted to show this carpenter that I could drive and he knew the carpenter's daughter couldn't. I took her probably two or three miles out in the country. I let her out an' she watched me turn around an' head back. I was so proud of myself, gosh here I am drivin' by myself, none of the other kids can do this. I got home*

an' come right on in the driveway. Then I had to make a sharp right hand turn to get in the garage. Well instead of slowin' up an' changin' the gears an' goin' in slowly, I went full speed and knocked the doors off the garage an' tore the right side of it off too. I reckon, he couldn't brag about me after all.

When a family owned a car, and that was seldom, it was assumed to be the possession of the male head of household. As such, when it was used, by whom, and for what purpose was at his sole discretion. Many women never learned to drive a car and never had any need to because back then, everything they needed for day-to-day life was readily available and within walking distance.

BETTER MAKE IT TWO
Buying liquor was a commitment of time as well as money.

Imbibers living on the northernmost edge of the easternmost part of Virginia have always had limited access to alcohol. If most of the womenfolk had their way, both then and now, alcohol would be even more restricted because of the alleged problems drinking caused to their families and community. To buy hard liquor, even up to 2006, a trip to Chincoteague Island, Pocomoke City, Maryland, or other more populated areas is required. In the early days, given the type and speed of transportation, buying liquor was a commitment of time as well as money. At one time, there was a beer hall in Greenbackville and a hotel with a bar in Franklin City. In the scheme of things, these two establishments were exceptions to the norm.

Prohibition was a noble experiment attempting to regulate the private lives of individuals, and it was a colossal failure. It was soon learned that trying to entirely quell the use of alcohol was like trying to put toothpaste back in the tube. Those who enjoyed or used alcohol for whatever reasons—pleasure, habit, or addiction—were not about to stop. Not only did they vow to drink, in all probability they drank more because it was a challenge to get around the law. This defiance was evidenced in other parts of the country by speakeasies, clandestine home brewing, and drinking grain alcohol—produced for purposes other than drinking. When Prohibition became law, most of the women of the community applauded. On the other hand, most of the men were greatly disappointed but did not wait long before devising ingenious ways to acquire their beloved alcohol.

During Prohibition, in rural areas throughout the country, moonshiners with illegal stills and bootleggers who trafficked in illegal spirits were

everywhere. The Eastern Shore of Virginia, especially Chincoteague Island with its oceanside location, also had access to bootleg whiskey from oceangoing vessels. Once smuggled onto land, the contraband was distributed by people loosely identified as bootleggers. As evidenced by the many tales based on exchanges with moonshiners and bootleggers, these entrepreneurs did a good business. An example of their dealings follows.

Against the better judgment of a son and in defiance of his wife's wishes, every Saturday morning a father convinced his son to drive him to his favorite distributor. The grandson remembered:

There was a lot of moonshine back then. I have heard from two or three, there were several gallons brought in here each week. Like my grandfather, he'd order a gallon a week, I've heard say. My uncle told me the following happened every Saturday mornin'.

> **Father:** *Get yerself up and carry me out to Sam's.*
> **Son:** *Pop, I'll carry ya out there but just get one gallon. Don't get two gallons. (If Pop'd get a gallon he could do what he wanted to do, but if he got two gallons it messed him up on his work schedule.)*
> **Father:** *You take me an that's all I'm gonna get.*
> **Son:** *Naw, you'll get out there an' he'll talk you into two.*
> **Father:** *He'll not talk me into two, I'm only gonna get one.*

When they got there, the bootlegger greeted them with bad news.

> **Bootlegger:** *Ya know them* [revenuers] *closed up ole Henry over there on the other side last week, I don't know if I'll be here next week or not. (That's when Pop'd start losing his breath, he'd be a puffin' and pantin' and scared to death he'd not get any the next week and sure enough he'd come back with. . .)*
> **Father:** *Well then, Sam, ya' better make it two!*

FINDING GOD IN THE MARSH
A child's imagination coupled with the mysteries of the marsh is a winning combination.

We were children and I was old enough to know better but there were all these old abandoned houses down on the Shell Road and we'd go down there just messin' around. This day there were three of us—me, my youngest brother, and

my friend who was a few years younger than me. We were down there breaking out window lights. We were chunkin' shells up at the windows on the old houses and breakin' them out. Just prior to that someone had been killed in town and there was a rumor around that someone was hiding out in those old houses.

I don't know if you've ever seen it but when the sun streams down through the clouds, it looks almost heavenly. Well, we were breaking out window lights and I saw that in the sky. I told the two younger kids who were with me 'Look at the sky. God knows that we're doing wrong and we need to get down on our knees.' Up to this point, it was all a joke with me; I just wanted to see if I could get them to do what I wanted them to do.

I got them down on their knees lookin' up at the sky. You know, they were very humble and very afraid and I was getting a big kick out of that. But when I looked up again where the sun was shining, there was an image of what a child . . . now, I know nobody's ever seen God or Jesus but I think we see images sometimes that we know by association could be Jesus or whatever . . . would think was God or Jesus. That image was shaking his head back and forth in a negative way. I can see it today like a picture on the wall. I knew that he was speaking directly to me and I knew that what I was doing was wrong. I was so scared. Then, the other kids looked up, saw the same thing, and were scared too. We all ran and didn't stop till we got home. We didn't talk about it at all for a long time, probably years.

Later, I asked my brother what he thought about that. He said, 'I think we were in danger . . . you remember they were looking for somebody and I think he was in that house where we were breaking the windows. I knew what the message was to me.'

Just a few years ago, I asked my friend (yes, she's still my good friend), 'What did you see? Do you remember that?' She said, 'I'll never forget it!' She saw the same thing I did and thought we were in danger.

Maybe we were in danger . . . but I thought for years I was the only one that saw that and when I ran they ran. But without me telling them what I saw, and none of us saying a word about it for years, it turned out we all saw the same thing. Over the years when people begin to doubt their faith, that will pop into my mind and you know, God is real! That may have been a way of reassuring me over the years. That's the one thing that I'll never ever forget.

One of the participants in the above tale confirmed the vision they had seen and also validated the ability of the older girl to scare the younger ones.

My friend and I always played out on the marsh. We just loved the marsh. An' at that time there was still a lot of houses out on the marsh. Right down from the house where I was raised was Shell Road. Today, it's all grown up you can't tell it.

If you'd go on down Shell Road a little way there was a spring that runs through there. If you go down to the canal now an' stand on the bridge, you can see how it meanders through. So anyway, we're down there an all the water is streamin' though an' with it is all this stuff that looked like slimy hair. An' my friend and me would go down there. She's a couple a years older than me. And at that time, she was my superior so I believed every word she told me. So as we're lookin' at the slimy stuff in the stream she says to me, 'Do you know what that is? It's Pocahontas's hair!' I'm sure she also told me some elaborate thing that Pocahontas was dead an' floatin' down the stream. I figured the body'd be comin' through next. I took off runnin' or something, you know? She scared me to death!

Playing in the marsh away from adults was a part of the life of most children in these communities and still is. A child's imagination coupled with the mysteries of the marsh is a winning combination for the creation of many unforgettable adventures.

BEAUTY IS IN THE EYE OF THE BEHOLDER
As I turned my back to leave, my good friend and neighbor flipped up my skirt.

We had some wonderful friends from the city who came to visit us nearly every summer. This particular time, they arrived near Easter and brought beautiful candy eggs for our kids. Now you understand, we always decorated eggs and celebrated Easter but these eggs were prettier than any we had ever seen before. The brightest colors, some with pictures of little rabbits and chickens, others with lace, and jewelry and well, you get the idea.

I was just finishing my shower as the company arrived so I had slipped on my dress and figured I could put on the underwear and finish dressing later. Right then, I needed to say hello, help them unload the car, get things inside, show them who was sleeping where, and make them some iced tea. After all that, I was still taken by the Easter eggs and asked to be excused to run next door and show them to my neighbor before the kids got into them.

I gathered them all up in the special basket they came in and left. When my neighbors saw them they were as taken with them as I was. After a short while, I told them I needed to get back to my company and started for the door. As I turned my back to leave, my good friend and neighbor flipped up my skirt. And oh, my! There was I without my underwear on! I squealed, turned very red in the face, and ran home. As the door closed, the husband of my friend said, 'Don't worry, yours is purdier than hers!'

PINKY THE HORSE
Horses are like that, they head home.

We had a pony named Pinky. Pinky was a pony from Texas an' they had used her to gather up goats off of Hog Island, or hogs off of Hog Island, or whatever they had there. I think it was goats, it coulda been hogs. Anyway, Dad bought her. I think that's where I got my love for horses. We had quite a many a story to tell about Pinky.

This one day my sister and I, it had to be in the '50s because we didn't have Pinky in the '60s, I was probably eight and my sister was probably twelve. We would hook her up to this old buckboard an' we'd go outside of town, out on Stateline Road. We'd rake up pine shats to bring back to the barn for Pinky. One day comin' back, long 'bout the head of Church Street, we think a bee stung her. She took off! You know, on a Western when you see a horse running, that's what she was doin comin' on down Church Street. At that time, there were a lot of people in Greenbackville. You know they worked on the water all day an' there was always people outside. Here's all these people wavin' their hands, yellin' an' trying to stop the horse. So she comes along about where Church Street starts, she makes her right an' she wouldn't stop for nothing or nobody. She comes on down by the post office. We were yellin' and screamin' 'cause we thought we'd had it. The more we yelled an' screamed', the more she ran. We had a dog, at the time, her name was Queenie an' she was up there on that buckboard pantin' her head

Pinky, the most famous horse in Greenbackville!

off an' riding it with us. When we got to the post office, people were comin' from everywhere tryin' to stop this horse. Well you couldn't stop her, buckboard and all she was racin' for sure. She made a right up by Marsh Mud Avenue an' the first house was our house. She veered on in. She didn't let up any steam till she got right smack at the stable door. Then she stopped dead.

Horses are like that, they head home. I don't know why that buckboard didn't turn over. We were half afraid to tell mom and dad what happened for fear they'd want to get rid of Pinky but we knew we had to 'cause everybody in town saw us.

THE GIRL WITH THE IMPALA
It was lucky I had that Impala.

Up until the 1950s, there were only a privileged few who owned a car, and at that, it likely was not purchased brand new or as the top of the line model. If you did own one, it was only used for a ride on Sunday and for funerals unless it was required for work reasons. Cars were the domain of men—women did not go out and buy their own cars until very much later. This is a story of a car that came to town brand new, was the top of the Chevrolet line, and over time had several owners and adventures.

It was one of the last things my dad bought before he got sick. He was so proud of it. It had, you know, all the red interior and was red and white outside. It was when they changed it from those big fins and the fins angled out: they were a lot more graceful. And it had checkered seats! We all thought we were so special when we rode around with him in it. Later, when he died, we used it for a long time as our family's car.

During the Ash Wednesday Storm the Impala was the subject of a testament to a woman's foresight and the honesty and concern of neighbors: *Before the water came up, my mom had taken the Impala up near the church where it's higher and left the keys in it. When the water really began to come up, someone moved it out of town to even higher ground.*

Later the Impala became mine and Mom got a newer car. When I worked at US 13 Restaurant I drove that Impala there every day. While I was working there I had an accident in that Impala. There was this lady boss and she asked me to pick up one of the cooks on my way to work. The woman lived off Sheephouse Road somewhere back in there. It was in the summer and I'd almost gone by her house and then I saw her in my mirror like waving. What I failed to see was the car that was sitting in front of me down the road. I knew it was there and I thought I had time but when I turned back to look, I hit it. There was no driver

The owner of a brand new Impala. His prized possession later became part of his legacy.

but there was a man and woman in the back seat and I sent the car between these two trees in a yard. They looked out with these great big eyes. I didn't realize I was hurt. The people there took me into their house, handed me a grungy towel. I thought 'Ugh' but it was wet and I was grateful. As I walked through their hall to the bathroom I saw the blood all over my fresh crisp white uniform and down in my shoes. I didn't have a mirror or anything but come to find out I broke the steering wheel with my face. My mother took me to the dentist in Snow Hill and he said we should try to find my teeth. She went out there and looked and looked and thought she found a chip of my tooth. Come to find out it was from a white platter that she had left in the back seat of the car. The platter had broken in the accident. It took a long time till I got my teeth and mouth all fixed. It was lucky I had that Impala, it was a big car and if I hadn't had it, I would have been hurt worse.

When I got married, I was gonna take that Impala to Texas with me because I loved it. But I had it checked and the mechanic said it had leaks around the seals and it would never make it. Now, I know that car woulda made it. It was a great car. Neighbors bought it from me. They drove it a while and later they sold it to another guy who was going to do some work on it. I don't know who the guy was.

I often wonder if that very special Impala won't be showing up all fixed up in these car shows that the firemen sponsor now.

CHARACTERS IN THEIR OWN RIGHT

THOSE WHO WERE DIFFERENT
Those who were different were kept in minds long after their passing.

In small, insular, conservative communities those who were different stand out more than their counterparts in more diverse urban settings. Those who were different from the majority of the populace were for the most part remembered with kindness and because of their good qualities. It was clear however that some residents simply did not fit the white, Anglo-Saxon, protestant, "Ozzie and Harriet" view of the world prevalent in small communities; consequently, they were remembered, and likely treated, differently from everyone else. To survive in such an environment one person said, *They simply had to know their place and keep a low profile.*

Race in General

Greenbackville and Franklin City are—barely—in Virginia, long known for its segregationist sympathies. In the early days, those who were different from the majority of residents were primarily of African ancestry. In modern times, those labeled as different tend to be of Mexican and, to a lesser extent, Asian and Indian origin. During the time of slavery, there was known mixing of the Native American population with African Americans on the Eastern Shore and both were held in equally low esteem by the whites of the time.

Later there were African Americans who worked as household cleaning ladies, farm hands, barrel makers, and railroad workers, but they lived in Stockton, Girdletree, or somewhere else outside of Greenbackville or Franklin City. More than once, reference was made to an unwritten but absolute local law: *No colored were allowed in town after dark.* Ignorance of this rule was no excuse and the law was enforced by both words and deeds. *One Saturday night a Mexican came into Greenbackville riding a bicycle probably to go to the store. People came out of their houses and yelled at him and threw things at him and ran him out of town.*

One woman remembered a racial situation from her childhood: *In the late 1920s when I was a little girl, my mother had a black lady who helped her with cleaning. This woman had a little girl about my age and so my mother invited the woman to bring her daughter with her so we could play together. She did bring her the first time and the two of us really had fun. So she continued to come with her mother and I looked forward to it. One day when she was visiting, I thought it would be nice to go to the store and get some candy. I was probably nine or ten years old at the time. I was ashamed to take this girl with me to the store. So I went by myself and brought back enough candy for*

both of us. You know in those days blacks and whites didn't mix but that never bothered me.

Another person said: *It wasn't a hard time or a bad time but just to tell you how things were here's a story. There was a woman who came in the summers to visit her parents but at the time, she lived in the city up north somewhere. She would bring down foreigners—Jamaicans, and whatever. I guess they were like maids for her an' to take care of her son. A couple of them were black girls—I'm gonna call them Jamaicans because they had a different talk. I made friends with one an' of course, I wanted her to come down to my house an' whatever. It seems to me I was told 'We just can't do that.' There was no big scene or nothin' like that.*

These stories illustrate what society of the day expected, as well as clear evidence of independent streaks that found a way to reject the expected and yet not get into trouble by openly flaunting societal customs.

The Only Black Resident

There is always an exception to every rule. Greenbackville had one black resident. No one seemed to remember any living in Franklin City.

He came to Greenbackville as a twelve-year-old boy. Observed from the outside of the house where he lived you could say he lived in a white household—from the inside of that house, his quarters were separate from the rest of the family and access to them was through the kitchen. He grew up eating the same food that his benefactors ate in the dining room—the only difference was that he always ate in the kitchen. He worked at the livery stable within walking distance of the Franklin City railroad station.

One little boy was perplexed by him. *After having gone to visit in the house where he lived, my mother and brother were walking home. My brother was a few steps ahead of my mother and all at once he turned around and asked my mother 'How come Mrs._____ has one black baby?' The colored man was always there and treated like family, so my brother thought he was the woman's son.* It would be interesting to know how that question was answered, but the mother's response was not remembered.

When the livery stable closed because people had access to automobiles, he was a grown man. At that time, he was hired by the railroad to repair track and do maintenance at the Greenbackville School. He was also the church's custodian. That job involved everything from keeping the church clean, to starting the fire early enough on Sunday morning in time for services, to ringing the church bell to call the faithful to worship.

When the man who brought him to town and with whom he had first lived died, he moved to the old school that was no longer being used and

that was owned by the church. In his advanced years, he was a double amputee and could no longer live alone, so another male member of his white family provided a home and took care of him. It was reported that *He never married. He didn't drink. He never purchased or built a house.*

He was a trusted and appreciated member of the Greenbackville community. Everyone remembers him and not one person identified him as anything other than *a good man* and *a hard worker*. He also new *his place* in that time of segregation in a small world filled with southern sentiments and values. He did many things for Greenbackville, including showing that the color of your skin has nothing to do with the kind of person you are.

It is interesting that many of the oldest living members of the Greenbackville community made it a point to talk about this special man. They introduced him to the conversation and seemed to want to be sure that he was included in their reports of "how things were in Greenbackville." They gave the impression that it was a badge of honor or an indication of their open-mindedness about race to tell about how good he was and how he was a part of their community.

The Remembered Man

Community members generously shared old pictures. One of the pictures was of a group of Boy Scouts laying a fire *c.* 1950. No native Greenbackville woman around in the mid 1950s sees that picture without exclaiming, *Oh my, that's _____! He was the best looking, most handsome young man that ever lived here and he was so talented.*

One of his female friends said, *Did you ever hear about ____? He was so good lookin' but he wasn't the outdoor guy that his father wanted him to be. He was interested in drawing, painting, an' I remember his father used to talk to him so bad. He wasn't what he wanted him to be but he was good lookin'. He had girlfriends galore as he grew older. We went skating together an' wherever he went, my mother would let me go. She trusted him thoroughly. An' see, he's three or four years older. So, that's why I got to see the world more. He moved away an' we lost track of each other. He died a few years back an' he'd had his legs removed. He had, I guess, sugar diabetes or something of that nature. He . . . got a rough go-around, not from everybody, just his father. I guess I'm just finding out more now how hard his dad was on him. His mother—sweetest lady in the world. He looked just like her.*

Men acknowledged his talent and would say things like, *He could draw and paint but never hunted or fished. His father was always on him about something.*

Another man said, *He was my best friend back then. People used to confuse us all the time because we were always together. We were both labeled as sissies*

and hung out together. Together we'd collect butterflies, draw, and read stories. We were lucky enough to have Boy Scouts and a leader who valued us and let us do things we liked and still be Scouts. Importantly, he let us be who we were. We earned every badge there was for what were labeled as non-masculine skills— map reading, cooking, music, and painting. And oh, our campsite. When we'd go camping we always won the award for the neatest tent and cleanest campsite. I was more intellectual and knew I was going to college. He, on the other hand, was not academically inclined so when he graduated from high school he left. He moved to Miami, got AIDS, lost both legs, and died a few years ago. I grieve about that.

Well over half of the people interviewed for this book mentioned, in one context or another, this young man. More often than not, it had to do with arguments between the boy and his father.

A few people believed that he and a cousin were playing with candles in the attic and were responsible for starting the first of the fires that destroyed three houses during a couple of days in the 1950s. Later this proved to be a false rumor. The person who discovered the first fire, at the house of this boy, dispelled that myth by insisting he wasn't even home that day.

Those who were different were remembered long after their passing. In some cases they are remembered with pride, in others with sympathy, and in still others simply because they were nice people who were too different to be fully accepted just because of the time and the place.

SHE WAS SOMETHIN' ELSE
In the beginning, they had serious elements of truth but with each telling they grew richer and likely further from the truth.

One woman was mentioned over and over again. The following is a composite of many different descriptions that qualify her as a genuine character from the past.

She was, by all descriptions, very obese and talked to herself all the time. She was known for her daily walks to the local beer joint to call her husband home for dinner. She is reported to have followed the same routine day-after-day so everyone of a certain age seems to remember her. She would leave her home and walk down the street talking to herself in a voice loud enough to be heard by all and apparently totally unaware of anyone else. Often the patter was related to telling her feet what to do. It went something like, *Don't step in the water. Watch out for the puddle. If you step in the water*

Characters in Their Own Right

you'll get all wet. Watch now. Oops there's another puddle. Don't step in the puddle, Look out. Careful. Watch now.

And so it went as she sloshed right through the middle of each and every puddle in her path. Upon arriving at the beer joint she would stand at the door and say in a voice loud enough to be heard in the bar and probably everywhere else in town *Mr. ____, Mr.____, Your dinner is served.* She would say it over and over until he came out. Then, she would slowly walk back home with him in tow, repeating the litany to her feet about watching out for puddles.

This couple was unusual enough to spark many a tale. They were made fun of by some and others entertained themselves dreaming up stories about what they did when they were at home alone. Once that kind of storytelling began, it was hard to guess what kind of predicaments would be imagined involving this unusual pair.

One of the outcomes of the many hours of chatter about this couple came to light during an interview with one of Franklin City's native sons.

> **Native son:** *Golly day, I don't know, did you come on that song about the Dirty Ole Sea Crab? I don't know who wrote it, somebody there in Greenback years ago. It was about _____ & _____ [names of the couple mentioned above].*
> **Interviewer:** *Some folks have told us stories about them.*
> **Native son:** *An' they haven't sung you the song? Don't know if I can remember all the words or not. You may not want to put this in a book.*
> **Interviewer:** *We might not, but then again we might. You can't tell.*
> **Native son:** *It went like this:*
> *Dirty ole sea crab sittin' on a post*
> *Along came fisherman an' took him for a roast*
> *Singin' Ding eye Ding eye Ding*
> *He put it in the piss pot while the ole lady slept*
> *Ding eye Ding eye Ding*
> *Ole lady got up to do some doo*
> *Ding eye Ding eye Ding*
> *The dirty ole sea crab bit her in the flue*
> *Ding eye Ding eye Ding*

All the time the native son was recalling these words, his eyes twinkled and he was all but giggling as he remembered each line. At the end, everyone

broke into laughter. Was he remembering the times he had sung it before? The people it was sung about? Or his friends who sang it with him?

Over the years the stories, based on actual events, grew and in some cases took on lives of their own. In the beginning, they had serious elements of truth but with each telling they grew richer and likely further from the truth. At any rate, this woman is one of the legends of these communities and remembered by many.

SHORE IS PURDY
It was often necessary for the women to go to the Harbor on Saturday night, collect their men, take them home, and clean them up so they would be presentable for Sunday morning services.

As mentioned earlier, there was a great deal of hard work done, as well as alcohol consumed, by those who worked on and around the water. Often, the work was done in the months when the weather was the coldest and nastiest because that was the time of year to harvest oysters.

Then and now, liquor is seldom in the family budget. Times were hard. Often people had to do without what today are considered basic necessities such as underwear and other store-bought items. In spite of their families' needs, many of the watermen felt entitled to spend some of their hard earned cash. Spending the cash was one thing, what they spent it on was another.

Even though the catch had been unloaded and sold, the boats still had to be cleaned and prepared for the week ahead. This process took much of the mens' Saturdays, or perhaps was strung out to take the whole day. With cash in hand from the sale of the catch, they could buy some liquor and enjoy it with their friends.

In the winter, the damp cold was multiplied by being on the water and having the wind whipping. It would have been difficult to stay on the water for six to eight hours without a source of heat. Heat for most watermen was provided by a boat stove. Come 'eres might envision a boat stove to be a cute little iron, pot-bellied stove that burned coal, but they were often little more than an oil drum or other metal container that had a top flap for adding fuel and a welded stove pipe for a chimney. The fuel was anything that would burn—old stumps, corn cobs, cardboard, driftwood, or whatever was handy.

One particular Saturday was especially cold. The week's catch had been especially good, so liquor was flowing. After using up all the fuel around,

the men—somewhat compromised by their level of alcohol consumption—decided they might as well use the creosote scraps of pilings that were strewn around the Harbor. These pilings were left there by those who had been repairing the bulkhead and pilings. Creosoted wood burning in boat stoves inside the boat cabins resulted in a great deal of smoke and a great deal of residue on the men. *But, it sure did burn good!*

Anyone who has spent any time in Greenbackville will affirm, it is the women of the town who keep religion and the church alive. From that day to this day, they support and attend the church. In those days they also made sure their families, especially their husbands, got a good dose of Christianity every Sunday whether they wanted it or not. When the seafood industry was thriving, it was often necessary for the women to go to the Harbor on Saturday night, collect their men, take them home, and clean them up so they would be presentable for Sunday morning services.

This one Saturday night, the men were more drunk than usual and they were also dirtier; in fact, they were black from the smoke of the creosote. Two women who were neighbors went together to the Harbor to collect their men. Once they discovered the inebriated state their husbands were in, they decided the only way to get them home was by means of a wheelbarrow. They also decided that there was no way the men's filth was coming into the houses they had spent all day cleaning. Together, they got their husbands into their front yards where the wheelbarrows were unceremoniously emptied—landing the nearly unconscious men on the ground. The next step was to hook up a hose and wash them off. After the first woman had hosed down her husband, her neighbor stepped over his head, reaching for the hose. As she stood over the head of her neighbor, the husband who had just been hosed down came to. He looked up with her standing over his head and exclaimed, *My, Miss _____ that shore is purdy*.

The man who made this unfortunate comment had had a tracheotomy and therefore had a tube in his throat leading to a hole in his neck that he used for breathing and talking. His wife's reaction to his unseemly remark about his neighbor's wife's anatomy was unhesitating. She took the running hose from her friend, put it on the tube, and water ran out the man's nose, mouth, and everywhere in between. He became quite sober very quickly and learned to never say the first thing that he thought of—especially about his neighbor's wife's anatomy.

6. Happenings

An event is a memorable activity that has a clear beginning and a recognizable end and is different from regularly repeated activities of life. Such "happenings" always spur excitement and leave a lasting impression. Sometimes the emotion is joy, sometimes fright, and still other times awe. Always, a happening is something that sticks with a person.

In small towns in very rural areas, such events were relatively few and far between. But when they happened, they were all the more exciting just because they were so unusual.

LIFE WITH WIND AND WATER
For a people that, by fate or choice, live beside the sea, there are inherent risks—weather being the major one.

The Ash Wednesday Storm
When collecting stories for this book, the authors always asked "What was the most exciting thing you remember over the years?" It was unanimous—the 1962 Ash Wednesday Storm. That is, unless you were around for the 1933 storm.

In early March 1962, those living in Greenbackville and the few still hanging on in Franklin City were just beginning to look forward to the end of a harsh winter—spring was on its way. Winters always bring a few unusually high tides, usually when a low-pressure front rides up the coastline or a full moon occurs. Rarely, when both occur at once, there are extremely high tides. These high tides can mean minor flooding at the Harbor and water flowing over the tops of a few low bulkheads, plus creeping water from the marsh moving into low spots on roads and yards. These occurrences are fairly common and a fact of life for anyone living near tidal areas. In other words, *no one gets excited about a little high water.*

The Ash Wednesday Storm started as a fairly common winter storm. Few would have predicted the fury it unfurled on March 5, 1962. There was a full moon on its way and a storm was beginning to blow. A high tide came

in and there was a little flooding. *We'd seen it before. As sure as the sun rises and sets, a high tide is always followed by a low one. Besides, there isn't much you can do about the weather anyway so why get in a swivet?*

Weather forecasting then was not assisted with all the high tech devices of today that allow satellite views and projections of storm intensity and path. Many did not have TV anyway, and radio reception was not great. The few remaining residents of Franklin City and all of the Greenbackville folks carried on with their work and other activities with confidence that *this too will pass.*

This storm had all the characteristics of a hurricane but because it happened outside hurricane season, it was called a nor'easter. The high tides of March 5 never went out. March 6 came and with it, two more high tides arrived to build up on top of the water already there. March 7 continued the high tides and flooding. By then, Franklin City, which is slightly lower than Greenbackville, was totally underwater and the remaining citizens evacuated. In Greenbackville everything was flooded except for one point on the street in front of the new firehouse. It was only on the fourth day that the tides' ebb and flow began again and the water started back down.

One man who was a teenager then remembered: *Dad and I was sittin' out to the house an' the tide began to come up. My Dad put a wooden match on the step. That wooden match crept up the first step an' then it crept up the second*

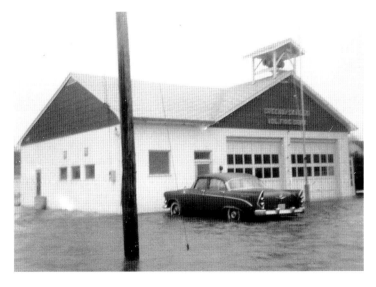

Stranded car thought to be safe from the '62 flood at the then-new firehouse.

step and the tide started to fall. If it'd gone back below the first step everything woulda been OK. But, when the match started back down it went back down part way of the second step an' it stopped. Dad said 'Lets go, we gotta get our furniture up on baskets.' Where our house was, was pretty high. We had bushel baskets, four of 'em to a stack. We'd stack 'em and put our furniture on top of that. So, the tide came again an' it started creeping back up again—slower an' slower. Dad said 'It's time to leave, it's not gonna go out.' It'd begin to fall but it wouldn't fall clear off. It just kept comin' in. It just didn't stop. It just kept comin' in and came over the top of our furniture. It was in everybody's house. I had an 18-foot scow with a 50 horse Johnson an' I was goin' from door-to-door takin' 'em off a their porch roofs. They'd walk off their porch roofs an' into my boat just like you'd step off a dock. Propane tanks were floatin' around like bombs and everyone was sayin' 'Don't smoke, don't smoke.' Y'know, no one lit a match. I was down to Franklin an' run over an automobile with my boat an' when I did, my motor cut off an' we were adrift. I told my friend, 'You better catch somethin' 'cause if you don't we're goin' to Chincoteague.' He grabbed a building goin' by an' I got the motor started but his hands were all tore up from holdin' on so tight.

 A then-young girl corroborates how quickly the tide came up. *The day the tide came in, when we woke up it was in the yard across the street. She [mother] put the oatmeal on for breakfast and before it was done, the water was coming in our front door. My sisters and I begged my mother to leave but she was adamant about it, she was not leaving that house. In the back of my mind, I'm thinking here we lost our dad just two years prior, and now . . . 'course I didn't say anything about that. Finally, the firemen came and said 'Miss _____ you can't stay here' and we all left on a boat. We had some forethought about things that were important to us and that we'd take with us. My dad had gone to Florida before he died and he brought back a little live palm tree. We nursed it along because it reminded us of him. So, when we left, we took three things with us—that palm tree, our bibles, and our puppy.*

 A waterman remembers where he was on the second day of high tides: *Only me and another fella were out drudgin' clams—the others stayed in that day. The tide was up but that didn't make any difference. We went out rain or shine and a little high water wouldn't stop us. I was havin' trouble keeping the drudge down on the bottom.* [Local pronunciation of dredge is *drudge*.] *Every time I'd get set and start runnin' it'd flip up on me. The other guy called over to me and asked 'What's all this stuff* [logs, buckets, etc.] *floating around?' 'Bout then, we both looked up and the water was up to the light on the Point of Shoals marker. We hightailed it back to the Harbor and when we got there, you*

couldn't see any lights, poles to tie up to or anything—that tide brought it up over everything. A man from Stockton was still there and had just finished tying down his boat. He said, 'C'mon over and anchor with my boat.' We did and then we all got out and onto dry land in his little 'dinky.'

The same storm hit Norfolk and the Hampton Roads area and their media stories report the damage it did, but they never mention the havoc that was wrought on the Eastern Shore. Then, as now, there are significantly fewer public services and other resources to deal with the devastation on the Eastern Shore than in the cities to the south. The outside help that came to the area went to Chincoteague Island, not the land side of the Bay where Greenbackville and Franklin City are located. The only memories of outside help were of the Virginia National Guard who secured the town until residents returned and also distributed a lot of surplus cheese. Other than that, the clean-up and restoration was done solely by residents.

Some people who *got water* left town to stay with relatives or friends who were in places other than Greenbackville and Franklin City. The rest of the people who were flooded out first went to Greenbackville's then-new firehouse. Flood waters had never reached that land before so they felt safe at first. By the second day, the tides crept closer and closer. By the third day of the storm, even the firehouse had water coming in. When that happened, it was neighbors five miles away in Stockton, Maryland who came to their rescue. They brought every vehicle available—school buses, tractors pulling wagons, other farm implements, and cars—to the high tide line, just outside of Greenbackville. Residents were delivered by the boatload to the high tide line and then taken to the Stockton firehouse or met by family and friends living further inland. Some lived in the Stockton firehouse for up to two weeks. All who experienced this event are continually grateful to their neighbors in Stockton who helped save their lives and provided food, shelter, and clothing.

The flooding from the 1962 storm was greater than anyone had seen in these parts in a very long time. Because the weather was windy but not rainy, *the storm snuck up on everyone.* In today's weather terms, it likely was a stalled low that moved up the coast and brought three days of northeast winds. Because the winds were from the northeast, the tides were blown into the Bay and could not go out, hence the flooding.

One young man who was making his way back home for a vacation from a college on the western shore remembers getting to Salisbury and then hitchhiking to Stockton. *When I got to Stockton, I paid somebody to drive me to Greenbackville. By that time, everybody was back in the Stockton firehouse.*

But the National Guard was at the two entrances to Greenbackville. So once I got down there, I couldn't get home but I stayed down there to help them. I spent about four hours at the Maryland entrance to Greenbackville with the National Guard guys to identify people coming in and out.

When the water went down, the people returned to survey the damage. Although Franklin City ceased to exist for a lot of reasons, this storm was the final blow to those who had lived there. By then, Greenbackville's population was larger and the Harbor was still a locus of activity for the seafood business. It was in everybody's best interest to *pull up our socks and get on with it. Thank goodness for our new fire company and its pumper truck. The men came around to each house and hosed the mud out. The women came behind them with brooms and buckets and got the houses livable again.*

All the houses back then were old homes built with lathe and plasterboard. All that water came in an' soaked up the plasterboard and insulation. You couldn't get it out of the walls. They were just saturated with it. Finally, most folks tore out all the weather boarding and plaster board an' then put insulation and paneling back up. That was the only way you could get rid of that smell.

One woman reminisced about her room that had been recently remodeled before the storm. *My husband had just died after a long illness. Toward the end, he stayed in a room downstairs. My three girls were young and they wouldn't go near that room after he was gone. I scrimped and saved till I had enough money to put hardwood flooring in there an' we painted it an' got a new day bed. Don't you know, that water came in an' mud was everywhere. It ruined it all! To this day, on a damp day those nails in that hardwood floor turn a different color.*

One Franklin City housewife had been keeping house for more than 40 years and just before the '62 storm hit she had gotten her first brand-new set of dishes. She remembered: *It blew up a gale for days. We thought we could ride it out. We'd probably get some water inside but that'd be all. Well, it kept comin' an comin' an comin'. An' you know, nobody had a lot of money or things but I had just got a new set of dishes. Oh, they were so pretty. We'd eat supper, I'd wash 'em up and set the table again so we could just enjoy them. The last I remember was when the boat came to carry us out, the water was so high, those dishes were floatin' right off that table!*

After the flood, all houses in Greenbackville were cleaned and painted and many were remodeled. One would think all evidence of the flooding would have disappeared. But, to this day, on a humid damp day, the tide line will reappear on some walls reminding those who see it of the depth of the water inside those homes during the Ash Wednesday Storm.

The '62 storm surge lifted boats over the pilings and onto the land side of the canal.

1933 and 1936 Hurricanes

Fewer people mentioned these storms because most were not born then or were too young to remember. Those who did remember had indelible images in their minds of how bad it was. The '33 storm without a doubt was the biggest one to hit the area in the twentieth century. The '36 storm, following as it did just three years later, was also a significant storm but likely got more credit for destruction than it deserved because recovery from the '33 storm was still in progress. Together these storms made permanent changes in the geography, seafood industry, and people's lives.

People alive today have vivid impressions from television of the damage that hurricanes can do. Transpose those images to the east side of the Eastern Shore and you'll have some idea what happened in the area.

What today is Assateague Island was a peninsula attached to Ocean City, Maryland at its north end until the '33 storm. That storm along with its tides and wind cut the Ocean City inlet that made Assateague an island. Some say it was the beginning of the end for Franklin City. With few weathermen or instruments to predict what was coming, preparations could not be made. Weather just happened.

One then-young girl remembered going to Public Landing where there was a bowling alley. She said, *When that storm hit, it ripped up the boards in the bowling lanes and they looked like the keys on a player piano just going up and down.*

Another woman, who was three or four years old in 1933, remembered, *I lost all my toys. I know there was lots of mud in our house when we finally got back to it. It was a terrible mess. The only other thing I remember is that all the things on the shelves of the store, next door to my house, had floated off the shelves during the storm. I remember running around pickin' up stuff with the other kids. We always knew when we had a bar of Ivory Soap—it floats!*

As is often the case, disaster often produces positive results. One man reported, *It was the best of times, everybody was helping each other. Everybody was as one. There was one body. Nobody was mad or fussing. It was beautiful!*

Hurricane Hazel—1954

This hurricane wobbled around in the ocean and grazed the Carolinas. Finally when it came ashore, winds in Hampton, Virginia were measured at 130 m.p.h. From there, it moved inland and rode the eastern edge of the Appalachian Mountains to Canada. Casual observers might ask, "So what's the big deal—that's a long way from the Eastern Shore?" Indeed it is, but a storm of that magnitude cuts a wide swath covering 100 miles or more. Greenbackville and Franklin City are approximately 80 miles from Hampton, Virginia and even closer to the coastal plain and Chesapeake Bay.

Anyone in its path experienced great damage from winds and flooding. The only good news was that by 1954 the population in these two towns had begun to dwindle from their heyday a half a century earlier. One young man who lived slightly inland was anxious to experience the wrath of this storm. He went to the bluff that is Red Hills, overlooking the Chincoteague Bay, and reported: *I looked over there, where you all are livin'. I'm not exaggeratin' believe me, I saw the whitecaps an' the storm an' the wind an' waves was up there where all those houses are. I seen it with my own eyes. It was all marsh then . . . the water went clear up to where that original farm house was . . . that hill stopped it up there. But over to the other side, we called it the Hammocks, it was real low over there an' all that was underwater plus the winds really tore down those pine trees. After the storm, the owner of the land asked us to just come over an' clean it up because we were in the timber industry, you know. We spent weeks over there just cleanin' up the downed trees and other debris.*

For a people that, by fate or choice, live beside the sea, there are inherent risks—weather being the major one. When it is good it is wonderful, but when it is bad it is horrid. In bygone days, it was even harder than today. Without modern communications and weather prediction instruments, bad storms were often a surprise. The devastation from these storms was nearly complete but the tenacity, sheer bullheadedness, and individual creativity

applied to the problems at hand allowed these people to survive, rebuild, and maintain their lives near the sea.

OLE TIME RELIGION
Tent revivals inspired the faithful, offered live entertainment from outside for a couple of weeks, and even converted some people along the way.

Real old timers fondly remember the times when the tent shows (revivals) came to town. Not only did it put more money in some locals' pockets for helping put the tent up, it was one of the most exciting things that happened every year. This annual event continued into the 1950s and some say beyond. Originally, revivals were the church's primary recruiting effort. They generally lasted two weeks and for many were entertainment as well as a religious activity. Almost all the people who went to them were churchgoers and the entertainment end of the operation for them was less important. The focus was on conversion of those who were not "saved," but that didn't interfere with some music, storytelling, and acting—all components of good entertainment.

The evangelist was sometimes the local pastor but often preachers from Chincoteague Island or even as far away as Danville, Virginia—several hundred miles to the west—came to lead the revival. Tent revivals inspired the faithful, offered live entertainment from outside for a couple of weeks, and even converted some people along the way. Some say the revivals *cleaned up the town at least for a while after they were here.*

One particular revival is well remembered. A *good lookin' woman preacher from Roanoke, Virginia* [nearly 400 miles away from Greenbackville] was the evangelist at that year's revival. One guessed: *a dozen of the men who drank all the time went to that revival, they got talked into it by their wives, and something happened there and the lot of em', they gave up drinkin' for good.* Another person, an ex-waterman, described it this way: *this one night, some of the town drunks went just to listen in an' they got swept up an' couldn't run fast enough to get to the altar to be saved an' some never drank again.*

One time identical twins and their next-door neighbor went to an outdoor revival. *When the evangelist gave the altar call to all who would be saved, the twins and their neighbor got up from their seats and went to the alter. The first twin and the neighbor stayed at the alter only briefly and then, believing the spirit had moved them, they returned to their seats. The second twin stayed and stayed at the alter until finally there was no one there but her. Finally, she*

realized she was alone there and returned to her seat. Afterwards, her sister said 'Why in Lord's name did you stay up there so long?' Her twin answered, 'Well I was up there and nothing happened so I thought I'd stay there a while to see if it would.' A few years later that twin went to another revival and was saved.

Revivals not only saved souls, they also exposed evangelists to the area. Some would return later or stay to live in the community. One man who is well-remembered came to town with a tent revival and never left. He was a professional organist who worked with circuses and tent shows. When he arrived in Greenbackville, he met and was very taken with a local girl. When the tent show was over, he decided to give up his traveling life, marry the girl, and move in with her and her sister. The church benefited from having a professional organist and the town had a new contributing member of the community. In fact, he soon was the owner of one of the local stores. The story could end there, but instead has an extra twist. When his wife became ill and died, the organist later married her sister and continued their happy household until they both were gone.

IF IT WEREN'T FOR THOSE PIGEONS
The real thing was to have 'em to where you could leave the door open an' they'd come back.

One tends to associate this member of the avian family with city life, but Greenbackville boys growing up in the 1940s and 1950s were great fans of the pigeon. Many raised them in pens in their backyard. Speculation is that because they were too young to go off to the war but still wanted to do their part, they reasoned that they could raise pigeons. In their fantasies, someday their birds would join the corps of heroic carrier pigeons that flew messages across enemy lines. To the best recollection of anyone interviewed, that never happened. However, the memory of those pigeons, the lessons learned while breeding and raising them, and a few pigeon-centered events brought a smile to some adult faces.

It was kinda like the Andy Capp comic strip where the kids raised pigeons. I built a cage where you could walk into it. It was four feet by maybe six feet an' had two by fours for a frame to hold up the chicken wire. An' it had some bird houses or whatever for in the winter and nesting. The real thing was to have 'em to where you could leave the door open an' they'd come back. You'd have to have it so they liked the place an' then they'd come back; but if they didn't, they'd fly away and not come back.

In the fifties, we had Hurricane Hazel an' in that storm the pigeon cage blew over. I went out to look at it and decided there was nothin' I could do; so, I started to go back in. I was going against the wind and the door of my house was a ways away. I was tempted to get to a point and rest. Then I figured, no, I better keep on going, I'll be a hero. As I got halfway between the pigeon cage and my house, I heard all this activity. When I got to the house, I looked back. The chimney had blown off the house an' all the bricks were right where I woulda been if I'd stopped to rest. I coulda lost my life because of those pigeons.

THE WAR REMEMBERED
World War II was as close as the ocean just five miles to the east and as near as the Chincoteague Naval Air Facility just eight miles to the south.

Often, the Eastern Shore is far removed and even out of touch with things going on in the rest of the country and the world. Many national and international events have little direct effect on the inhabitants of the Eastern Shore; therefore, they waste little time or energy on them. World War II, the last popularly supported war in this country, was different. In most cases, it was not the war itself—its battles, politics, and drama—it was individual reactions to the business of war that were remembered. For them, it was up close and personal.

Pearl Harbor
I remember it like it was yesterday. It was a Sunday afternoon and we'd been down to Greenbackville for Sunday dinner with my grandparents. Afterwards, we all sat around in the living room and listened to the radio. Back then, folks didn't sit much in the living room unless it was Sunday or you had company. Anyway, it was December 7, 1941. The announcer came on and said the Japanese had attacked Pearl Harbor and much damage had been done. With no television, no one really knew where Pearl Harbor was or even had a clue what it looked like. All we knew was, we were being attacked by the Japs, as they were called in those days. None of us had probably ever even actually seen one. Colored people and Mexicans were the most ethnics we had ever seen being in a majority white town.

We were all patriotic back then. I wasn't scared in the least. I was only 13 or 14 and would have gone to fight the Japs in a minute if they'd let me. Kids, whose parents could afford it, had little uniforms with hats and all. Some were

Navy, others Army, some Marines and so forth. We considered ourselves too old to play war but we talked a lot about it and what we'd do if we had one. We wore our little uniforms proudly.

Hitler

Another man remembered one of the major players in that war. *When I was a little kid we had a radio and all we could hear was about the war and about Hitler. There was this guy in town who had a low, gravely, growlin' voice and, I don't know why—nobody ever told me or nothin'—I think I just made it up, but I used to think that guy was Hitler. I was just little and he had this strange soundin' voice that kind of scared me. I don't know. I guess I thought Hitler was scary and so was this guy. So, I figured he was Hitler.*

Rationing

Most folks remembered rationing but many were not affected much by it. Farmers and watermen were exempt from gasoline rationing because they were food producers who directly supported the war effort. The other reason gasoline rationing was a minor issue here was that many did not have automobiles and those who did only used them for Sunday afternoon rides and funerals.

Many of those interviewed were fairly young during World War II, so they would not have been aware of the process and restrictions on purchases. Children, on the other hand, are always aware of the availability of sugar and products made from it. One young boy was given a cherished piece of chocolate. He had never tasted chocolate and it was very different to him. He gave it to his sister and told her *Here, you can have this 'sick as a sow' candy.*

One woman reported: *My dad was a farmer so I think we were exempt from the gasoline rationing. But that didn't matter, we never used the car except maybe on Sunday to go visit my mother's folks nearby. I remember that the top half of the headlights had to be painted black so if we didn't get back before dark the lights wouldn't reflect up and be seen by enemy airplanes. The only way rationing of food affected us was flour and sugar and maybe canned pineapple. Didn't make much difference on the other things because being farmers, we raised all our own food and what we didn't grow we exchanged with neighbors. You never went to a neighbor's house but what when it was time to leave, they'd say 'You got any potatoes' or tomatoes or whatever was in season in their garden. If the answer was 'no,' or 'not many,' you'd go back home with all you could eat.*

Another conversation between a young girl and her mother making supper went something like:

> **Mother:** *I would make an upside down cake but we don't have any sugar.*
> **Girl:** *Does God have sugar and pineapple in heaven?*
> **Mother:** *I don't know, why?*
> **Girl:** *Well, at Sunday school the teacher said that in heaven no one would have to worry about food, or clothes, or heat, or cold, or anything. So, when we go to heaven then can we have pineapple upside down cake?*

Another person reported going to visit an aunt and uncle. The aunt asked her husband to get her some sugar. The storyteller was old enough then to know rationing was going on and that sugar was one of those things that simply was not easy to obtain. The uncle invited the youngster to help him get the sugar. They went up the stairs to the attic, where there were many packages of sugar, flour, and other rationed goods. *I didn't think anything about it at the time but later, I wondered how he'd gotten it and where he'd gotten it. Probably not all on the up an' up.*

Homeland Security

Americans not living near the coastline were unfamiliar with the very serious practice of blacking out windows and civil air patrols. On the other hand, inhabitants of the east and west coasts knew exactly what was expected and complied without question. Greenbackville and Franklin City residents were only a few miles away from known German U-boats patrolling off the coast. The possibility of attack by sea was greater than attack by air but both were believed to be distinct possibilities. Consequently, all houses were required to either replace or put up black shades or other coverings over all their windows so no light escaped to be seen by the enemy. *When the whistle blew, everyone had to pull the blinds an' turn off the lights an' there was no funny business—everyone did it. There were men in each community whose job it was when the blackout whistle blew to go around to check and be sure no one was makin' us a sitting duck for the Germans. There were some also whose job it was to watch for airplanes but I don't know exactly how that all worked.*

Missing in Action/Lost at Sea

Only two boys went to World War II from Greenbackville. One did not return. His sister described how her family learned the sad truth. *He and his friend, from the next door farm, joined at the same time. My brother went to the*

Navy and his friend to the Army. My brother was one of the people who loaded torpedoes into the place where they were fired from. We got some letters from him, but of course, he wasn't allowed to tell us much. The paper ran a big picture of a star and everyone who had someone in the service was supposed to tape it to their window—we did and were proud to do it. I don't know exactly how long it was until, one day, a chaplain came knockin' on the door to say my brother was missing in action. Every time my mother would hear on the radio that a ship or a serviceman who had been floating at sea for days had been rescued, she'd always say, 'See they found that one, I know he's out there and they'll find my boy.' There was a flier that came out about my brother's ship and from it I got two names. I wrote to those boys, one in West Virginia and another in Tennessee. One wrote back to me and told me he was there the day the ship was attacked and saw my brother die. I didn't tell my mother for the longest time but sooner or later I had to. And that was the hardest thing I ever did in my life. He was missing for 11 months before we were officially notified that he had died when a torpedo struck his ship. From then on, the star in the window from the newspaper was replaced by a small flag with a gold star—the symbol seen throughout the country of a family who lost someone in the war.

Filling In
At the canning factory during World War II when so many of the men had joined the service, women did a lot of the jobs that men had always done. During that time, one of my jobs was to unload empty cans off the box cars—a job that had always been done by men. I got paid a man's salary too but soon as they came back, I was back to the peeling line and brought in a whole lot less money.

How Close was the War?
One night in the middle of the night when I was a really little kid there was a loud noise. It woke everybody up. The next morning my dad said a ship off Chincoteague got torpedoed by a U-boat. According to *The Official Chronology of the US Navy in World War II*, on April 2, 1942 the American freighter *David H. Atwater* was sunk by the German submarine U-552 east of Chincoteague Inlet. Three members of the 25-man crew were rescued by the Coast Guard and taken to the Chincoteague Island Coast Guard station.

Another source of late-night noises came from even closer. Although it was unknown to the people in these communities until after the war, in 1943 the Navy's Bureau of Ordnance set up a facility to secretly test aviation ordnance at the nearby Chincoteague Naval Air Station.

Prisoners of War
There was a prisoner-of-war camp in Westover, Maryland approximately 20 miles from Greenbackville and Franklin City. It was populated mainly by Germans captured in Europe. The prisoners were transported daily from the camp to work sites on farms and other places where they could perform useful labor. During that time in the late summer, a busload of POWs arrived daily at Greenbackville's canning factory. A son remembered his father's description of an interesting exchange between his father and one of the prisoners. The father was the bus driver and was asked by a POW what he would do if they tried to kill him and steal the bus. The German himself diffused the tense situation when he said, *You know, we could if we wanted to but we would not do that because even though we fought against them, the Americans have been so very kind and good to us.*

World War II was very real to the people in Greenbackville and Franklin City. It was as close as the ocean just five miles to the east and as near as the Chincoteague Naval Air Facility just eight miles to the south. It was in their lives every day from the planes flying in formation overhead, to the blackouts, the rationing, the local boys who enlisted, and the newspaper and radio reports.

HARD CANDY CHRISTMAS
It just wasn't a plush life.

We had our Christmas things, at least all we could afford. My husband always put up the tree after the kids went to bed on Christmas Eve. He'd set it up, put the lights on, and get the decorations on it. Meanwhile, I'd be washing and waxing the kitchen floor and washing, ironing, and re-hanging curtains in the kitchen so everything would be pretty for Christmas morning. After he'd got the tree ready and I had my work done, he'd call me in to hang that silvery tinsel on the tree—one strand at a time. When we went off to bed, it was Christmas!

I'll always remember the year I got high-topped boots for Christmas. They were the best thing my husband could have ever given me! As both wife and helpmate, she worked alongside him in their clam shack. In today's terms, they were brokers who bought shellfish from watermen and then sorted, transported, and resold the seafood to other brokers or wholesale outlets. Together, they processed and trucked to Crisfield millions of clams, oysters, and crabs. To this day, an essential part of every waterman's wardrobe is a pair of high-topped, usually white, boots. The same was true in earlier days;

however, women would not typically own boots or be seen wearing them because it was simply too costly to have two pair in the same family. The best a woman working around the water could hope for were hand-me-downs; but, by the time a pair was handed down, they were usually pretty well worn out. All those years, this woman had worked at their clam shack alongside her husband with all the accompanying sand, water, and cold without the benefit of high-topped boots until that memorable Christmas.

Memories of Christmas through the eyes of children were of happy times. *At Christmastime, my mom would get nuts and fruits, an' that was about all she could afford but it was a treat. Grandmom'd always try to get one toy or a piece of clothing but sometimes that just wasn't possible. It just wasn't a plush life. But I always remember being so excited and happy on Christmas.*

One woman from a more affluent family than most remembered: *I had a really good childhood but what stands out in my mind was all the wonderful Christmases that I had. We were fortunate and had large Christmases an' my birthday is in December. My mom always made sure we had a tree up by my birthday in the middle of the month. If we had a live tree, she'd take Ivory snow an' whip it up and make it look like real snow on the tree. One year, we got a silver tree, so you didn't do that. I've always loved horses an' one Christmas I remember, I got a hobby horse. It wasn't on a rocker, it was on a board so it slid back and forth an' felt like a real horse when you rode it. It actually had fur and marble eyes! Mom put it up in the attic when I got older. When she went back a few years later, the moths had eaten it all up. I felt so bad about that. That hobby horse was a beauty. It was tan with a platinum mane and tail, an' those eyes! If I ever find one, I'm buyin' it!*

Still another remembered, *We never bought Christmas trees. When it was time to get one, we'd just go out in the woods somewhere, pick out a cedar tree, an' cut it down. One year, I'd been huntin' over in what's now Captain's Cove an' when my mother said it was time to get a Christmas tree, I told her I knew just where a good one was. It was a perfect size, all filled in nice, and had a good strong branch that went straight up for the angel on the top. I went out there, cut the tree, and threw it in the back of my truck. I'd seen a nice bunch of ducks on the shoreline so I left the tree an' my truck, took out my shotgun, and went after 'em. I got back to my truck with a mess of ducks but the tree was gone. I just cut another one and went straight home. A week or so later, we'd been invited to the landowners house and what did I see right there in his living room? My tree with the nice strong branch on the top for the angel! He never said a thing about it an' neither did I but we both knew what happened. The next year I got our tree from somewhere else.*

One girl remembered being six years old: *We always had chickens and you bought chicken feed for them that came in beautiful cotton print feed sacks.*

Once the sack was empty, you carefully took out the stitching, washed and ironed it, then you had a nice piece of cloth. The trick was to get two or three sacks with the same print design, then you could really make something nice. That didn't happen very often 'cause we couldn't afford to buy two sacks at once and lots of times when you went back for the next sack there were no more of the print you already had. This one Christmas, I was so happy when I opened the only present I got that year. It was a blue plaid skirt and a top that matched with little cherries embroidered on the white collar. My most favorite things were the color blue and cherries. Somehow, my mother had managed to get two bags of chicken feed with the same print and made me an outfit.

In a few homes there were lots of gifts and fancy or expensive things. But, in most there was not a lot of money available for luxuries even at Christmas. Fruit, nuts, and candy were pretty much guaranteed for the children but more than that was not to be counted on in most homes.

COLD CASE FILES
Occasionally, there were unusual events.

It is notable that residents of these two communities, for the most part, have been able to resolve their differences, solve serious problems, and maintain order without intervention by outside authorities. The unwritten understanding is, *Whatever the problem is, it won't get better by gettin' outsiders up here big-shotin' around.* Occasionally, there were unusual events that neither law enforcement officials nor local approaches to problem-solving were able to clearly resolve. In those cases, no one seems to know, remember, or be willing to give a definitive answer about what happened. Hence, even Greenbackville and Franklin City have their cold case files.

The Murder
Some said a Greenbackville bachelor was found *with his head cracked open, brains all over, an' the iron skillet that hung on the wall beside him on the floor.* Theories about what happened were plentiful and included:

> The victim reached for the skillet and it hit him on the head.

> He had just been paid and someone from *outside* followed him home and robbed and killed him.

He was killed by a young man who appeared in town around the same time and who was a drifter.

The victim and the sheriff were both *runnin' around with a woman who did everyone for a price*. Some say she killed him for back debts while others will always believe it was the sheriff who did it out of jealousy.

A man who was the victim's paperboy at the time tried to set the record straight: *I'd already delivered his paper and was coming back home when I saw all the people around. He was on the floor with blood coming out his ears. There was no 'brains all over the floor' or anything like that. He had had an aneurysm. They later investigated and said no one was to blame.*

Nevertheless, the body, buried in Maryland, was later exhumed and taken to Virginia for an autopsy where the incident was pronounced an accidental death. In the city that would likely have been the end of it; but, as often happens in a small town, the rumors have taken on a life of their own and grown far out of proportion to the actual event. To this day, you will have a hard time convincing most of those who were around that it was a natural death or an accident.

The Drowning

A woman *showed up drowned in the Harbor. She was the wife of a water cop*—a Virginia Department of Natural Resources law enforcement official. Some said she *wasn't quite right* or that she was a little *teched* or *touched in the head*. Regardless, no one ever knew what happened. There seemed to be no accomplices or perpetrators.

The Rape

When there was a bar in Greenbackville, there was a man who was a regular customer. Every noon and evening, his overweight wife would walk from her house to the bar to fetch him. A couple of boys, old enough to have heard adult words and concepts but too young to have much understanding of them, watched her every day. One was 13 years old and the other 10. The older came from a more well-to-do family and had a whole cowboy outfit—chaps, hat, toy six-shooter cap guns, spurs, and lasso. The younger one made do with a corncob in his pocket for a gun.

One day they decided they would rape the woman who went to the bar twice a day to collect her husband. The plan was that the older boy would

lasso her and the younger would pull down her underpants—their idea of a rape. As she passed by their hiding place one day, she was ambushed and lassoed by the older boy. The younger boy did his job according to plan but was so startled by what he saw, he ran home sobbing all the way.

The Waterman Who Didn't Return
At the end of one day, a well-known member of the community was seen on the Bay headed toward the Harbor. In the middle of the Bay, his boat turned around and went in the opposite direction. After several hours passed and the boat didn't return, some men went out to look for it and found its captain dead and badly burned, lying across the engine. Most guessed that he had a heart attack or stroke but no tests were done to confirm it. Whether foul play was involved will never be known but what is known is that a valued member of the community was lost and is still missed.

Prostitution
Rumor has it that there was a woman who was quite the sensation in town when there was a beer hall. Several of the men were known for getting quite *well-oiled* and it was said that that's when this particular woman would be summoned to join the party.

Some remembered her as Horsey while others called her Hoss Head. In later years, those who have heard the rumors but never encountered the woman have engaged in a great deal of speculation about how her nickname was earned. Was it her size? Her mannerisms? Or, were there particular incidents or behaviors that earned her that moniker? Other members of the community prefer to ignore or deny the possibility of a woman with such allegedly loose morals ever being in Greenbackville.

One person said he saw a picture of an attractive woman *ridin' down the middle of town naked as a jay bird on a car's hood*. When he asked who it was, the picture's owner said, *It's Horsey!*

There were real incidents of unexpected and unexplainable deaths that sparked interest and spawned speculation about criminal behavior, but none was ever confirmed. The childhood pranks of a few whose "criminal" intent was based on their lack of understanding of the acts they believed they were committing, along with some inappropriate adult behavior resulting from the mixture of alcohol and bad judgment, were the "cases" that made life interesting and fueled the gossip mills of their times.

As these brief incidents illustrate, real modern-day crime was unknown in the day-to-day life of these communities. Doors were left unlocked day

and night. People trusted their neighbors. Outsiders were not welcomed with open arms and if they were around, everyone watched them carefully. The reason these incidents are so well remembered is that they were the exception to the rule.

NOT LITTLE LEAGUE
We were all interested in baseball. We played and, those of us with radios at home, listened to it on our family's big Silvertone or RCA floor model radios.

The boys played ball anytime they could get away from their chores. *We'd play day or night—lots of nights until it just got too dark to see—but never on Sunday during one particular preacher's time in the town. He simply forbade it.* Since the church owned the field where they played, he could enforce what he read as God's will. The tradition of the Methodist Church is that ministers are relocated every few years, however. So when the stern preacher was sent to a new place and a new, more liberal one who had kids of his own became the preacher, Sunday games resumed.

Before a game could be played, *we cut the field with muscle-driven rotary mowers. We played hard, and were told we played pretty good. We played on the spur of the moment. Best of all, we played because we wanted to play. Not Little League organized, adult-supervised baseball, but baseball played on a field behind the old school.*

In the late forties into the 1950s our team even had a team name, Greenbackville Pirates, and we played teams from Stockton, Chincoteague, New Church, and Oak Hall. Two of the local men helped us to arrange those games with the other towns. They were big supporters of our team. In about 1950, they told us boys that, if we won the most games of all the teams we played, they would see that we got to see a real big-league baseball game. We won 'em an' they kept their word. They got a bus. Put us 'ball team boys' on the bus and gave us a day to remember.

It started with a bus ride to Philadelphia—most of us had never been that far away from home before. We got to see the Boston Braves play the Philadelphia Athletics. We always just called them the Phillies. I remember that game like it was yesterday—every play. Then, they took us to the zoo. Us boys had been huntin' all our lives, we had seen everything that lives on the Eastern Shore but none of us had seen anything like the things we saw in that zoo. We saw elephants and camels and polar bears—I never saw any animals as big as them before. After the zoo, we got back on the bus and headed home but on the way we

In the 1960s this was Greenbackville's ball field—a score board and bleachers—upscale compared to earlier days.

stopped to eat in a fancy restaurant with real white cloth tablecloths—my Mom had an oil cloth tablecloth but I'd never seen a table covered with a real cloth like that one in the restaurant. We knew the man who ran the restaurant. He lived in Greenbackville in the winter and ran the restaurant in the summer. But we had never been to a restaurant like that one before. He paid for dinner for all of us. What a day! I think that was one of the best days of my life.

Baseball wasn't just a kid's game. When baseball was mentioned, one man immediately remembered, *We were all interested in baseball. We played and, those of us with radios at home, listened to it on our family's big Silvertone or RCA floor model radios. They were bigger than TVs today. Then, we'd read about it in the* Philadelphia Bulletin *the next day. We could buy that paper right here in town 'cause back then, daily trains brought newspapers along with freight, passengers, and a whole lot of other stuff*

At a service station and store right there at the Maryland line, you could count on hearin' the baseball game if there was one on the radio. Most of the games seemed to be the New York Yankees and the Philadelphia Phillies. These ballplayers never had fans any more intent on the game than the men and boys sitting around that store on wooden benches replaying and second guessing every play. When there was a home run they'd whoop and holler and go wild. We all loved baseball!

That love of baseball extended well into the 1960s and some say into the 1970s. In 1967 Greenbackville had its own field—down by the clam shack at the Harbor. That field had bleachers, a score board that read Greenbackville Ball Park, and even a refreshment stand. There were generations of boys who were not only baseball fans but baseball players as well.

SLED TRAIN DISASTER
As we were comin' around the corner back into town, one of my boots dropped down off the sleigh. I lost my grip…

Years ago it was much colder and it snowed a lot on the Eastern Shore. There are no hills for sledding, but kids are kids wherever they are and will find a way to enjoy the snow. *As I remember it, winters were much colder when I was a child. We ice skated, or just slid on the ice with our shoes, on backyards where the water was up or at Big Mill, and we sledded when it snowed.*

Adults, or at least those with access to a vehicle, also got into the act. They would put chains on a car or truck and then: *We'd tie one sleigh to the back of the car and then the others would tie their sleigh to the one in front—you know, like a train. My father had built us a really nice sled. But he made us promise we wouldn't ride behind a car on it. 'Cause that was a really big thing but some kids had gotten hurt doing it. We promised we wouldn't, but . . . When I was 12 just as Christmas vacation was starting, we had a big snow and everything was froze down. My younger brother and I took the sleigh Daddy had built and as we got to the church along came a car with a line of sleighs tied on and they said 'Hey ya wanna go?' and we said 'Yes!' and we tied on and after us just one more tied on. That one wasn't a real sleigh, it was an old car hood turned upside down with two boys on it. So the car hood was tied onto our sleigh and that was the end of the train.*

The ride was a long one. They took us out through Rabbit Knaw and we didn't have much in the way of winter clothes. Our gloves were old socks and our boots were plastic bags; except, that day I had on a big old pair of boots that my brothers used on the water. So my brother and I were on the same sleigh and it was getting a little scary as we went out of town 'cause we were goin' back and forth all over the place as we went down the road. Some times scary is fun but this was scary in a different way. I was sitting behind my brother on our sleigh and he must have been a little scared too. He looked over his shoulder and then he told me 'If you fall off the sleigh, don't go off to the right 'cause if you do you'll get hit by that car hood behind us. But if you do go off that way roll out of the

way as fast as you can.' He was smart enough to know it was going to swing around that way.

As we were comin' around the corner back into town, one of my boots dropped down off the sleigh. I lost my grip and I went off to the right. I couldn't control it so as soon as I fell I started to roll. Well that curve made the car hood go up on a little bank of snow and just as I started to roll it came down that embankment right on me and hit me in the face. Fortunately, the boys who were riding on that overturned car hood jumped off before it hit me.

It happened so fast I didn't feel anything. Well there was so much blood they couldn't tell what was wrong with me. They decided to take me to the nearest house so somebody asked me if I could walk and I remember saying 'I think so.' And, I remember one of the kids picked up something out of the snow and it just happened to be my two front teeth. When he realized what it was he went 'Agh!' and threw them over his shoulder.

The woman who lived in the house they carried me to had a basin and she kept washin' me and the blood just kept comin' and she kept saying 'I don't know where it's comin' from. I don't know where it's comin' from.'

Of course, the driver stopped right away but we didn't have a rescue squad or anything so they had to do something. Somebody went and got my mom and dad and they bundled me up, put me in that car, and it seemed like it took an hour to get me to the doctor in Snow Hill. He took a look and said he couldn't do anything for me: they needed to get me to the hospital in Salisbury. It took a long, long time to drive because the roads were so bad but they got me to the hospital.

The result: two front teeth lost, a gash in the scalp, a bad concussion, a jaw bone broken in several places, a face that was cut and black and blue everywhere, and a week's stay in the hospital. That was my Christmas vacation.

VANILLA, CHOCOLATE, PINEAPPLE?
To this day, Greenbackville is locally famous for its homemade ice cream.

It was the Fourth of July, we'd all taken the Franklin City train from Girdletree to visit my grandparents' home in Greenbackville. I know we ate lots of good food but what I remember is making the ice cream. We didn't have nothin' but an ice box so, we couldn't keep anything frozen in that. The only time we got ice cream was if you got it at the store, and there wasn't hardly ever money to do that, or we made it.

I do remember making it. It was a family affair. My grandmother and my mother would mix up all the stuff. I know they used what we called cream

Turning that crank on the old wooden ice cream freezer produced the best ice cream anyone can remember.

[canned evaporated milk] *and for the pineapple kind, that was my favorite, they added canned pineapple. While my mother and grandmother were mixing up stuff in the kitchen, my granddad and dad were fixing up the ice cream freezer. I really don't know what else to call it. It was a wooden pail with a metal can that fit down inside. The can attached to a crank handle, and it all latched together. What I do know is, us kids were given big chunks of ice and hammers and taught how to "tap the ice" in really small pieces. Seems to me the pieces had to be no bigger than a little nick* [a small clam] *to satisfy my granddad. We put all that chopped-up ice in a barrel so it would be ready for the time when we were cranking the ice cream.*

Then came the fun. Everybody would be outside and my grandmother would give the metal can to my granddad. It was full of whatever she and my mom had mixed up in the kitchen. It was almost a ceremony. My granddad would take the can, open it, and put the stirring paddle [dasher] *in it and put the top back on. Then he would put the can into the wooden bucket and put layer after layer of ice and rock salt in the space between the inside of the wooden bucket and that metal can with the good stuff in it. Once that was done everybody took a turn at cranking. Between the cranking, adding more ice and salt, draining off the*

extra salty water that collected as the ice melted, and lining up the next person to do the cranking—it seemed to me, as a child, it took the whole afternoon till that crank got too hard to turn. My granddad and dad would always take the last turns on the crank and all at once one of them would say "The ice cream is ready!" They'd unlatch the metal can from the crank mechanism, pull it out of the wooden bucket, pull out the stirring paddle, and there it was. Real ice cream. Best ice cream I ever ate!

That family was privileged to have ice cream in the summer. Clearly, summer would be the best time of year to eat the frozen delicacy; however, many others remembered ice cream as a winter treat. After all, with no electricity and ice being a precious commodity, it was necessary to take advantage of nature. One woman reported, *When I was little, we were so excited once it got cold enough to freeze the water in the ditches. That meant we kids could go out and chop up a bucket or so of ice into pieces little enough to fit that old wooden ice cream freezer. And then, my mother would mix up the stuff and we'd all have ice cream.*

To this day, Greenbackville is locally famous for its homemade ice cream. People wait for the magical moment when the sign appears in front of the Firehouse announcing "Ice Cream for Sale." Today, it is made in large batches by members of the volunteer fire company, but it's still made with canned evaporated milk and basically follows the same recipe that has been used for generations. Orders are taken in advance for quarts of vanilla, chocolate, and the ever-popular pineapple. The better part of the firemen's evenings for a week before the sale are consumed by the production process. Over the years, the enterprise has grown and now serves as another source of income for the fire company in addition to preserving a community tradition.

MY LUCKY BREAK
She grabbed me and took me down to the principal's office.

I was in the 11th grade. I was taking Chemistry. My teacher gave a test. I had one question wrong and I thought it was a trick question. So I spent probably two weeks with what few resources were available to me—there weren't many books in the library on chemistry but I used every one. I kept coming to her with the information I found that I thought proved the point that my answer was right. Finally she said 'OK, I'll count your answer as correct.' Then she said, 'What are you doing about college?' I said 'Nothin.' And she grabbed me and took me down to the principal's office. She got the secretary in the principal's

office to get the admission forms for UVA [University of Virginia] out and made me sit there and fill them out. There wasn't any choice about what school I would go to. UVA was a state school so it was the cheapest. I only applied there. I didn't even apply to any of the others. I took the College Boards and I did OK on them. I had to go to Salisbury to take them—that was the nearest place they were offered.

There was another thing that happened that made going to UVA more real to me. I had a friend in my class in high school who had a brother who was a senior at UVA. The next year when I was in the 12th grade, he and I and another kid went to Charlottesville to visit his brother. So I always think that my friend's brother paved the way a little bit for me just by being at UVA and showing us around when we went to visit.

It was actually in the 11th grade that the decision was made that I would go to college. It's a good thing it was made early. Even though the principal knew about a scholarship that was designated as having 'preference for a student from the Eastern Shore of Virginia,' it took some time to get everything set. I filled out the papers and then the principal started working on that. The initial scholarship was $400—that wasn't enough for tuition, books, room and board—and my family didn't have any to contribute. So the principal went to bat for me and got that scholarship doubled to $800. With what I could earn in the summers and that scholarship—that got me through college.

I'll always remember that chemistry teacher and the principal. That teacher was only in my school for that one year and I can't even remember her name. But she and the principal—they gave me my lucky break.

RIDING THE TRAIN, BY GUM!
A memorable treat to those who had the opportunity to ride.

The trains were a part of the lives of residents of Franklin City and Greenbackville. Were it not for the train, Franklin City might never have come to exist and thrive, so it is not a surprise that many of the stories remembered include experiences of riding the train.

Gum Machine
One 90-year-old woman remembered riding the train as a young girl from Franklin City to visit relatives in Millsboro, Delaware, some 50 miles away. Different from most children in the area in those days, she got to ride the train because her uncle worked for the railroad and got passes for his family.

Happenings

When asked if she remembered the conductors, or the station, or what it felt like to ride the train, she said *No, I don't remember any of those things. What I remember was a gum machine right there on the train. I just remember asking my granddad for pennies so I could put them in the gum machine and turn the handle. That's all I remember about my train ride!*

Visiting by Train

Another recalled when the train brought her grandmother to visit: *When I was five years old about to turn six, I lived in Girdletree* [just eight miles from Franklin City]. *My grandma lived in Franklin City. Oh, I remember that birthday. My grandma sent my mother a penny post card to say she would be coming to visit for my birthday. She always took the train from Franklin City to Girdletree when she came to visit. We didn't have telephones so the only way we would know when to meet her was by her postcard. Well, we were at the station when her train pulled in and she got off with two big boxes. I knew they were presents for me—I was so excited. We got home and after dinner she gave me one package. I opened it and it was a pretty new dress she had made for me. Only then did she give me the other box. I opened it and it was a doll with eyes that opened and closed—like she was flirting. I had never seen anything like that before. I named her "Flirty Flossie." She was beautiful and she was dressed*

The train brought Grandma and special presents—matching dresses for a little girl and her doll.

in exactly the same dress my grandma had given me for my birthday. We were twins, me and Flirty Flossie. I had that doll for a long time and every time we'd take the train to Grandma's I'd be sure she got to ride along.

Off to the City

The train not only brought the outside world in. For a lucky few, it allowed them to experience life beyond the Eastern Shore. For example, one woman remembered, *There were only three of us in town whose fathers worked for the railroad and got free passes. So, we went on the train often. I remember going to the Washington Zoo and the Philadelphia Zoo. When I was 11 or 12 years old, I was considered big enough to go to those places with the other two girls who had passes. We traveled all by ourselves but I think my father knew some of the conductors on those other trains and he always had them looking out for us. We only went places where we could leave in the morning and be back that same night. We always packed our lunches but sometimes (most times I think) we ate them before we left the Greenbackville station. At Georgetown [Delaware] a man came aboard with a basket of things you could buy—sandwiches and goodies.*

The oldest of the girls was about three years older than me and she thought she was in charge. One day, we were on the train and, of course, there were all these other people around—including some boys. We were at the age when we were a little scared that the wrong boys would pay attention to us. So, the oldest girl looked at my hand and saw that I had a birthstone ring on my finger. She said 'turn that ring around so all you can see is the band, nobody will bother you, they'll think you're married.' At 12, I probably didn't look married but I turned that ring right around and left it that way till we got back home that night.

Excursions

Atlantic City, New York City, Philadelphia, and Washington D.C. seem to have been prime destinations for adventures, called "excursions." These trips weren't about getting seafood or produce to market. They were about taking people places and having fun.

There was excitement in the air when an excursion was about to happen. Many folks, especially kids, who were not going on the trip but wanted to be part of the excitement gathered at the station to *send off the lucky ones who got to go*. Sometimes the excursion was for the day, other times it would be for several days. *One of the things I remember being the most fun about excursions was going down to Franklin City to wave good-bye to the people on the excursion train. Even though I never went on an excursion myself, I loved*

These girls were all dressed up at the Franklin City station, waiting to board an excursion train.

going down to the station when an excursion was about to leave. We'd wave and the people on the train would wave back as the train pulled out of the station.

In Atlantic City they enjoyed boardwalk entertainment, among other things. Though only the mother and father of one particular family actually went to Atlantic City on an excursion train, the rest of the family, 11 children, were often treated to remembrances from that trip. In fact, some stories became family legend. Ask anyone in this family about Zeemo and they will reel off the following in a sing-songy, loud, run-together way of talking like boardwalk barkers: *Zeemo the turtle boy. Three feet high. Head no bigger than an apple. Captured on the coast of the Yucatan. . . . Who knew where Yucatan was anyway! We always laughed and laughed when my dad told us about that excursion. He'd string it out as long as he could but always finished up with the thing about Zeemo. My mother always told another one about seeing Tony, the horse. It seems they went to a show where a man and a horse were lifted by some kind of thing high over the heads of the audience to a platform. Once they were up there, the man got on his horse, Tony, and told him over and over every night to jump. When my mom told the story, she would always say, 'He would yell at Tony and you could tell Tony really didn't want to jump.' Finally, the story goes, the man and the horse did jump and landed in a pool of water and splashed everybody who was watching. It was the most amazing thing they'd ever seen.*

Kids' Rides

One man remembered watching the trains come and go between Franklin City Harbor and the nearby bunkhouse as a child: *We knew that they hauled oysters, vegetables, and passengers to Baltimore, Philadelphia, and New York but we never got to ride them. We didn't have any place to go or any money to ride. They were a part of our lives only because we heard and saw them several times every day. We thought they were exciting. Every time a train came through, we watched it like we'd never seen one before.*

When the crews got to Franklin City they would get off the train and go to the bunkhouse. They'd leave one crew member, the fireman, on board to keep the coal burnin' so the steam engine would be ready to roll come morning. Some of us boys got to know the fireman. At night, while the crew was sleeping, we'd go down to see the fireman and he'd let us get on the train and then he would take us for a ride—from the bunkhouse to the Harbor and back. It wasn't a long ride but it's the only time I ever rode the train. This ride amounted to a distance of less than half a mile but it made the day for the boys who got to do it.

Girls also got to ride the train in a special way. Their rides were very short ones and they were more enterprising than the boys. Girls' rides produced not only a new exciting experience, they had other benefits. Tourists came on the train to do business or enjoy the attractions of Chincoteague or Red Hills. Once they disembarked at the Harbor and boarded the ferries to Chincoteague Island or horse and buggies (later taxis) to other nearby areas, the train went back to the bunkhouse for servicing, cleaning, and crew changes. *That short distance from the Harbor to the bunkhouse was our big chance. They let us on at the Harbor and we would go through the cars picking up stuff people had left behind. We got lots of things, but mostly funny papers from the city newspapers, coins that had been dropped, chewing gum or snacks that hadn't been opened, comic books, and magazines. We got to keep whatever we found so we considered it a wonderful game of finders keepers.* This treasure hunt for the girls probably saved the train's cleaning crew some effort, too.

The train was something very special and important in the lives of these people. It was a memorable treat to those who had the opportunity to ride—however long the ride.

7. Here Abouts

Places near one's home are often just far enough away to make them special and just near enough to enjoy without too much effort. So it was with two spots where people broke loose, let down their hair, and enjoyed themselves.

Then, there are other places nearby that people sometimes wish were elsewhere. They bring people, ideas, and ways of life that are not always appreciated. But, they also bring jobs and money into the community, so they are tolerated.

RED HILLS
Back then, it was Red Hills that was the attractive vacation spot, not Chincoteague or Assateague Islands.

The name Red Hills comes from the hillside of eroded red soil that provides the background for a white sandy beach on the Chincoteague Bay near Greenbackville and Franklin City. In a place where hills are few, this high place can be seen from a long distance, especially if you are in a boat. On a summer day, the water is usually warm and calm because it is shallow there. It is an ideal place for young children to play, teenagers to be nearby but not under the adults' feet, adults to visit and relax, older folks to enjoy some shade, and for everyone to fish and dig clams at nearby Queen's Sound. What today is a small, white sand beach tucked in a cove off the Chincoteague Bay near Swan's Gut was a much bigger beach before the storms of 1933, 1936, and 1962. Back then, it was Red Hills that was *the* attractive vacation spot, not Chincoteague or Assateague Islands, today's tourist meccas.

Old Times
Red Hills has been a favorite summer spot for a very long time. It was in its prime from the early 1880s until 1936, while others say into the 1950s. It was not until the 1962 storm that the last vestige of commercial enterprise (an oyster bar known for its oyster sandwiches) at Red Hills closed. It

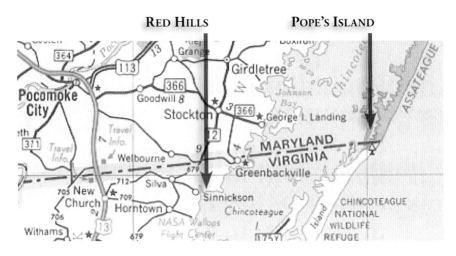

This map of the region includes all the locations mentioned in this chapter. (Courtesy U.S. Geological Survey.)

was the place of camp meetings, Sunday school outings, family reunions, festivals, picnics, regattas, Boy Scout campouts, and a wide array of other organized and impromptu events. Almost everyone who lived around the Chincoteague Bay went to Red Hills and remembered good times there. In the days before the bridge to Assateague, Red Hills was where you went to picnic, swim, and enjoy sun and sand. During the 1880s, a wooden structure was erected to house the amenities of the resort. In this pavilion you could get refreshments, use its bath house and changing rooms, or just mingle with other people who were enjoying the resort.

Summer Visits to Red Hills

On Sunday afternoons in the summer, my father would take us by car to Red Hills. Every time we went and we got to that steep hill going down there I was sure the brakes were going to let go and we'd end up in the Bay. There were lots of people there and we knew most of them. One time when I was around 12 we went there and my father gave me some money and I went into the restaurant and bought a chicken salad sandwich (I don't know why I remember the kind of sandwich it was, but I do). A little later, he came into the restaurant and he looked that sandwich over and he didn't say a word. Well, when we got home, he said 'When we go down there again don't order a sandwich. People will think you don't get enough to eat home. Order ice cream.' I've laughed about that for years.

In later years, there was a small restaurant and oyster bar at Red Hills. It was said to have only 10–15 tables. No alcohol was served and there wasn't a lot of variety, but it served the freshest seafood right from its own floats in the Bay nearby. People came from all around and from the cities in the north. On weekends, there would be lines of people waiting to be seated and often a famous person could be spotted waiting in line like everyone else. *You could pretty much tell the city folks 'cause they'd come on a Saturday night in their best dressed clothes—beautiful shoes an' hats. It was comical to me, 'cause there were outside toilets up the hill—one for the men an' one for the ladies. We kids'd sit there an' laugh 'cause those city folks had nice clothes an' shoes an' they'd go slippin' an' slidin' all the way up that muddy hill.*

There are adults now in their 30s and 40s who have fond memories of Red Hills even though they weren't born until long after the resort's last gasp of life in 1962. What do they remember? *Dad would be goin' fishin' and we were just little kids, so Mom would pack a picnic, take our towels and toys, and we'd all get in Dad's boat. He'd take us to Red Hills and drop us off. We'd be there for the day while he worked on the water. We played in the water, dug in the sand, tried to climb the hill, caught clams, and had a big time.*

Fourth of July

Many a Fourth of July has been celebrated at Red Hills and there are lots of memories of them. *It felt like the whole town spent the day at Red Hills. The women would cook for days before and that morning we'd all pile in the*

The Red Hills pier at the turn of the century. Large sailboats and beach goers share the scene.

workboats and go to Red Hills. As soon as we'd get there, the little kids would swim, clam, and play games while the women fussed with the food and each other. The men, and boys who were old enough, took off in the boats again and put out the nets. I felt pretty big for my britches when I got to go with the men!

After a few hours the men would come back with the nets full of every kind of fish this Bay holds. They'd dump them out on the beach, clean 'em, and then cook 'em over the campfires. Lord, we had hardheads, spots, trout, soft crabs, hard crabs, back willies, toad fish, you name it, we had it! I don't know which family brought what of the potato salad, carrot salad, cole slaw, Jello salads, applesauce, pickles, homemade rolls, and other fixin's. It was just all spread out and we'd all eat till we were full. After we'd eaten and drunk as much as we could hold, the men would go off to themselves and do their smokin' and drinkin', the women would clean up and then sit around sometimes singin', sometimes tellin' stories, teenagers would begin their courtin', and we little kids would fall asleep.

More than one of us was too full and got sick. Not because of the food, because of the soda pop. We didn't have soda pop then like you do today, but that was the day we had all we could drink of real bottled soda pop. It was those little Nehi bottles and always grape or orange. Before the men went out to set the nets, they'd fill wash tubs with ice and soda pop and you could drink till it was gone. I remember counting 11 that I drank one year!

Tulip Tree
There used to be a natural wonder nearby—a tulip poplar tree that was dated by a forestry official as being over 450 years old. *Everybody who went to Red Hills would go see the tree at one time or another. Thirty years ago when the leaves were off, you could see it from all around 'cause it was so huge. When we were kids, I'd say under 15, it took 12 of us arm-in-arm to reach around the trunk of it. Lot of it has rotted now, she's now 'bout all gone. It was unbelievable. Humongous. It was for sure bigger than the Wye Oak that everybody got so excited 'bout a few years ago. The trunk is still there.*

Local Destination
Red Hills, although its buildings and resort-like atmosphere are gone, is still a local destination for many, provided they own a boat or have friends who do. The land is now private property and the road is closed to the public. But it still has a quiet sandy beach accessible only by boat, and to date, the property owner generously looks the other way when local folks return to enjoy it.

To this day, there are adults who take their boats and go to Red Hills for parties or weekend get-togethers. What do they find there? It is still a quiet

When people went to the famous big tulip tree, they were almost always in the shadow of its branches.

beautiful beach, not too far from home, in a snug cove, with a perpetual breeze even on the hottest day. Red Hills is not noted on any current map but it is a place fixed in the memories of many generations of those who live by the Chincoteague Bay.

POPE'S ISLAND
It is an isolated, uninhabited strip of land—an off-the-beaten-path place where locals partied, fished, and hunted.

Assateague Island faces the ocean. On the land side of Assateague is a back bay called Pope Bay enclosed between Assateague Island and a smaller island—Pope Island. It is an isolated, uninhabited strip of land—an off-the-beaten-path place where locals partied, fished, and hunted. Charts label the area as Pope Bay and Pope Island, but no local ever calls it anything but Pope's Bay and Pope's Island.

Before 1933, there was an inlet there between the Atlantic and Chincoteague Bay. The big hurricane that year opened the inlet at Ocean City and also filled in the inlet between Pope Bay and the ocean. Today's local watermen, who work more in the ocean than the Bay, pray for the next big storm to re-establish that inlet near Pope's Bay. Were that to happen, they would have direct access to the ocean instead of having to waste valuable

time and fuel motoring all the way around Chincoteague and Assateague Islands to get to the ocean.

The Butch and Floating Shanty
Whenever I hear someone say Pope's Island, I always remember The Butch. *She was a nice boat for the time—about 20 feet long, had a cabin and two bunk beds inside, as well as a little stove and a head. When the war was over, my dad had the job of taking care of it for the owner who lived up in Maryland. The* Butch *was commandeered by the Coast Guard or the Navy during World War II. They burned in their big identification numbers down the side. No matter how much scraping, sanding, or painting—if you got just the right angle, you could still see those numbers.* Landlubbers may not know that, even today, all boats on public waters must be registered and wear their assigned number on either side of the hull. This law was instituted during World War II to enable the government to seize and use any boat for wartime use. The numbering system allows easy and unique identification of any boat on the water.

The same man who owned The Butch *had a houseboat that dad took care of that we called the* Floating Shanty. *The houseboat had three or four bedrooms, a kitchen, and it leaked all the time. We always had a pump going to pump the water out. It was a mechanical pump so I had to go almost every day to pump the thing out.* These days, you have a battery-operated bilge pump with a float that trips the pump when the water gets to a certain depth.

Several times a summer—I'm guessing two, three, maybe four times a summer—we'd take the houseboat over to Pope's Island for the owner. There was a little pier and he'd have a party weekend. Early on, my dad and I, and later just me, had the job of towing the houseboat over there. The Butch *(the cabin cruiser) was the towboat and the* Floating Shanty *trailed behind. The owner and a few of his guests would meet us there, I think on a Saturday, and stay over till Sunday and then we'd tow the houseboat back on Sunday night.*

The part I can't remember is how he and his guests got there. They could have gotten there by coming over the bridge south of Ocean City to Assateague Island, there was a road on Assateague then, and then come across to Pope's Island but I can't remember just how that worked.

I remember one time, I was there on Pope's Island after towing the houseboat over. I was the only one there. Since it's a very short way to the ocean and I was waiting around for the owner of the boat to show up, I decided I'd just go over and go swimming in the ocean—something that I didn't get to do very often. The tide was really strong. I'd keep testing it—you know, walking in a little bit to see

how strong the pull was. It was way too strong for me. I was really disappointed that there was my chance and then I couldn't do it. Come to find out there was a big storm out at sea.

So Who Will Know
I remember thinking one time when I went to Pope's Island that it was a good thing the game warden didn't ever go over there. One day I had to go up to Maryland to pick up the houseboat and take it over to Pope's Island; so, I got one of my friends to go with me. The guy who went along hadn't been over there before. It was in the early spring and we picked up the houseboat and when we got over there we got off and were walking around. There were some duck blinds right around there and there was a shed. Well he opened the shed door and what did he find? Bushels of dried corn. The game warden would have loved that! For non-hunters: baiting wild ducks or geese is considered highly illegal to say nothing of unsportsmanlike, but that would be the only reason to have all that dried corn around.

Pope Bay is a strange place. To this day, when you sit in a boat in the middle of that small bay, you can see on one side the ocean and beach (and often the ponies that live on the National Wildlife Refuge on Assateague Island), and on the other side Pope Island with lots of very tall loblolly pines that completely block the view of Chincoteague Bay. On Pope Island are some old rustic cabins and even a couple trailers that must have been floated over on a monitor at some time when the tides were very high. Today, Pope Bay is so shallow few people venture there.

CAPTAIN'S COVE
The old farm was chopped into thousands of very small lots, and a swimming pool, golf course, marina, tennis courts, and other amenities began to appear.

Those interested in a detailed history of this area should consult other sources, few as they are. Suffice to say, little has been written that is dedicated to either Greenbackville or Franklin City. Likewise, Captain's Cove, just five miles to the west and with a mailing address of Greenbackville, has yet to become a destination worthy of more than some newspaper items in the local press.

One early reference was to the owner of Pharsalia (Captain's Cove) who was known to go to the defense of Assateague Islanders. Daniel Mifflin, a well-to-do Quaker, owned the land and was on record in 1764 for defending

the honesty of those living on Assateague when they had been accused of stealing the cargo of a ship that wrecked on the nearby shoals.

Later, in the 1800s, there was a farm called Montrose just south and west of Greenbackville, probably near Cockle Point. Today it is part of Captain's Cove, but it once adjoined Pharsalia. It was owned by Matthew Lindsay, who is often credited with starting the Chincoteague oyster boom. Lindsay had a mill that ground grain for locals. They paid him in oysters but he had so many that he just put them in the Bay for later use.

One night a schooner from New York anchored overnight near Cockle Point, and the captain pulled up the largest oysters he had ever seen. At the time, oysters were bringing far less than a dollar per barrel. The schooner's captain told Lindsay that he could get triple the going rate and more in New York City. There was a supply of oysters in the Bay and demand for them in the cities. All that was needed was a workforce and transportation to link the two. In order to work in Virginia waters at that time, a waterman was required to own an acre of land for at least a year. Hence, Lindsay's marsh—later to be known as Greenbackville—began to be divided into one-acre plots and sold at outrageous prices (reportedly $100 per acre) to prospective watermen. Once they had owned the land for a year, they were eligible to extract oysters from Virginia waters and share in the great profits.

Land Rushes
In this part of Virginia, real estate development has always been more attractive to some than more labor-intensive pursuits. The first land rush was caused by Lindsay and John Franklin, who saw a way to turn their useless marshlands into a major source of income. At that time, the development of Greenbackville and Franklin City had little effect on the land that today is Captain's Cove. There were those who saw the development of that useless marshland as dishonest at best and possibly as a scam. A then-owner of a nearby inland farm is said to have remarked, *That land's not worth a Greenback* (the recently minted paper currency that appeared after the Civil War and was considered to be worth virtually nothing), hence the town's name. The same was not true of the rich land of the large adjoining farm that was more inland and on higher ground. The adjoining land was a large tract that was successfully farmed by several generations of the same family until the middle of the 20th century.

Another land rush happened in the 1960s when the large farm south and west of Greenbackville went up for sale. Developers quickly bought the farm and, just like Lindsay and Franklin, went about their scheme to

get rich quick. The development was named Captain's Cove. The old farm was chopped into thousands of very small lots, and a swimming pool, golf course, marina, tennis courts, and other amenities began to appear. It was the typical hyped investment property for folks from the cities—complete with high pressure salesmen driving around in limousines with two-way radios announcing moment-by-moment sales. There were televisions and other gifts for anyone who would come to Captain's Cove to listen to the sales pitch. The advertising seemed to be everywhere. Many lots were sold, but less than 100 houses were built before the initial developers fell on difficult times. Some of their problems included violation of environmental protection laws and governmental regulations as well as the developers' own financial problems. Due to these problems, little development occurred in Captain's Cove from the 1970s to late the 1990s.

It was reported by some that in at least one case, Captain's Cove's first developers were accused of destroying a seafood business. Having exhausted his options to obtain a cease-and-desist order against the Cove's development, the owner of a seafood business at his wit's end used a good deal of his precious cash to buy enough clams to pile them high on a monitor. He tied the monitor up in Greenbackville Harbor, covered the clams with a tarp, and left them sitting in the sun for four days in the middle of summer. When the proper level of stench had been reached, he floated the dead clams on the monitor to the shoreline of Sinnickson/Swan's Gut near Captain's Cove. He loaded the dead clams into the floats that he maintained there. He believed that this would provide evidence to sue the developer of Captain's Cove because his clams had died. He did sue, but the only winners were the gulls who had several days of fine meals off the dead clams, and the lawyers who prosecuted and defended the case.

At the beginning of the new millennium, age, failing health, declining interest, and at least a two- to three-fold increase in market prices from his initial investment caused the developer to look for a buyer. In 2003, he found one—real estate brokers from 40 miles to the north in Ocean City, Maryland, an urban resort community. The new developers began with a rush of cosmetic changes—a new stone entryway to the development, a redesigned golf course, tearing down the community building known as The Marina, dismantling the campground, and plans for a new community center with indoor/outdoor pool, restaurant, meeting rooms, and exercise equipment. Additionally, agreements were made to sell blocks of lots to large operation home builders. The new developer's stated goal was to build out the development in seven to ten years. They projected that Captain's

Cove would be similar to Ocean Pines, a large community near Ocean City, Maryland, and that 10,000 people would live in Captain's Cove by 2015.

With the new developer in place, land sales and house construction boomed again in Captain's Cove. With a finite amount of waterfront property all over the East Coast, such land brings top dollar. Waterfront lots and homes began to sell within a day of going on the market and in most cases were bringing four to five times the price they would have sold for just 10 years earlier. Many of the new buyers seem to think those prices are a bargain. Nearly 300 new homes are being constructed each year compared to barely 100 in the first 30 years of the development's existence. The cost of construction here, as well as the cost of living, is lower than in many other areas. However, more people will require more and more commerce as well as public services such as sewers, water, and fire protection; therefore, taxes and prices will necessarily rise just as the cost of land has.

Captain's Cove's meteoric rise has not gone unnoticed by Greenbackville's more stable community members. Their population is aging and many older homes and nearby acreage is being sold for astronomical prices. There is speculation that condos will soon be sprouting throughout the area, just like in Ocean City, Maryland.

Memories of Captain's Cove

Before development, the land was primarily a large family farm composed of open working fields, livestock, a large and stately farm house, barns and other out buildings, stands of both soft and hardwood trees, and acres of land that sloped naturally into the Bay. Many volunteered their memories of earlier times on the land that is now Captain's Cove:

> I'd ask my mom what she wanted for supper. She'd say an' I'd go over there huntin' an' bring it home inside a couple a hours. Didn't make no difference, you could get deer, ducks, geese, gull eggs, muskrats, rabbits, squirrels, even yellow legs. Everything was plentiful then an' nobody paid any attention to property lines an' fences.

> Chapmantown. That's 'round there by that old farm house on the way back out. Used to be several smaller farms in there, all owned by one Chapman or another. When the developers came, the Chapman who owns that house wasn't havin' no part of sellin' his land to them an' to this day still hasn't.

I remember as a Girl Scout, we'd go campin' out there. That's probably the most beautiful land anywhere around. Ya know, it's on that high knoll right along the Bay between Cockle Point and Greenbackville.

When I was a boy, we'd jump shoot ducks along the shore between Cockle Point an' where the marina is now. Back then, we called it Cedar Hammocks.

Livin' in town, there were more trees back then but we didn't have a lot of what would work for a Christmas tree. We'd always go over to The ____ farm an' get a really nice one.

In the spring we used to always go over there an' pick daffodils. They were those frilly old-timey kind. We'd find 'em out toward the Bay between the outskirts of Greenbackville an' the back entrance to the Cove. You could tell old houses had been there 'cause you could see some of the foundations an' they were always in a clump of trees. They must of been planted there by somebody 'cause they wouldn't a come up naturally.

The family home of a nearby farmer. It was demolished when the farm became part of Captain's Cove.

The Result

From the early farmers who thought the development of marshland was ridiculous up to today, most locals, when they are honest, will tell you they wish Captain's Cove did not exist. In their words it has brought:

> *A bunch of come 'eres who want it to be just like it was were they came from an' even if we made it that way, they'd wanta be somewhere else cause that's what they left.*

> *Busy bodies. We take care of ourselves an' don't need city folks or anyone else for that matter tellin' us how we oughta live our lives.*

> *A loss of our old huntin' grounds. Can't go over there anymore huntin' or gettin' your Christmas tree either.*

> *Way more traffic. Next thing ya know we'll be havin' traffic lights to go to Pocomoke.*

> *Jet skis and dumb boaters.*

> *Just plain pushy people. Those from New York and New Jersey are the worst. They're flat out rude.*

Is this criticism warranted? Whenever a population increase as great as the one that happened between 2003 and 2006 occurs, there are likely to be people to whom all of these characteristics can rightly be attributed. Others will soon learn that many of the reasons that led them to invest in the new development—escape from city life and closeness to wildlife, fresh air, nature, and the like—will be disappearing because of the high density, suburban-style community that is under construction.

On the other hand, local residents appreciate, if they don't love, what Captain's Cove has contributed to their lives:

> *Jobs working in the Cove that did not exist before.*

> *An increase in property values that makes selling their house or farm much more profitable.*

More money in circulation that helps support local businesses and the local economy.

Swimming lessons at the Cove for kids from all around.

Exposure to different nationalities

Experience with new styles, different foods, and other ways of life.

And yes, some have found a new friend or two.

It is not the purpose of this book to rehash the pros and cons of what has happened and is happening in Captain's Cove. It can be said that the early development of marshland, although criticized by some in those days, led to two vibrant communities on Virginia's Eastern Shore. The growth and development of those communities brought a quality of life to the area that has not been seen since. At the time this book was written, one of those communities has gone back to marshland and the other was in a state of limbo between decline and growth, with the choice being up to its residents. Either way, inserting a community of 10,000 people into the middle of one of the last truly rural waterfront areas on the East Coast will bring irreversible changes to the people who have always lived there and the land and waters that they revere.

A TALE OF TWO TOWNS
They were the center of their world and everyone came to them.

For the most part, residents of Greenbackville and Franklin City were happy with their own world as they defined it. They saw little need to go elsewhere and did not take kindly to others who tried to bring the outside world to them. Baseball games on the radio, city newspapers delivered by train, dances for teenagers at the Redmen's Hall and an occasional picnic or outing was quite enough for most of them. If they needed more city life there was always Chincoteague Island and Pocomoke City.

Chincoteague Island
Today this is a popular oceanside summer vacation spot. It is less than five miles away from Greenbackville by boat and 17 by car. Nearby Assateague

Island with its National Wildlife Refuge and National Seashore including a generally un-crowded beach are the main attractions. The Assateague beach only became accessible when a bridge was installed between Assateague and Chincoteague Islands in the early 1960s. In the old days, those wishing a beach experience went to Red Hills on the land side of the Bay. Few locals mentioned Chincoteague or Assateague Islands as places they thought about visiting.

The main reasons to go Chincoteague Island were to deliver chicken feed by boat or to procure illegal alcohol. It is likely that during the oyster boom there was a fair amount of competition between watermen from Chincoteague Island and those whose home ports were Franklin City and Greenbackville. Other mentions of Chincoteague Island had to do with baseball and courting, both competitive sports by any young man's definition.

For all these reasons, and other unspoken ones that are ingrained in the local culture, real locals on the land side of the Bay will tell you they do not have a lot of love for *Teagers* (Chincoteague Islanders). In fact, one man said *You gotta watch, those Teagers will steal the compression right out a your engine.* And a woman said, *I wish I knew then what I know now. When I was first married, we lived over there. Every night I'd look across the Bay an' see Greenbackville's lights an' I'd just cry an' cry an' cry. Marrying him was the first mistake an' movin' to Chincoteague made it a bigger mistake.*

Pocomoke City
On the other hand, Pocomoke City was the "go-to" destination once modern transportation made the 25-mile round trip possible. At one time, it truly was a small city with a couple of national chain department stores, automobile dealers, a few factories, movie theatres, grocery stores, restaurants, doctors, dentist, smaller specialty stores and services, and yes, bars. Before everyone had cars, they would go by the Red Star bus or in carpools for shopping and entertainment. Going to Pocomoke (locals tend to drop the "City" from its official name) was a part of life in this area and is mentioned throughout this book.

In the early days, trips to Pocomoke happened on weekends. Religious beliefs limited some to only going on Friday and Saturday, others went on Sunday as well. There was precious little time for frivolity during the week when people worked from dawn to dusk. Besides, there was plenty of whatever you needed in the stores of Greenbackville. The modern practice of daily trips to the grocery store and other businesses simply was not necessary. Errands, grocery shopping, medical appointments, and entertainment were

all saved up for the once a week trip. As private transportation became more available, Franklin City disappeared, and Greenbackville's commerce declined, trips to Pocomoke became more routine. To this day, on a Friday visit to Wal-Mart, you will encounter at least half of the long-time residents of Greenbackville.

Interestingly, Pocomoke has always been seen by Greenbackers as different and *a place I wouldn't want to live*, but a necessary and tolerable collection of businesses and people to the west. The reported animosity toward Teaguers was not replicated in regard to Pocomoke.

In the heyday of Greenbackville and Franklin City, their residents did not need to go anywhere. They were the center of their world and everyone came to them. As times changed, their neighboring population centers, which from the very beginning had more than one reason for existence, began to evolve and grow. Chincoteague Island had market hunting, plus poultry and seafood businesses, and later tourism. Pocomoke had commercial transportation from three sources—the river, the railroad, and a highway, all of which made it an ideal location for factories and other commercial operations. The diversity of commerce and intercourse with the outside world allowed both Chincoteague Island and Pocomoke City to survive and, in some ways, thrive. Conversely, when Greenbackville and Franklin City's main reason for being—seafood—was no longer viable, other ways to earn a living there were few.

Afterword

Voices of the Chincoteague are not just echoes of the past; they are reminders that the past is indeed the prologue for the future. From generation to generation these stories told and retold paint pictures of a different time and place. Some are stories of people and events that cause even those who were not there to laugh, sigh, or even groan. Unexpected moments, foolish antics, and even the mundane activities that provided a living and nurtured the soul were the focus of these stories.

Places, events, and practices are easy to record and describe. And usually the result is a pretty sterile record of what occurred. It is the people involved who make the difference, bring understanding to life, and force a smile or tear.

The people of Greenbackville and Franklin City and the lives they led are the focus of this book. They were humble and for the most part happy, even if the coins in their jeans were few. They were a strong, independent, and in some cases downright stubborn people. They didn't seek fame, though some never stopped hoping for fortune. They were strong of will and body because they had to be to face the rigors of their lives. They took pride in their work whatever it might be, loved their families, understood and respected nature, conserved natural resources, and cared for their neighbors. Most of all, they had "heart," integrity, intelligence, and ingenuity. It was this way of life that makes these stories worth not only telling but preserving for the future.

This book was a humble beginning of an effort to preserve the past of these two towns and their people's rich lives. There are many more stories that need to be recorded, personalities who should not be forgotten, practices and mores that are notable, as well as events that forever changed the world of Franklin City and Greenbackville, Virginia during the 1900s and earlier. The authors invite and encourage others to join this task by writing their own books, by sharing stories and remembrances with future authors, and finding new ways to recognize and celebrate the rich past of these two boomtowns beside the Chincoteague Bay.

Afterword

William Least Heat-Moon, noted non-fiction author, when asked how to know when the author's work is finished, counseled "You begin and end when the calendar tells you to otherwise the gathering of material will be endless." After four years of interviewing and writing, it was time to make the first stop in a long journey focused on preserving the rich memories and history of Franklin City and Greenbackville.

These two towns have seen repeated patterns of growth and decline since they were founded in 1867. As surely as the moon waxes and wanes or the tides ebb and flow, the many futures of these towns and their people are yet to play out.

Appendix 1. Local Lingo

Every community and culture has its own special meanings for common words. Further, sometimes words are strung together to create phrases in ways not heard outside the community. Greenbackville residents are no exception. In fact, there may be more specifically different words and meanings among these people than in many other places. This local lingo contributes a great deal to understanding the uniqueness and character of these people.

Professional linguists, cultural anthropologists, and others whose business it is to study the way people communicate would find rich opportunities among Greenbackers. In fact, many have studied Smith Islanders in the Chesapeake Bay, and although their speech patterns and pronunciations are unique, they are not at all like the ones heard around the Chincoteague Bay.

Some words and phrases were too rich in meaning to ignore. The list that follows was not systematically gathered, analyzed, or interpreted and is probably incomplete. For some this glossary will be critical to understanding some of the text and flavor of the content of this book. Natives, on the other hand, may learn for the first time that these terms, used everyday, are unique to their community.

WORDS
Acme—teenager's facial problem (acne)
Arsters—oysters

Bateau—any boat with a pointed bow
Bay bushes—duck blinds
Biddy—chick or very young chicken
Black willies—black sea bass
Ballmer—Baltimore
Blow toad—blow fish
Boat stove—an oil drum or other steel container with a hole in the top, a soldered pipe for a chimney, and which burns whatever is available

LOCAL LINGO

Bronical—as in pneumonia (bronchial)

Ceiling—floor of a boat or top of the bilge
Chester drawers—chest-of-drawers
Chicken neckers—people who crab using chicken necks as bait; sometimes used as slang for tourists, who often crab this way
Chimley—chimney
Chunk—toss or throw, "We chunked shells at windows"
Come 'eres—non-natives, tourists, outsiders who moved here
Cream—canned evaporated milk

Dinky—small boat powered by a pole or oars (dinghy)
Drudge—dredge

Finders Keepers—An age-old "law" based on the rhyme, "finders keepers, losers weepers" wherein the finder of an unclaimed item is entitled to keep it, no questions asked
Floats—pilings with a series of ropes and pullies that raise and lower shellfish in and out of the Bay, often used to hold seafood in its natural environment until prices rise or transportation becomes available
Fish Pots—large nets, usually with a pocket at the end and secured by a series of poles from the shore into the Bay to trap fish

Gingoteague—Native American word that later became Chincoteague
Greenbacker—a resident of Greenbackville
Gut—a tidal creek, a creek that runs into the Bay

Hardheads—croaker, a type of fish, good eating but lots of bones
Haymans—variety of white sweet potato only grown on the Eastern Shore, so sweet it requires no butter or anything else for dressing
Hobo bun—flat cinnamon bun

In the window—innuendo

Jump Shoot—walk along the shoreline to flush ducks for shooting

Line—rope used on a boat
Little Nick—very small clam
Nip—sip or drink, usually of alcohol

Nor'easter—violent storm with strong northeast winds, usually in winter or spring

Monitor—small non-motorized barge used for transporting oysters and clams

On the book—recorded in an IOU journal kept by storekeepers
Old Timers Disease—Alzheimer's Disease
Over—putting a boat in the water from a trailer or storage

Pine shats—pine needles
Prayer chain—phone calls made every morning usually among the women but also a source of news and other peoples' business.
Proggin'—poking around in the marsh
Prostraight—prostate gland
Pulling your leg—telling a yarn or falsehood as a fact
Purddy—pretty

Railway—system of rails, pullies, and lines to raise large boats out of the water for repair, painting, etc.
Refrigerlation—refrigeration
Rock—A hard part of the bottom of the Bay where oysters grow
Rutting—mating season, as in deer rutting season when they begin to run with abandon across roads

Salt water tree—used to "pull the leg" of a come 'ere asking about a stake, to mark a sand bar, put in the water by an unfortunate boater who has gone aground there
Salt water bushes—what some come 'eres call duck blinds
Scow—any boat with a squared off bow and stern
Screw bore—screw worm that destroys oysters
Shats—pine needles
Spat—baby oysters
Stump—to run into a stationary object and hurt yourself (stub)

Teched—mentally unstable, not quite right
Toad fish—a type of blow fish, all parts are said to be poison except the tail meat
To slight—use leverage, be smart with lifting

Tongs—two very long poles with rake-like metal pieces and prongs on the ends used to harvest oysters by hand

Well oiled—drunk, inebriated
Water Cops—marine police
Went up—broke down, died, or won't work anymore

PHRASES
Ridden hard and put up wet
You're gettin' on my last nerve
Beer tasted like horse piss
Month still left at the end of the money
He's so good he can catch clams on concrete
Teagers will steal the compression out of your engine
Your dad won't die till you do—you're the spitting image of him
He's so dumb, he wouldn't know how to pour piss out of a boot with the directions on the heel
Must have been hit upside the head this morning with the dumb stick
I'll not be likely to be polin' outta here today
There's more of me than those jeans
This water's rough enough to roll the yeast out of a biscuit

Appendix 2. Early History

The material in this appendix is based exclusively on the works of Kirk Mariner. The community and the authors express extreme gratitude for his lifelong collection of data and research about the Eastern Shore and specifically about Greenbackville and Franklin City. Without his contributions, the very early history of these areas would be lost.

Many folks on the "other side of the bridge" don't even know there is an Eastern Shore of Virginia. Not only that, few know or remember that one of the biggest and fastest land rushes happened right here on the Virginia-Maryland line in the late 1800s. Other land rushes were prompted by the quest for land, gold, and a variety of mainland pursuits. The land rush described here, like those, was for the purpose of making more money quicker than was feasible by any other means. But, this rush was different. It happened not for the land but rather for the water surrounding it and the "gold" it contained—oysters.

During the settlement of this country, new communities were located near some means of transportation. Transportation is critical to commerce as well as social interaction. Early on, that meant old Indian trails, rivers, and harbors were the preferred sites of new towns. Soon, new trails such as the Overland and Santa Fe were developed by businessmen who got rich transporting other people and their goods. Those trails became the stimulus for more communities to develop. Later, railroads and their intersections became fertile areas for new communities to spring up. Roads and highways have performed a similar function.

The development of the Eastern Shore was no different. The earliest inland towns were found near Native American foot trails while water-based communities were usually located where a river joined another river, or the Bay. Although extensive research has not been conducted, Greenbackville and Franklin City were probably the first settlements on the Eastern Shore of Virginia where the transportation came to them rather than vice-versa. Before there were bridges on either end of the peninsula, in a time when

chicken farms and watermen provided food for local tables, and when tourists and automobiles were rare, there were two land owners who saw a chance to make big money. Their entrepreneurship coupled with the valuable commodity—oysters—changed the middle western shore of the Chincoteague Bay forever.

As this country was being explored and settled, the custom was for the explorer to claim land for whoever had sent him to explore—sometimes a country like England or Spain and other times a commercial entity like the West Indies Company or Virginia Company. Then, the land was given to individuals by the country or company whose explorers discovered it. Such land grants were large tracts of land usually owned by an already well-to-do gentleman who was well connected to power circles. Once the land was granted, the owner was richer and had the opportunity to make more money by either using or selling the land.

Greenbackville

Most of Virginia's Eastern Shore was first divided in land grants that reached from the ocean to the Chesapeake Bay. Over the years, those large tracts of land were subdivided between heirs and others who the original grantee saw fit to give or sell to. By the early 1800s, Solomon Tull, one of the later land owners, sold part of his land known as the Russell farm to Mathias (or Matthew) Lindsay. Lindsay's son, Henry Clay Lindsay, built a house and mill on the estate and called it Montrose. The house was built on a high knoll south of Greenbackville and north of Cockle Point overlooking the Chincoteague Bay. Lindsay, a gentleman farmer and businessman, made his living farming and grinding grain for residents of Assateague Island, Chincoteague Island, and others. Because the currency of the day, silver and gold, was very hard to come by, Lindsay was usually paid for his mill work in fruits, vegetables, and oysters. Having more oysters than his family could consume, he threw the extras back into the Bay along his shoreline.

Another large piece of land south and west of Greenbackville, currently known as Captain's Cove, was owned by a Quaker named Daniel Mifflin. This prominent man defended and spoke on behalf of Assateague Island residents when authorities suggested that they were thieves. Assateaguers were notorious for appropriating anything that washed up on their shores from shipwrecks on the nearby shoals.

Back then, the Chincoteague Bay was much deeper and there were several entrances where ships could enter from the Atlantic Ocean into the Bay. The

number of shipwrecks charted off the shoals of Assateague confirms this fact. Further, it is clear that the name of the town a few miles up the Bay, Public Landing, did not happen by accident. Legend has it that one day a captain of a schooner from New York sought permission from Lindsay to anchor overnight near his home—probably between today's markers 12 and 14. That evening, he was checking the depth of the water, scraped the bottom, and came up with the biggest oysters he had ever seen. The next morning, he offered Lindsay $1.35 a bushel for as many as they could deliver to New York City. Until then, the going rate for a bushel of oysters was 50–75¢.

There was only one problem. In Virginia waters, it was not legal to harvest oysters until you had owned and occupied land in the state for one year. Virginia legislators passed this law to favor their Eastern Shore friends who, like them, were large land owners. Lindsay, being the businessman he was, saw an opportunity to convert much of the marshland to the north of his estate into one-acre lots that he sold to prospective watermen for $100 each. By 1856, ten people had bought these lots. Henry Pope, a neighbor of Lindsay, said in passing, *Those lots are as worthless as greenbacks*, a disparaging comment not only on the quality of land but also his view of the new currency of the United States. As time went on, Pope's assessment of the town, which became known as Greenback, was not shared and it thrived.

In 1874, Lloyd T. J. Wilson moved to Greenback from *down county* to become the schoolmaster. He worked hard to have a post office established in the town and in the process thought the town needed a more respectable name, so he attached "ville" to Greenback in his application to the federal government requesting that a post office be established. From the time the post office was approved, the town's official name has been Greenbackville. Nevertheless, many locals still refer to it as Greenback even though it has been over 100 years since the post office was established in Greenbackville.

There are now no signs of the Montrose house but in the spring, daffodils bloom in a field where they were undoubtedly planted well over a century and a half before. The site of the field perfectly fits the description of where Montrose was located.

Franklin City

Only a year or so after Greenback lots started being sold, Judge John R. Franklin of Snow Hill saw a way to "kill two birds with one stone." First, he influenced the Washington & Atlantic Railroad—of which he was a board member and major shareholder—to extend its line to the Chincoteague Bay.

EARLY HISTORY

This Franklin City house is on pilings with water underneath it. Notable is the boardwalk, not sidewalk, from the house to the street.

Much of the land from what was known as the Sea Road, later Maryland Highway 12, was owned by Franklin, as were the fields and marsh where the railroad terminal would be located. Interestingly enough, the route he recommended cut diagonally through his land and ended at the marsh just south of Long Point and north of Greenback. The real target of the railroad was the Chincoteague market. Franklin City was created simply because its location was the most direct way to get to that destination.

The rail spur was named the Delaware, Maryland & Virginia Branch of the Washington & Atlantic Railroad. This terminus would become a ferry port and shipping center for seafood and produce to and from Chincoteague Island. Trains from this station headed to the lucrative northern markets of Baltimore, Philadelphia, and New York. Once established, the train did away with the old method of literally "shipping" seafood and produce to the cities by boat. No longer did the watermen have to worry about ships headed to markets sinking or the loss and stench of spoiled seafood from a ship that was becalmed. The train delivered its bounty from Virginia's Eastern Shore to the cities of the north in one day.

In addition to remuneration for the use of his land for the new railroad line, Franklin was determined to compete with Lindsay in selling lots. He already owned all the land from the north side of Stockton Street in Greenback to the marsh and east to the Bay. In 1877, he was selling lots along Stockton Avenue and had the idea that there was room for another

town—Franklin City. He planned his town to be geometrically perfect with three streets going east-west and five cross streets intersecting them. This gave the town 20 rectangular blocks, most of which had 24 building lots on them. A typical lot had 25 feet of frontage and sold for $25. Franklin's dream was 649 homes and 2,000 residents. From the historical records, it appears that Franklin City was the first developer-planned community on the Eastern Shore.

The lots were cheaper than Lindsay's lots and the location was essentially the same. Buyers undoubtedly asked themselves, *Why pay four times as much for the same thing?* The fact that Franklin's lots were only a quarter the size of Lindsay's and either in the marsh or dangerously close to it seemed to make no difference. Although Greenbackville was also growing by leaps and bounds, Franklin City clearly outpaced it at the outset.

Near the railroad station at the end of the line was a hotel, a store, and several oyster packing businesses. In 1884, trains left Franklin City daily for the north with 1,600 bushels of oysters in each. Two years later in 1886, the commercial pier had to be enlarged and the next year the passenger platform was remodeled and made larger. By 1890, there were two trains per day plus an additional one weekly just for shipping oysters, potatoes, and fish. In 1891, 50,000 bushels of potatoes were shipped and in 1892, S. R. Stebbins opened a barrel factory in Franklin City to make the thousands of barrels necessary for shipping the produce and seafood. Needless to say, warehouses, shucking houses, a canning factory, and boat repair businesses also grew up to support the booming seafood industry.

In addition to the commercial interests, there was also a Redmen's Hall, a post office established in 1877, several churches, and a growing number of homes. One wise owner was the talk of the town when he built his home on pilings—a practice later commonplace in seaside communities where tides and storms often cause flooding.

By 1915 a number of forces conspired to begin the decline of Franklin City. In addition to dwindling supplies of oysters due to over fishing and bivalve diseases, a big fire in 1896, and several devastating storms, Franklin City was beginning to shrink from the vision of its founder. The final straw was the growing popularity of the automobile and the opening of the Chincoteague Causeway, which made it possible for man and oyster to travel much more easily and conveniently. Franklin City was no longer the linchpin. From then on, a slow and painful demise occurred throughout the 20th century. All that remains now are the footprints of a few buildings, marshland, and many memories.

Sources for Early History

Mariner, Kirk. *Nothing Ever Happened in Arcadia.* Onancock, VA: Miona Publications, 1968.

Mariner, Kirk. *Off 13: The Eastern Shore of Virginia Guidebook.* Onancock, VA: Miona Publications, 1987.

Mariner, Kirk. *Revival's Children: A Religious History of Virginia's Eastern Shore.* Salisbury, MD: Peninsula Press, 1979.

Mariner, Kirk. *Once Upon an Island.* Onancock, VA: Miona Publications, 1996.